CHICAGOSCAPES

CHICAGOSCAPES

PHOTOGRAPHS BY LARRY KANFER
WITH ALAINA KANFER

University of Illinois Press • Urbana, Chicago, and Springfield

Manufactured in the United States of America
C 5 4 3 2 1
∞ This book is printed on acid-free paper.

Library of Congress Control Number: 2014943733
ISBN 978-0-252-03499-2

To our children, Anna & David. We thank you for sharing in our adventures and we will always treasure our long walks through Chicago together.

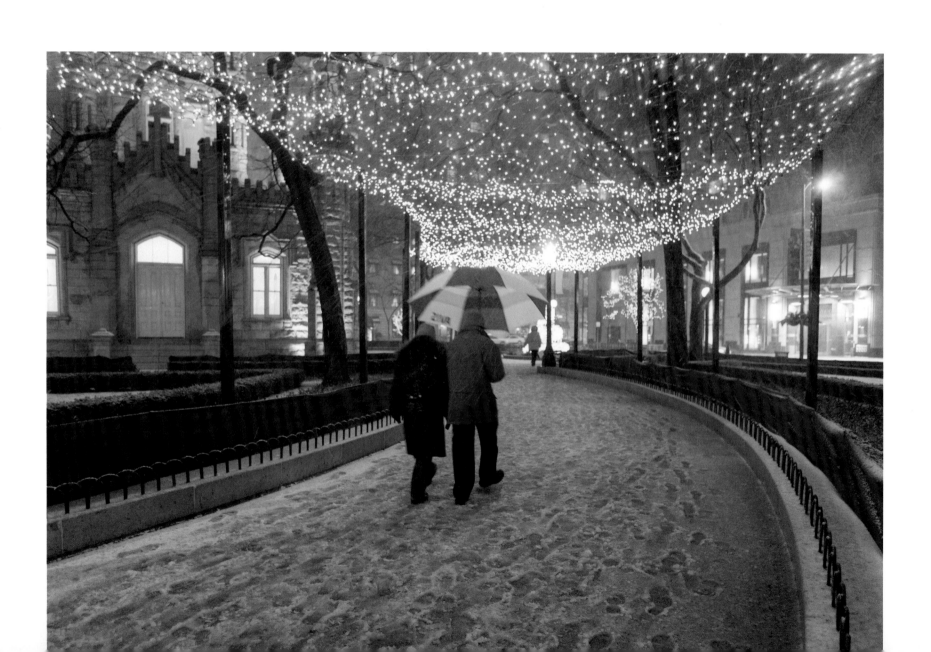

OUR CHICAGO

Ever since I moved to the Midwest in high school, the great city of Chicago has been a destination for me. I can still remember how big Chicago felt when I came into the city for the first time on a train from the south with a high school buddy. I saw tall buildings in the distance, and then it took such a long time before we finally pulled into the station downtown. Stepping out onto State Street, I could not believe that in this big city, with all its noise, hustle, and bustle, I could still smell fresh air! I loved the Els—the screech of the trains and their industrial look. I remember that we went to the Berghoff Restaurant and the Art Institute. And I remember how tiring it was. We put in a very long day trying to see everything, to soak it all in.

Since then, Chicago city life has offered a counterbalance to my life in Champaign. Weekends in Chicago with my family have become a tradition, packing in as rich an experience as possible in a short time. I still experience Chicago with that same feeling of exploration and excitement.

In 1984 I took my first photograph of Chicago: a skyline taken from what used to be the hairpin turn on Lake Shore Drive at the Chicago River. It captured the glitter of my early Chicago experience. I also appreciated the many opportunities Chicago offered to photograph significant architectural details and interesting lines and contrasts that drew my eye, educated by a degree in architecture. My Chicago collection grew.

A few years later, I met Alaina, now my wife. She was a real Chicagoan who introduced me to my first Chicago hot dog, ethnic neighborhoods, and my first Cubs game. Through her eyes, I was able to appreciate Chicago from the insider's point of view, and my collection grew even more.

Working on this book project with Alaina has been like a treasure hunt. She sent me out to different neighborhoods to try to experience what Chicagoans love about their city. Through the process, I think I've grown to love Chicago like a native, and I hope the depth of my Chicago collection reflects that.

We'd like to thank so many friends, family members, native Chicagoans, and visitors for sharing their passion for Chicago with us. We'd like to also thank the University of Illinois Press for supporting our vision, and even more important, for pushing us to get it right, especially Bill Regier, Michael Roux, Jennifer Reichlin, and Dustin Hubbart.

My wife's eyes still sparkle when she talks about her city, and the source of that enthusiasm is the Chicago I wanted to capture in these photographs. When my mother-in-law read through our manuscript, she said, with tears in her eyes, "That's my Chicago." With *Chicagoscapes* I hope to evoke that feeling of sharing the real essence of our Chicago.

Larry Kanfer

Approach Chicago by car, rail, boat, or plane and you are lulled by the repetition. Corn, corn, corn or water, water, water. Ahead, where the earth kisses the lake, Chicago arises. An almost magnetic pull lures you to join the densest center of human activity in the vast American Midwest. Your eyes are dry from not blinking because you don't want to miss anything.

Up close, the city's sheer vertical mass is an almost shocking contrast to the horizontal repetition of the approach. Chicago is the birthplace of the skyscraper and generations of other architectural innovations. But although the skyscrapers of downtown draw attention to their vertical presence, daily life is navigated on a horizontal expanse. The city feels like it goes on forever, embellished with exhilarating zones of commerce, cultures, and activities. The physical and emotional edge of Lake Michigan gives the city a north–south orientation and anchors residents and visitors with an ever-present sense of space to the east.

You can drive, bike, or walk for miles, from one end of the city to the other, transported from one neighborhood to the next, each with its own history, traditions, and character. Alleys cut through the long side of city blocks, providing places to play—and places to drive when the streets are blocked with traffic or snow.

Chicago is the land of a thousand festivals, from citywide celebrations in Grant Park or Millennium Park to neighborhood and ethnic fairs. Fourth of July along the Lakefront, the Chicago Marathon, the Air and Water Show, a Thanksgiving Day parade, the Bud Billiken Parade and Picnic, and two parades on St. Paddy's Day.

And there are many other ways to pass your time in the city. Architecture gazing and people watching. World-class museums. Outdoor public art. Theaters and restaurants. Symphony, opera, and the blues. Da Bears and da Bulls. Two zoos and one of the largest aquariums in the United States. The world's largest public library. Shopping and nightlife on the Magnificent Mile. Chinatown, Greektown, Little Italy, Pilsen. World-famous pizza and hot dogs. Boat tours on the rivers and canals. Acres of city parks and miles of public beaches. A beautiful lakefront with places to play, to congregate, and just to look and contemplate.

Chicago has the perfect mix of organic and industrial grit, sophistication and the down-home friendliness of the Midwest, stimulating urban density and serendipitous open space. Here, people from all around the world live next to each other, sharing a common Chicago with a palpable sense of pride—a pride we share here, with Larry's loving view of the city.

—Alaina Kanfer

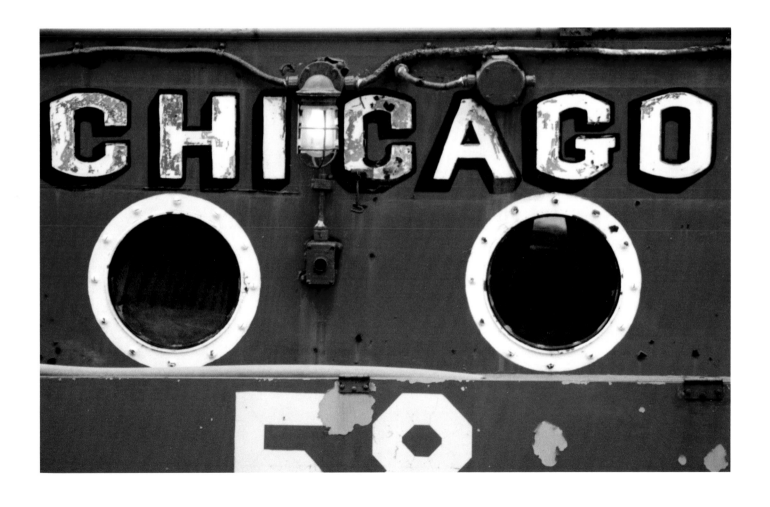

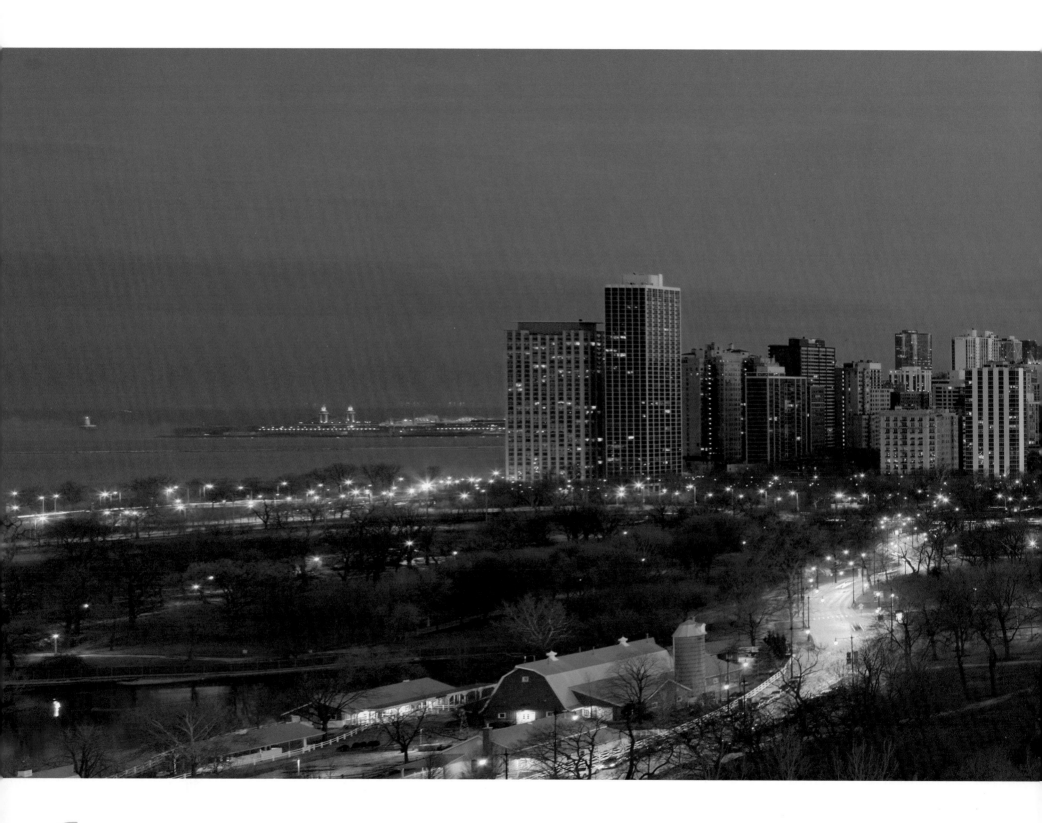

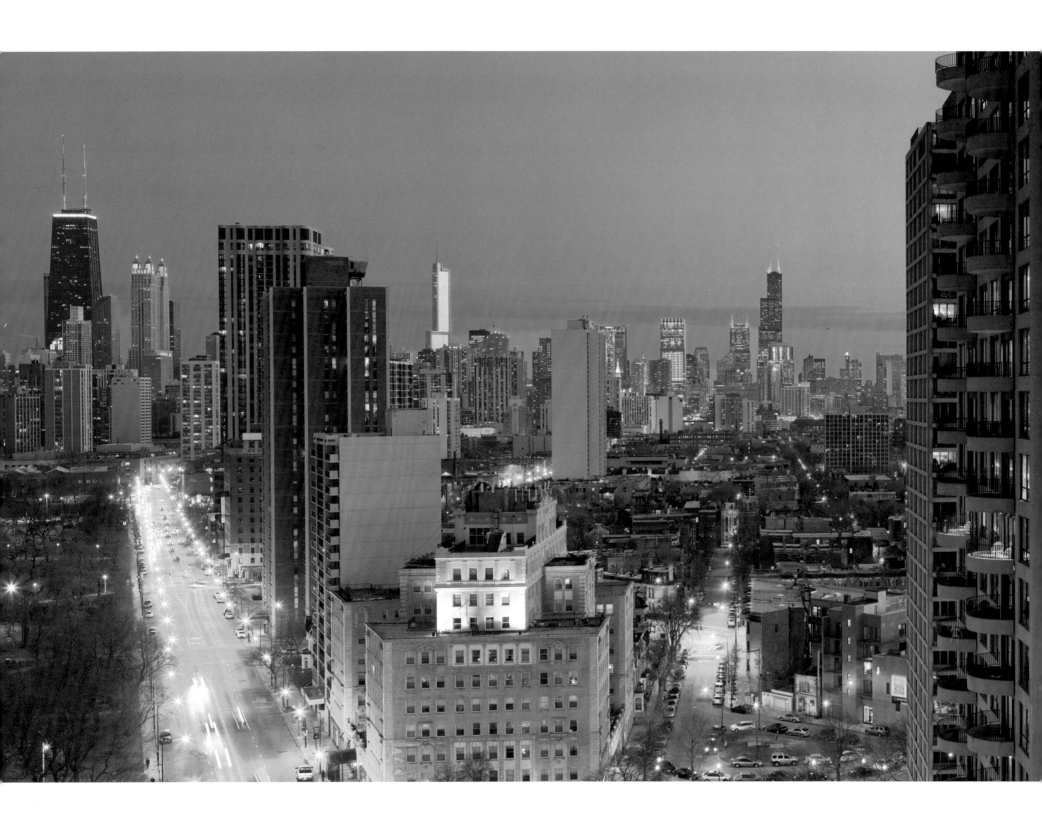

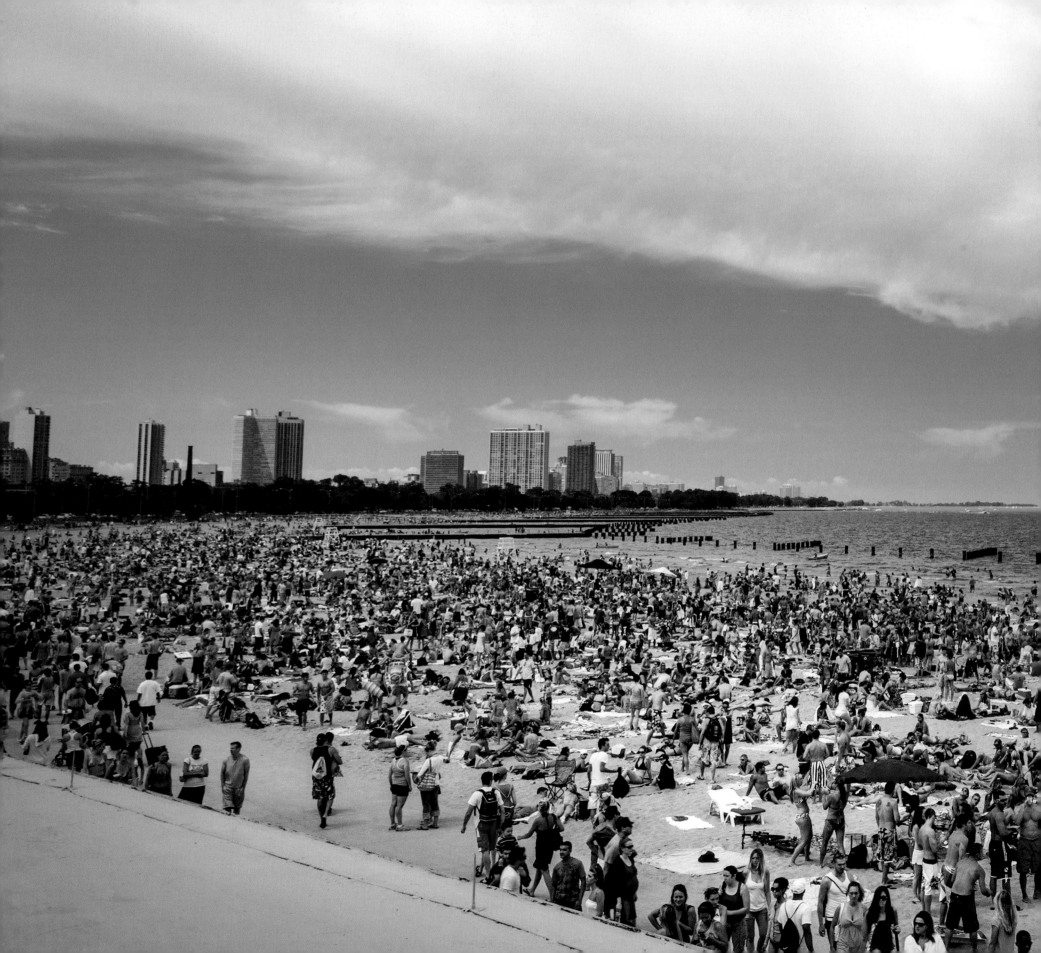

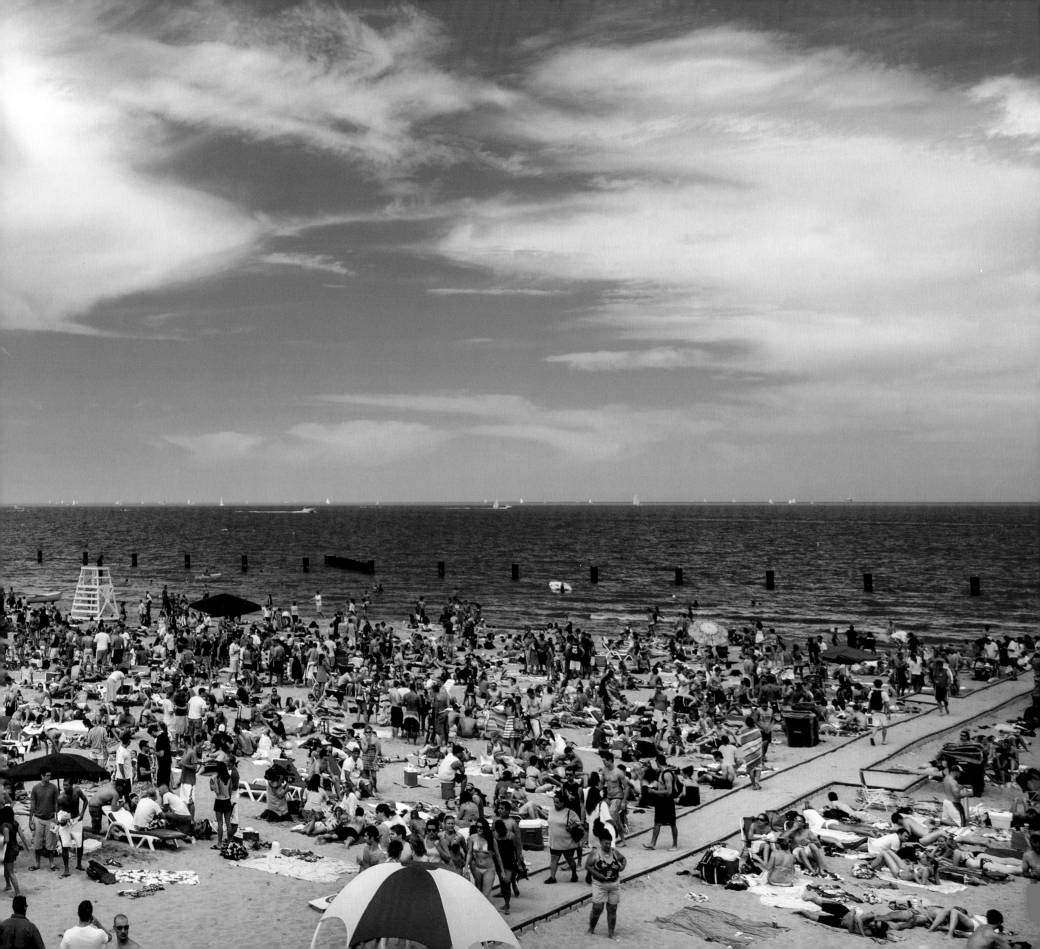

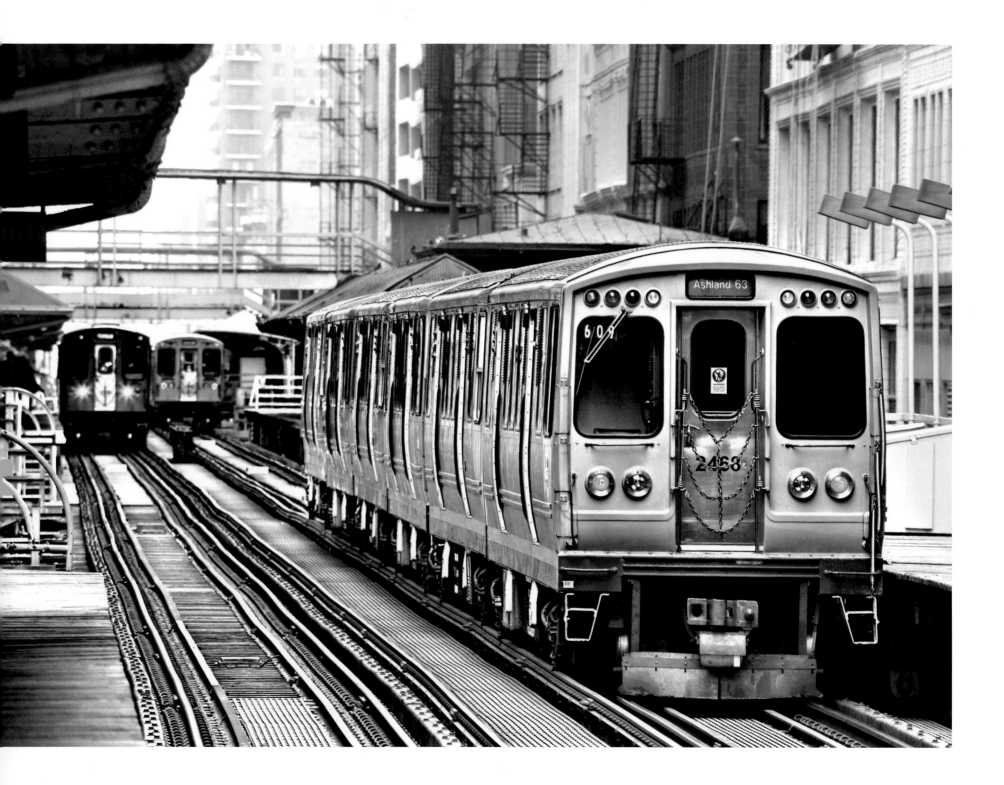

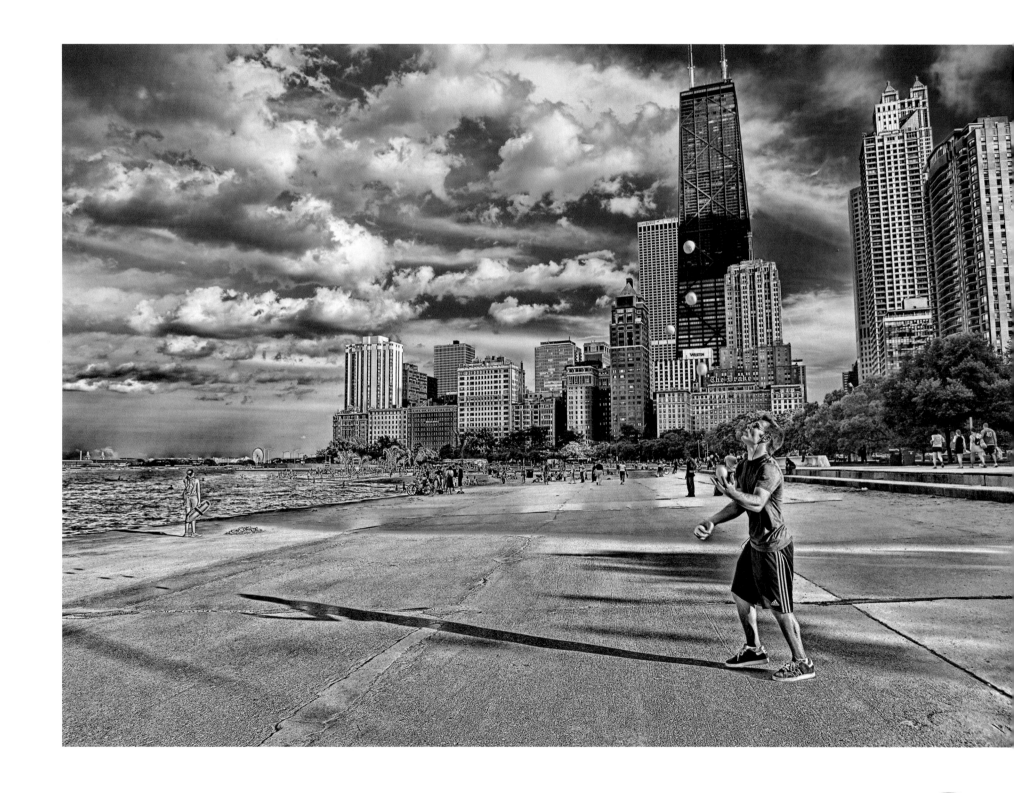

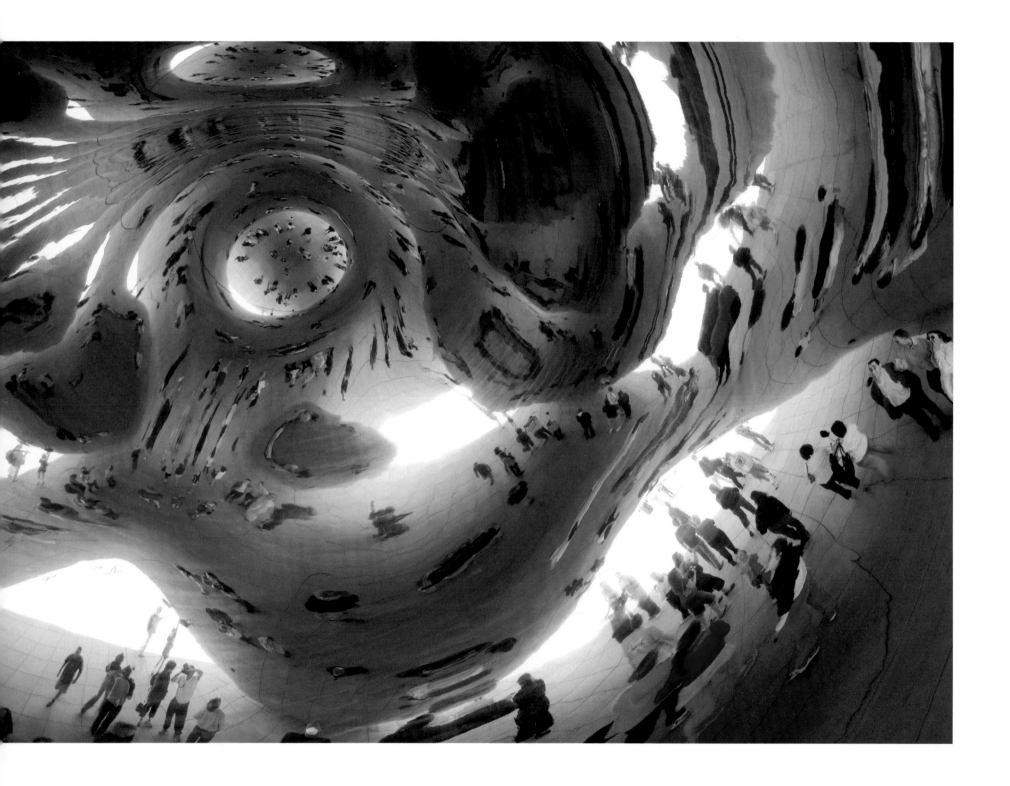

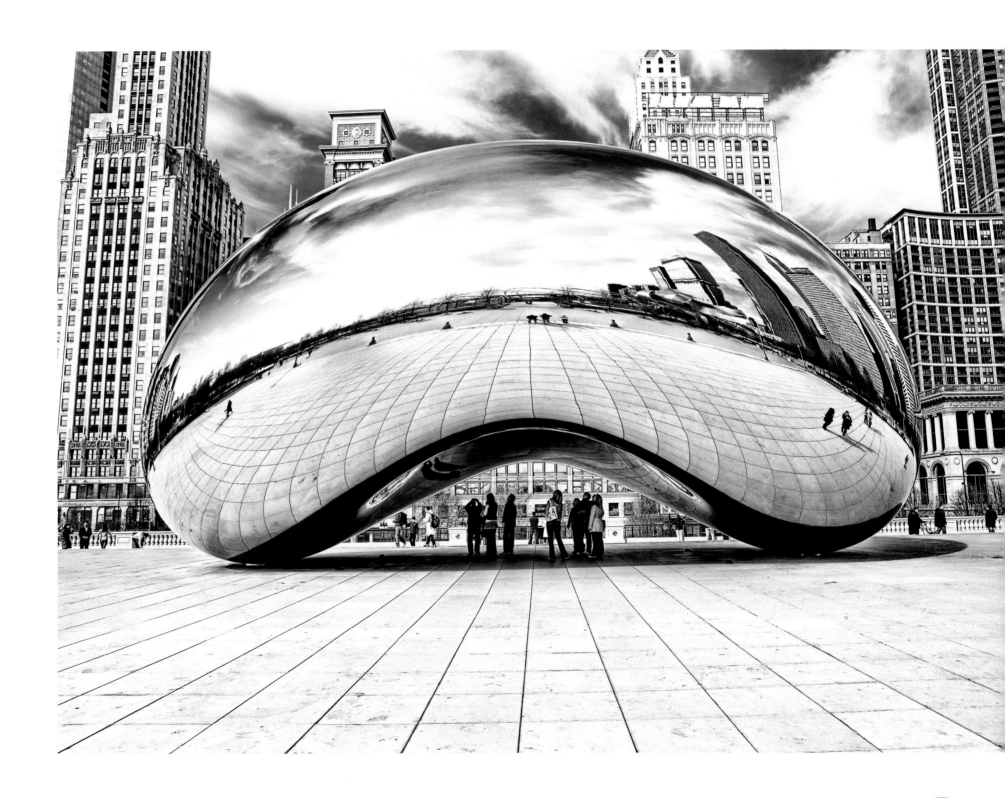

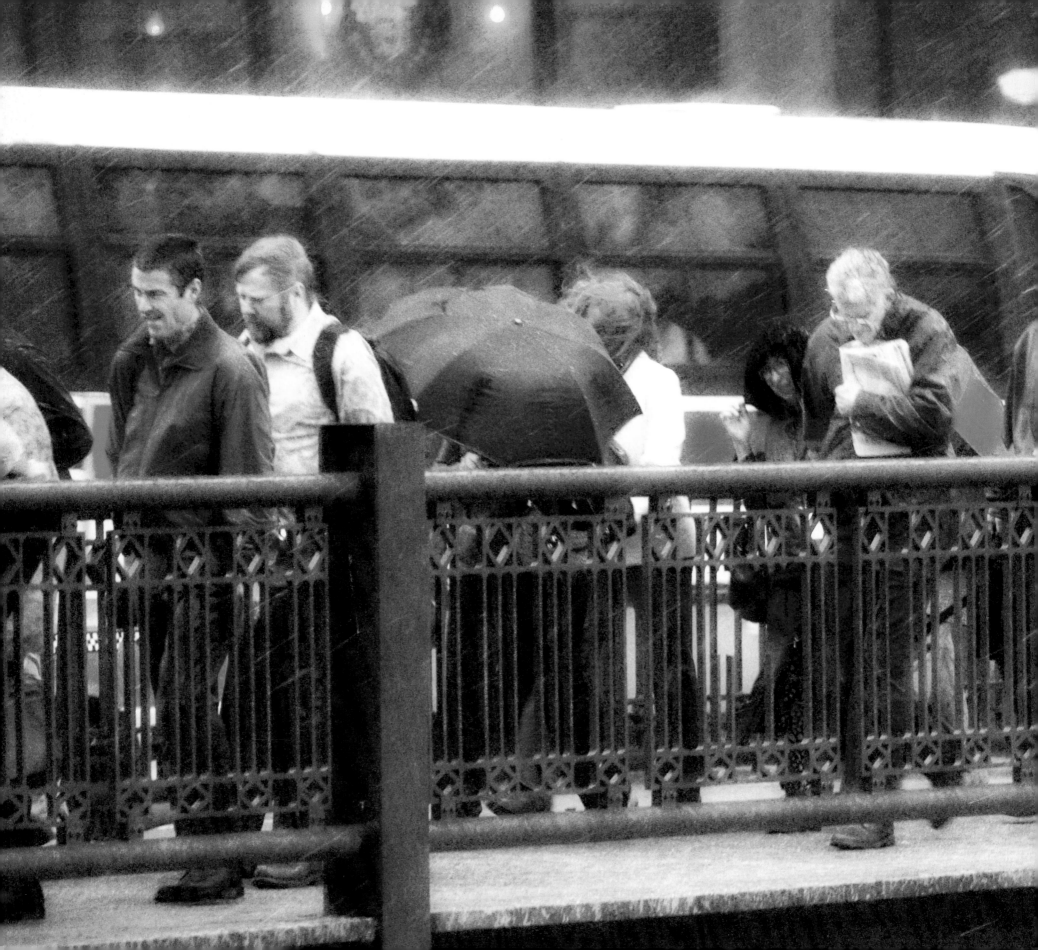

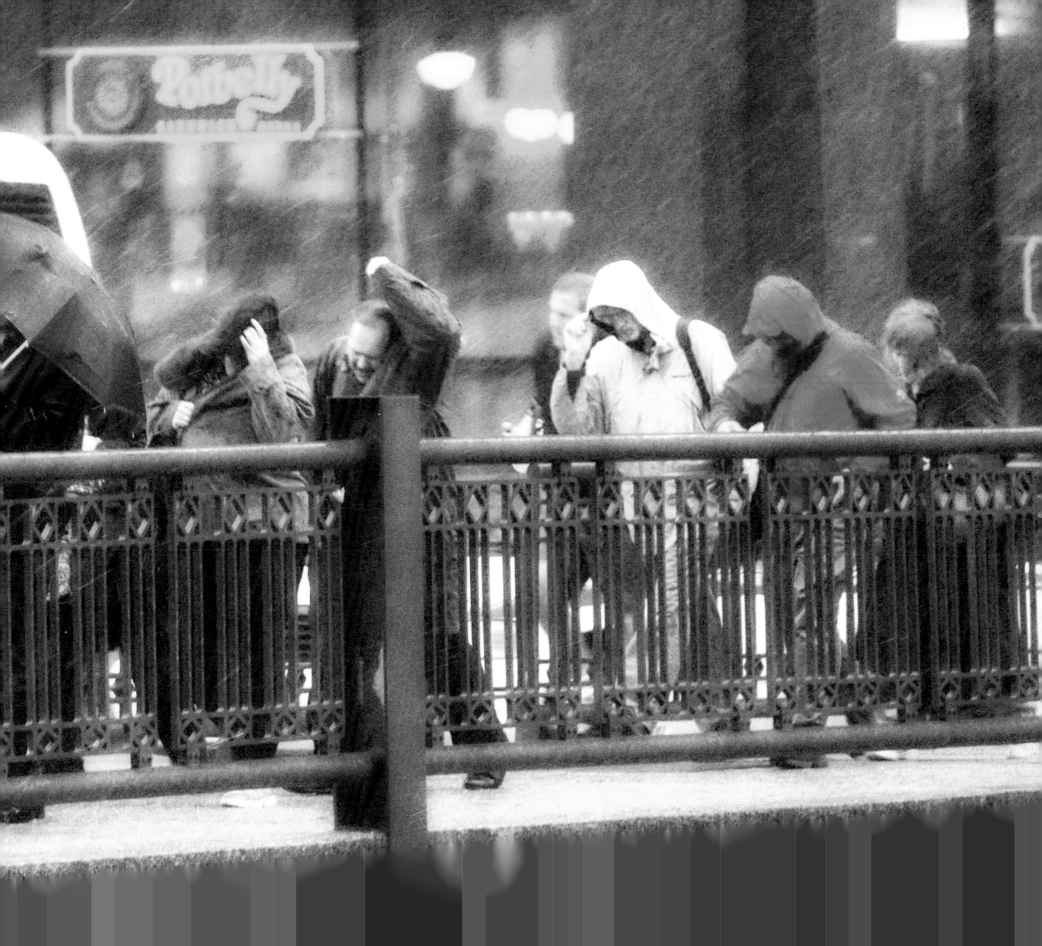

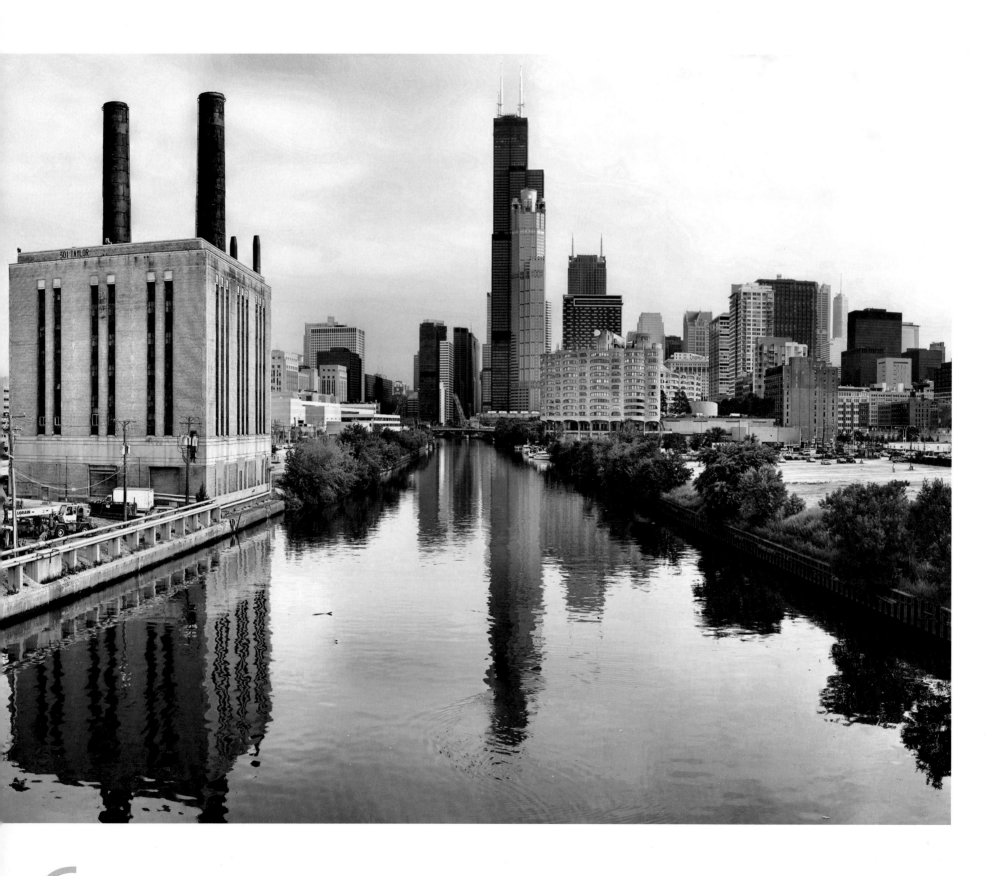

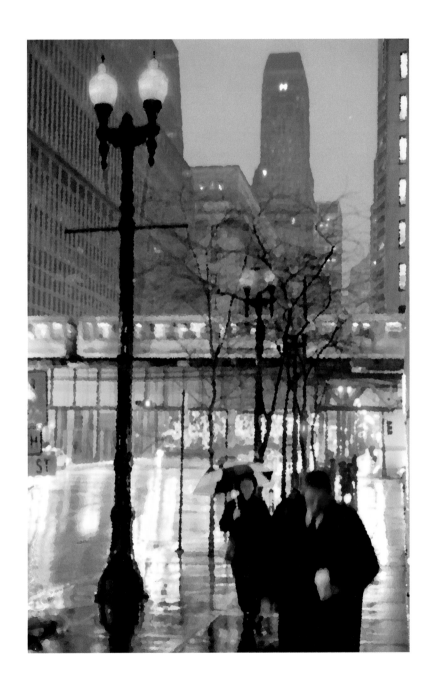

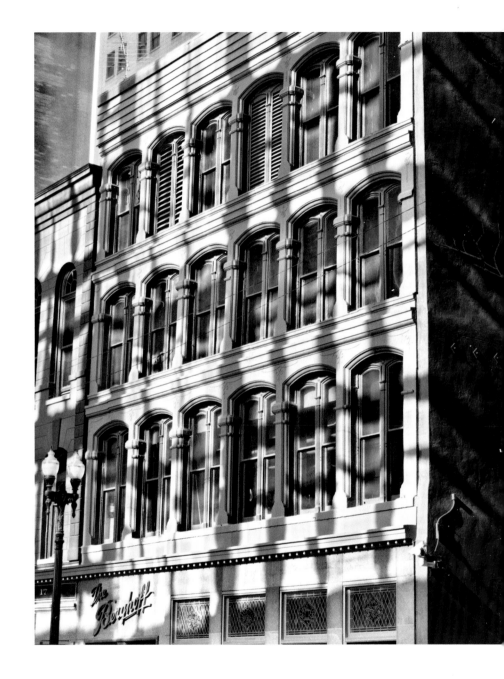

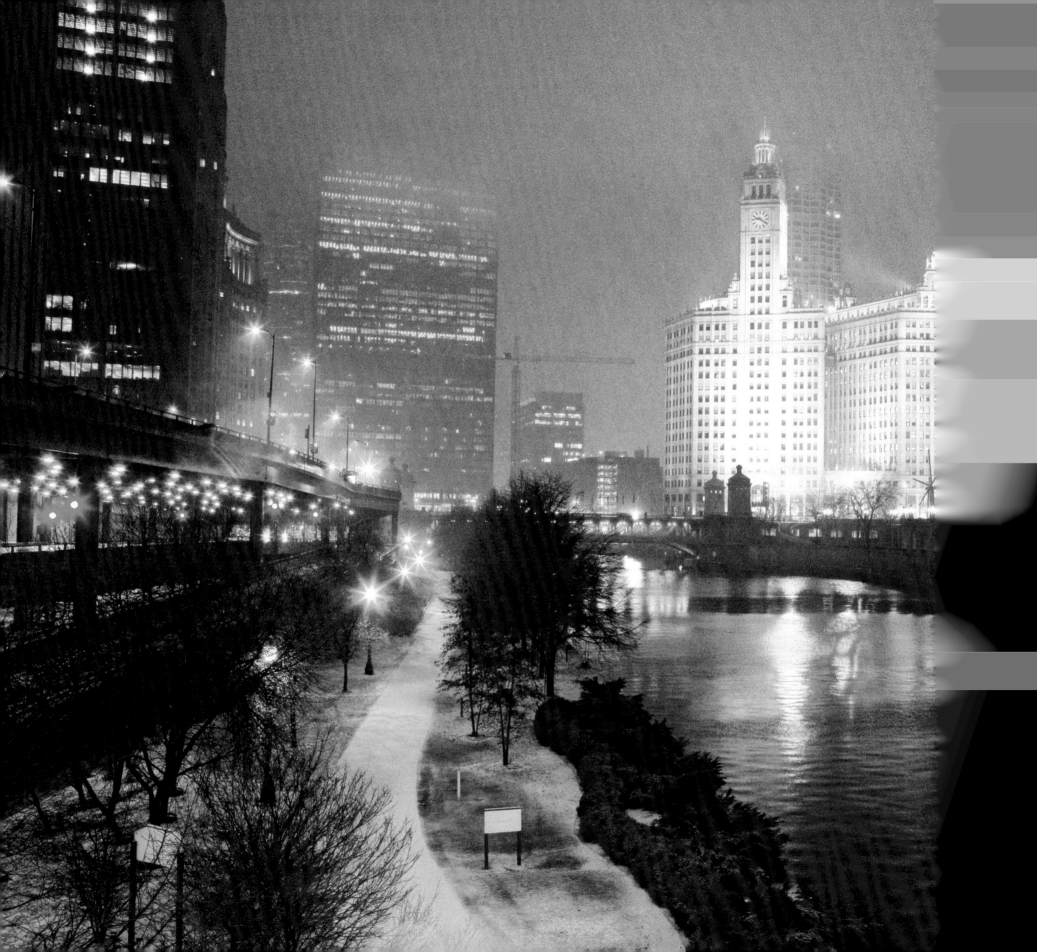

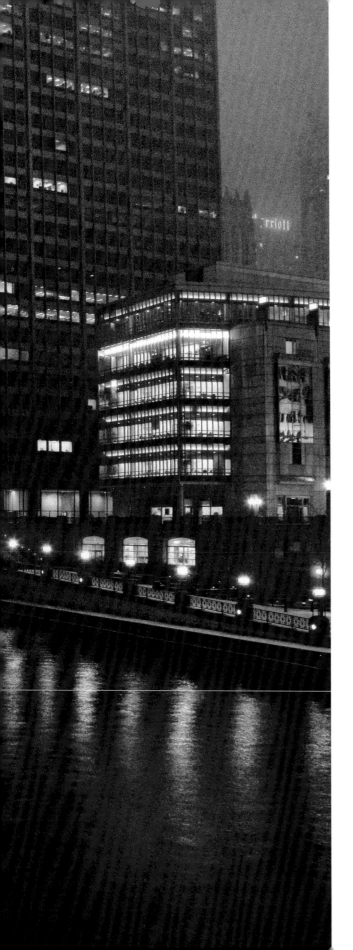

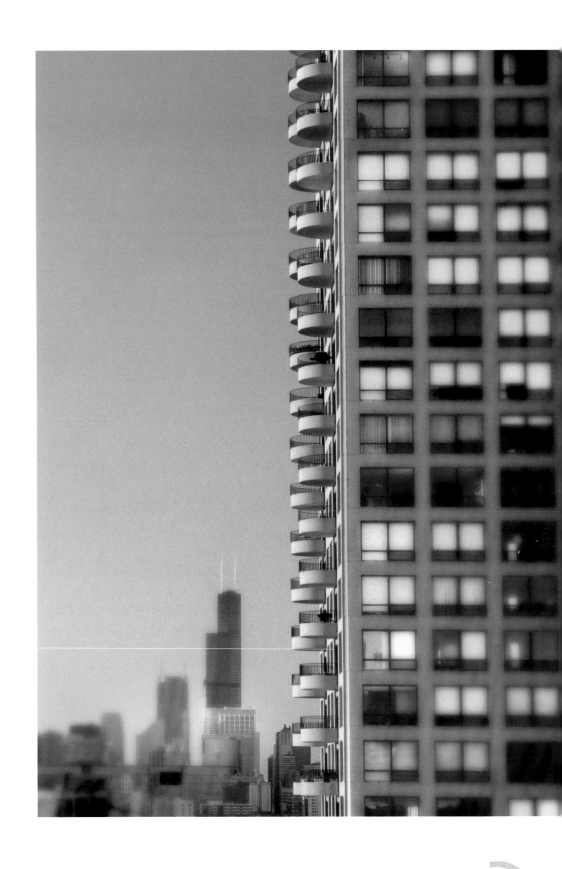

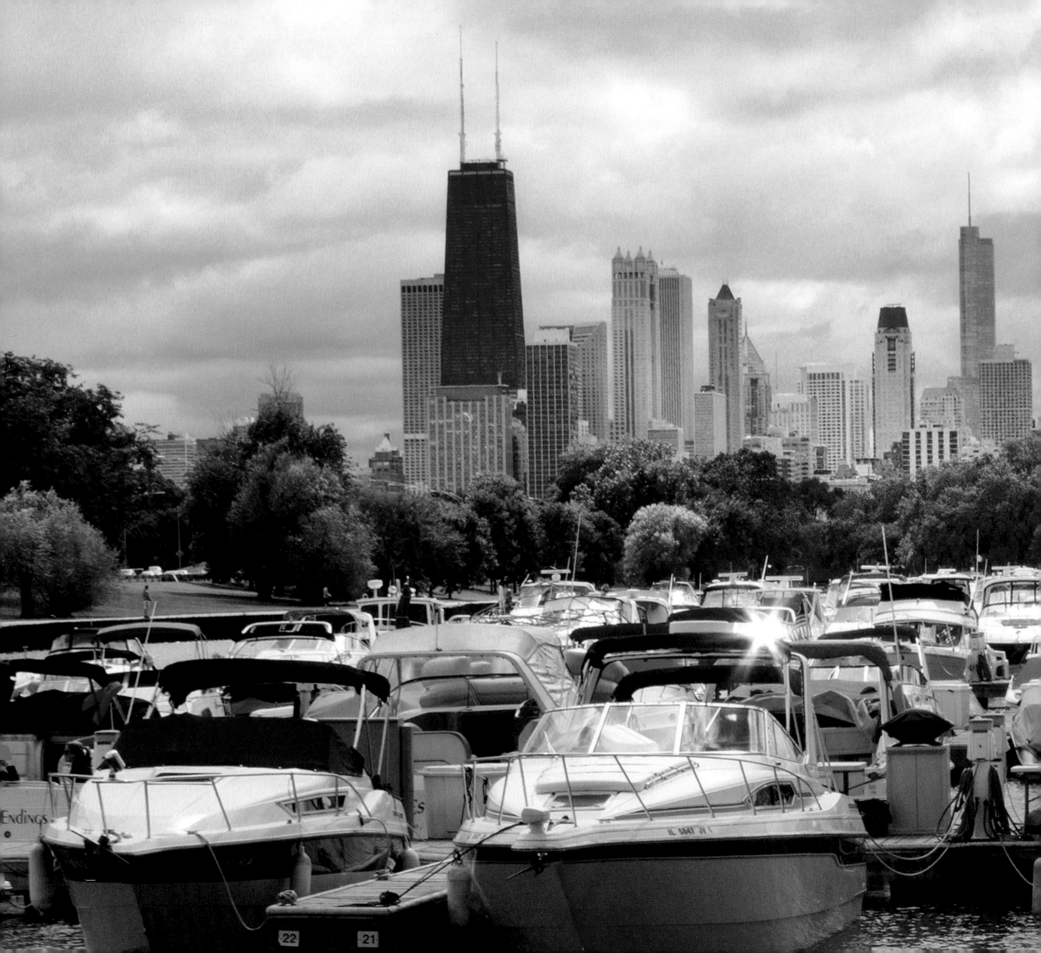

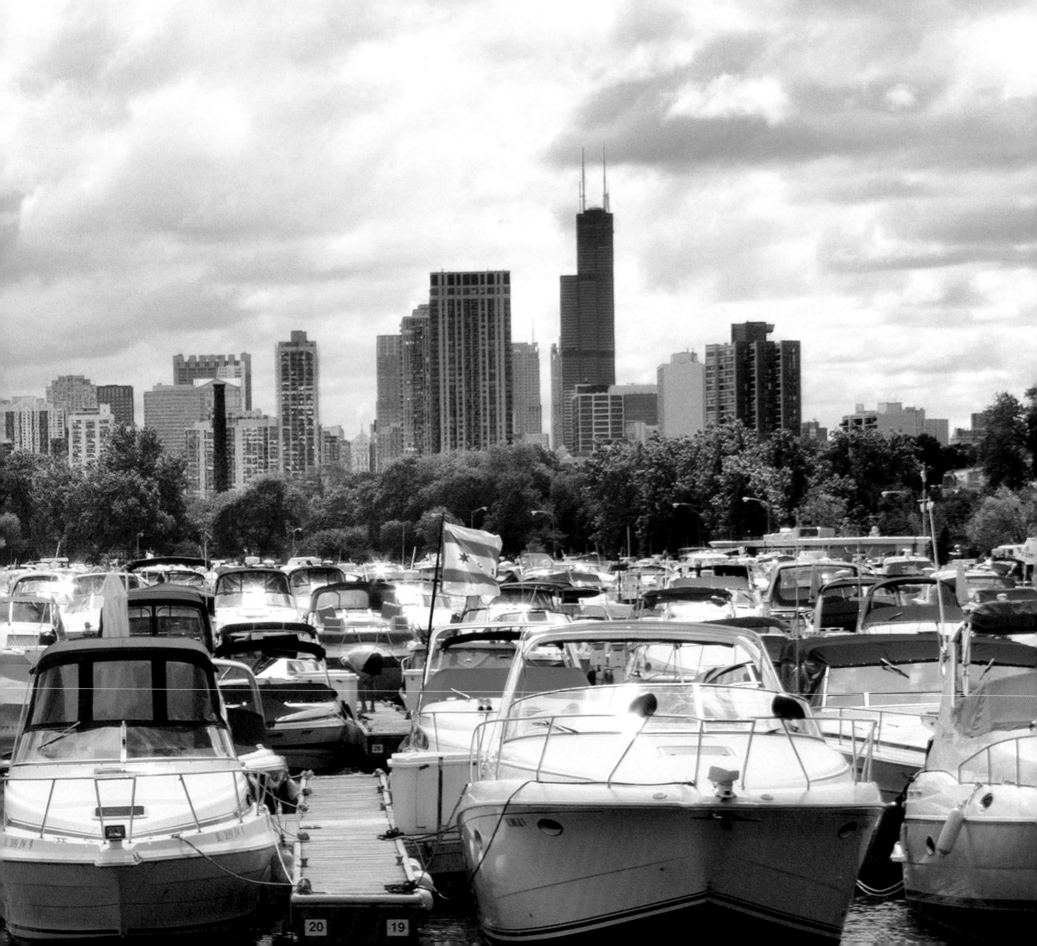

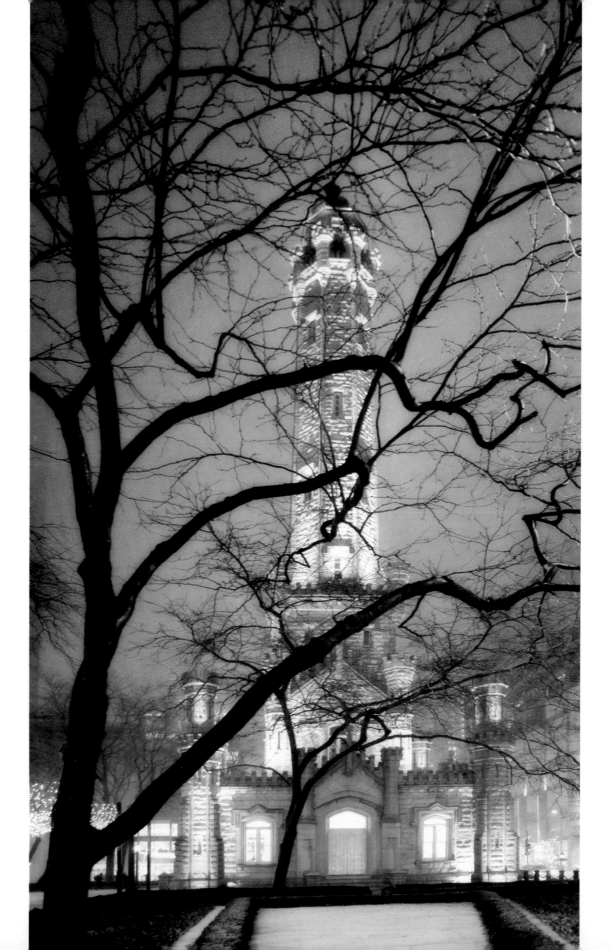

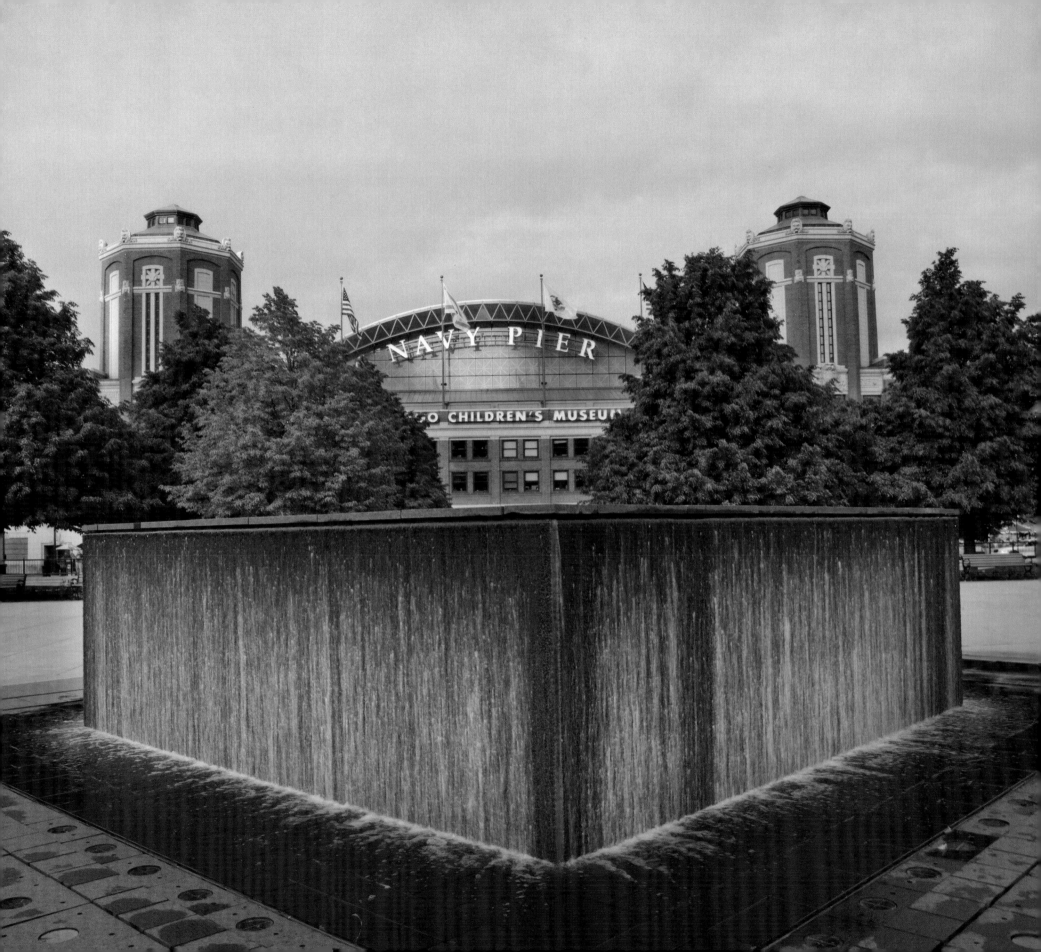

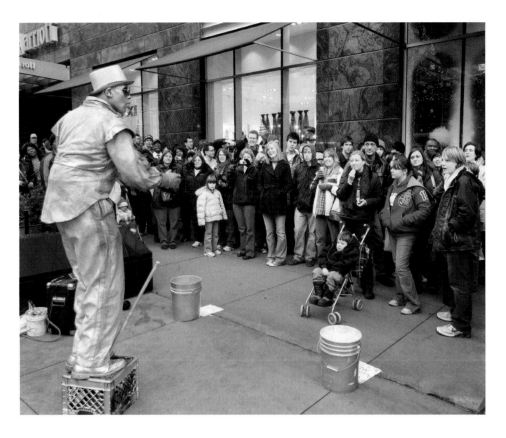

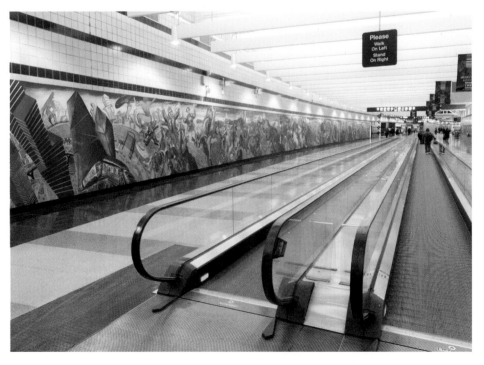

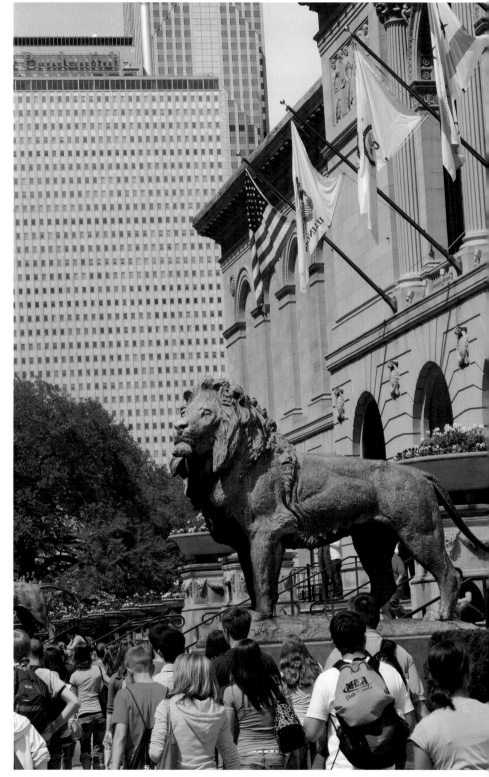

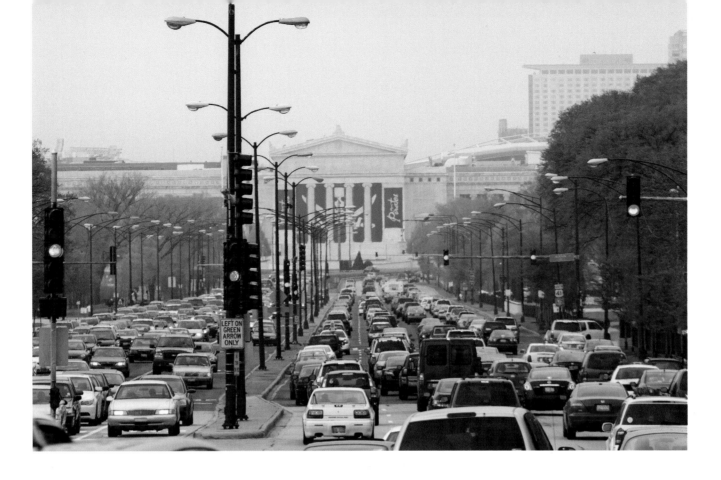

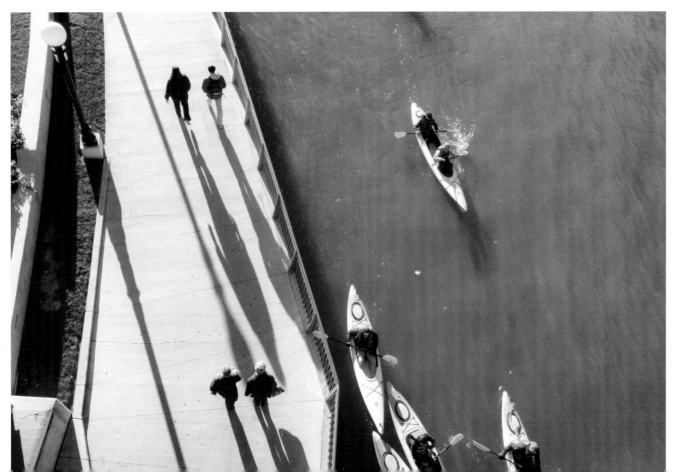

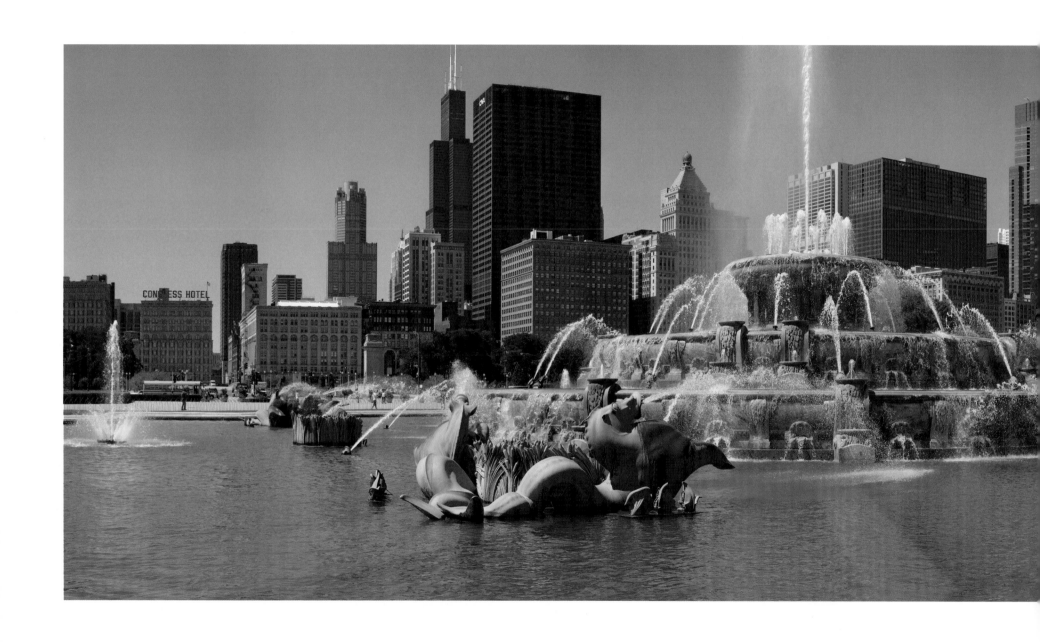

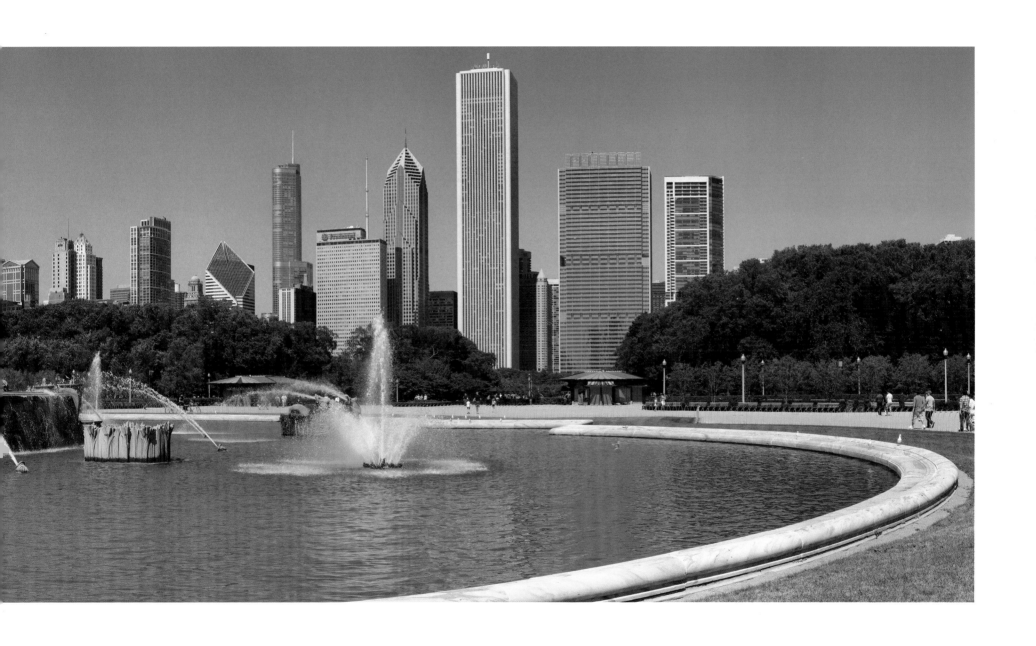

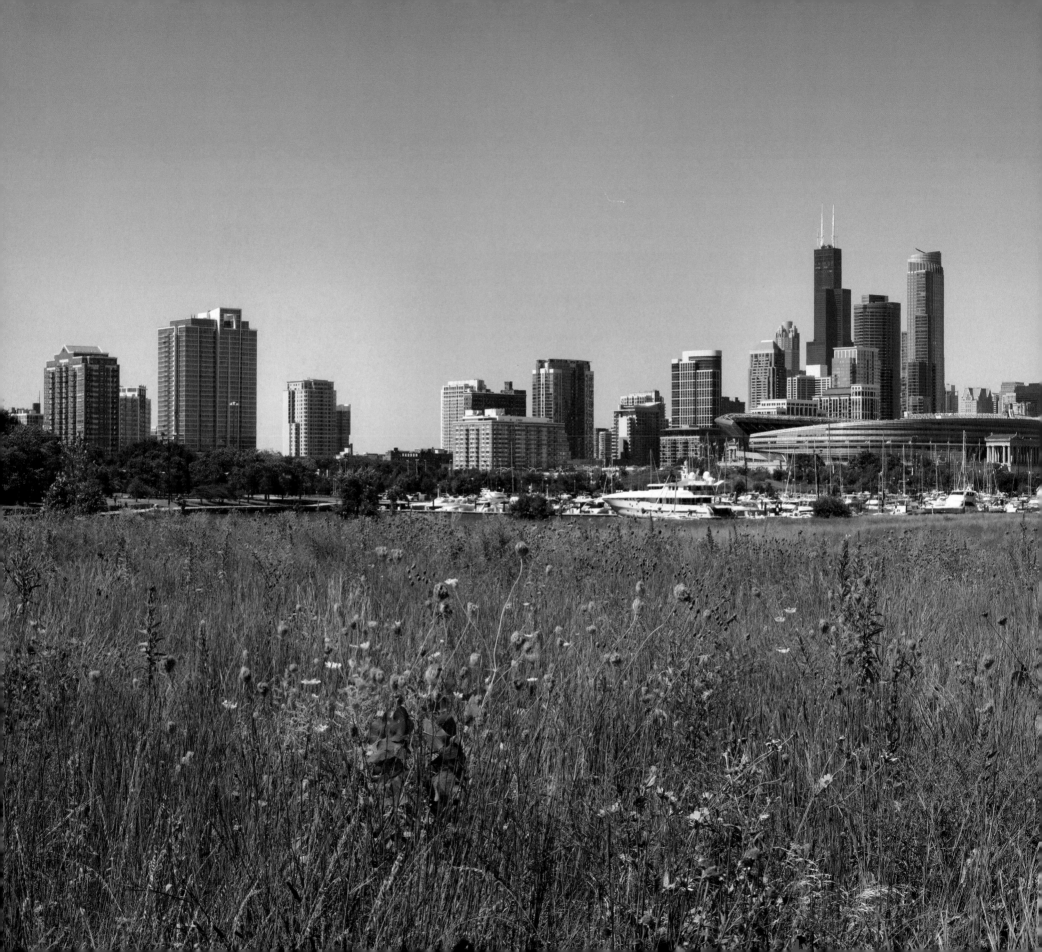

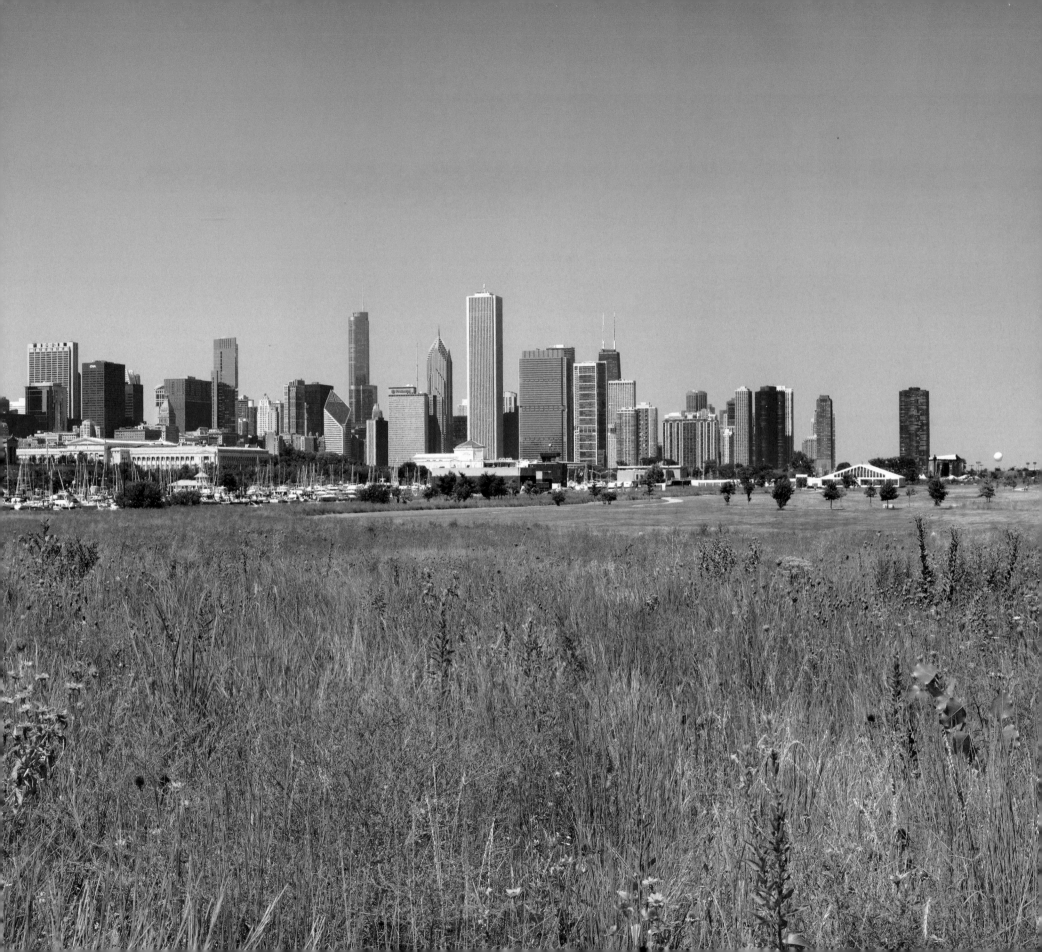

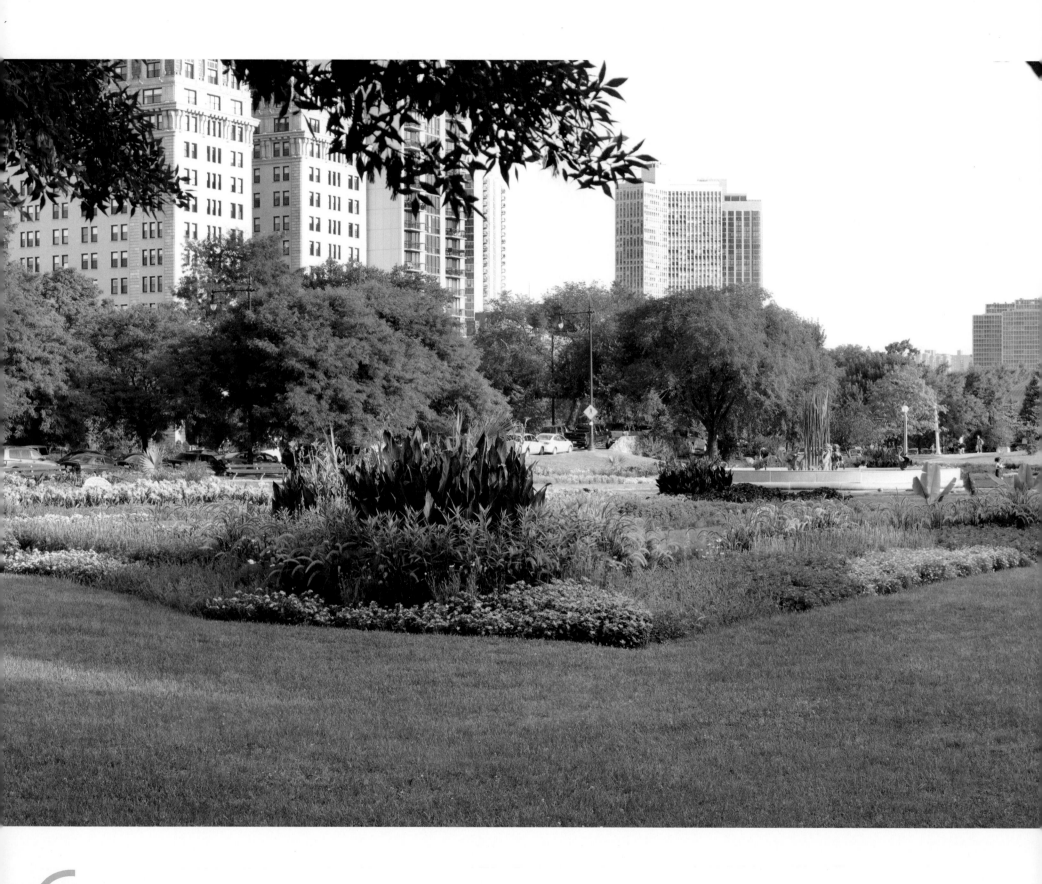

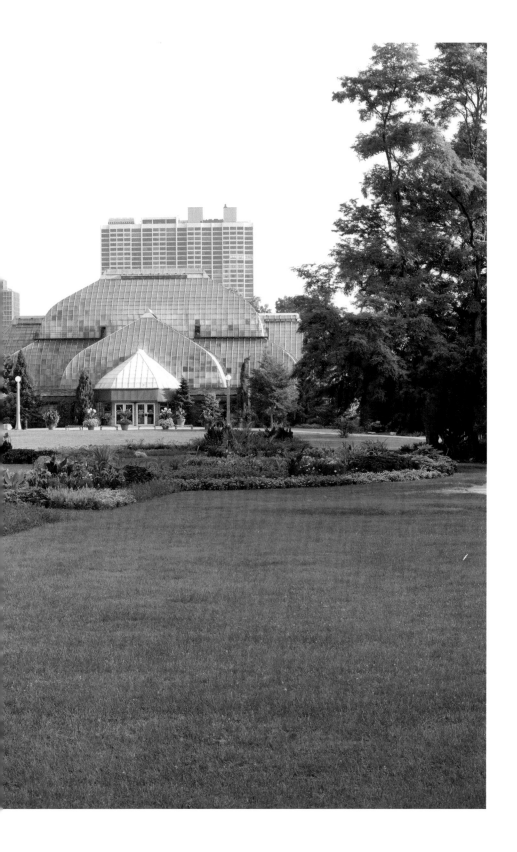

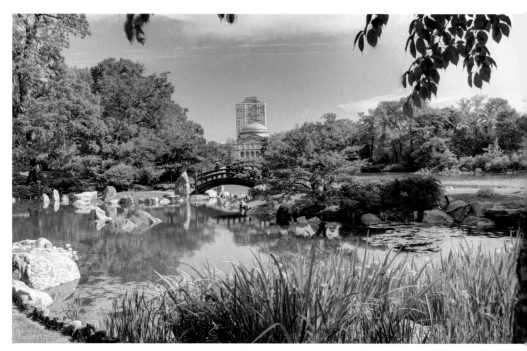

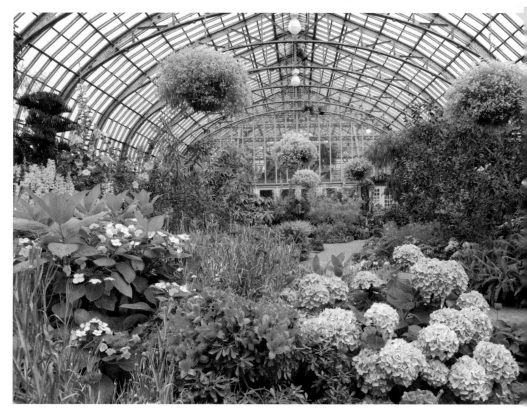

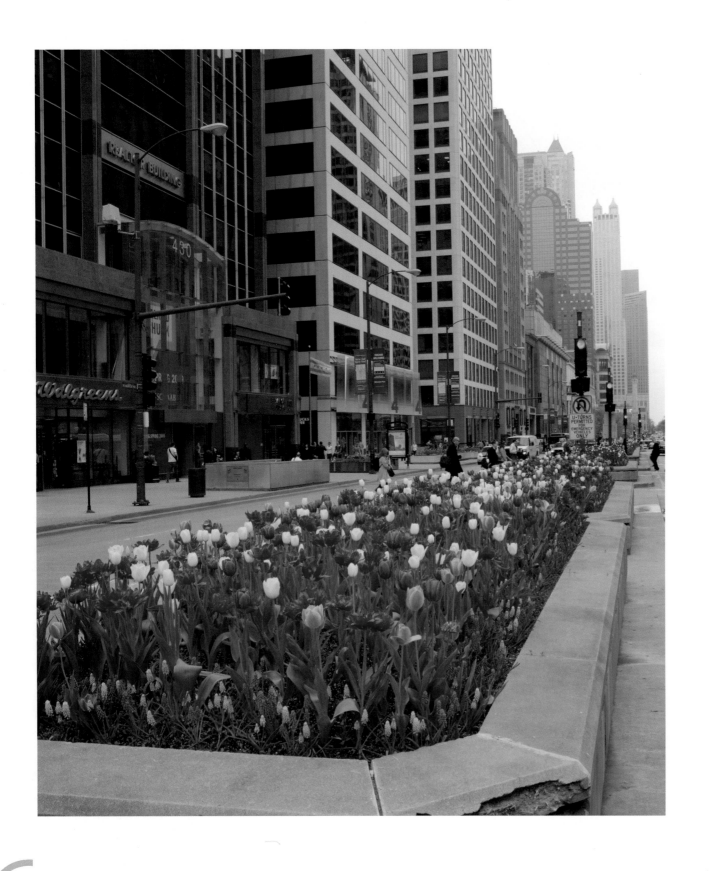
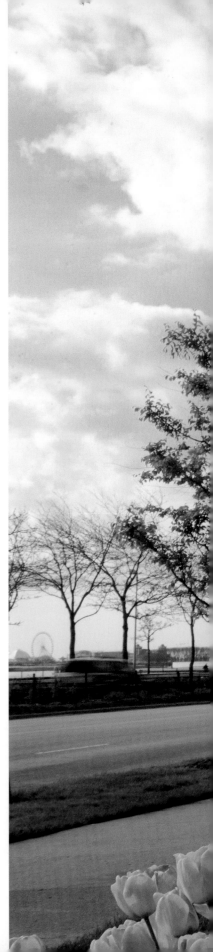

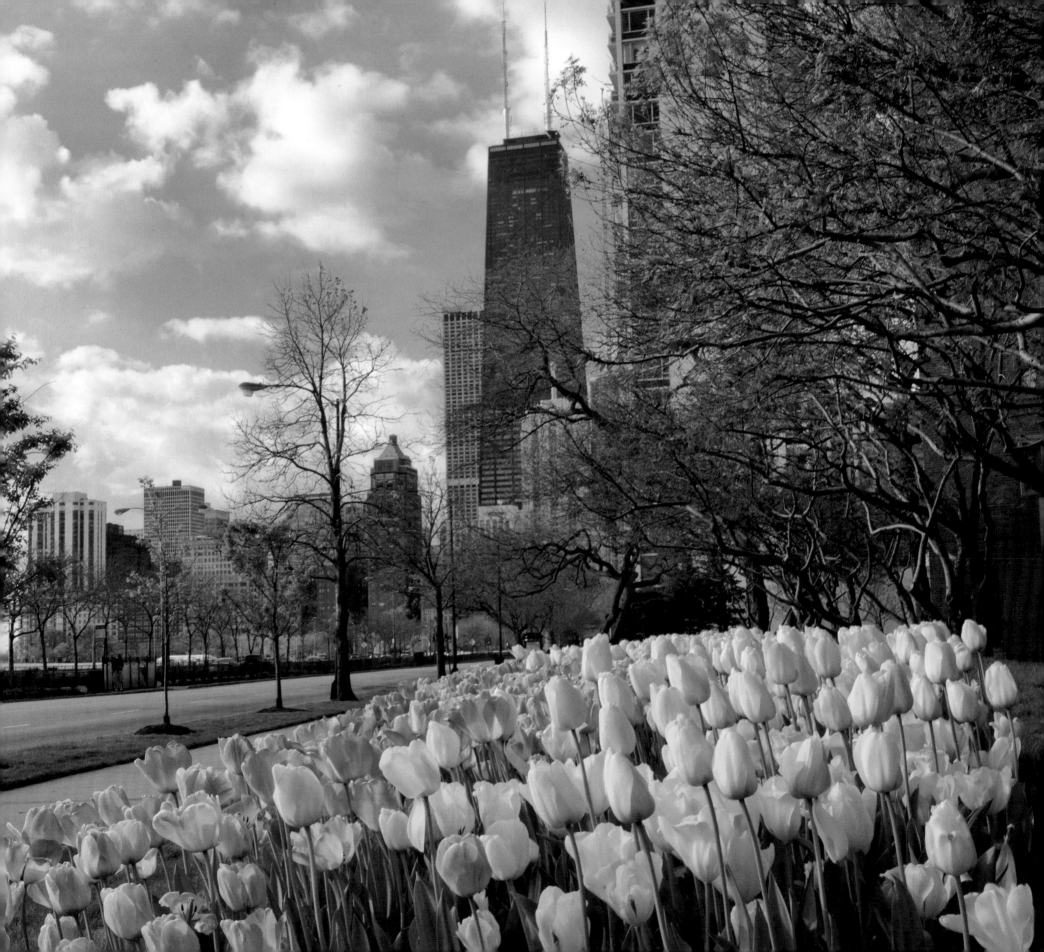

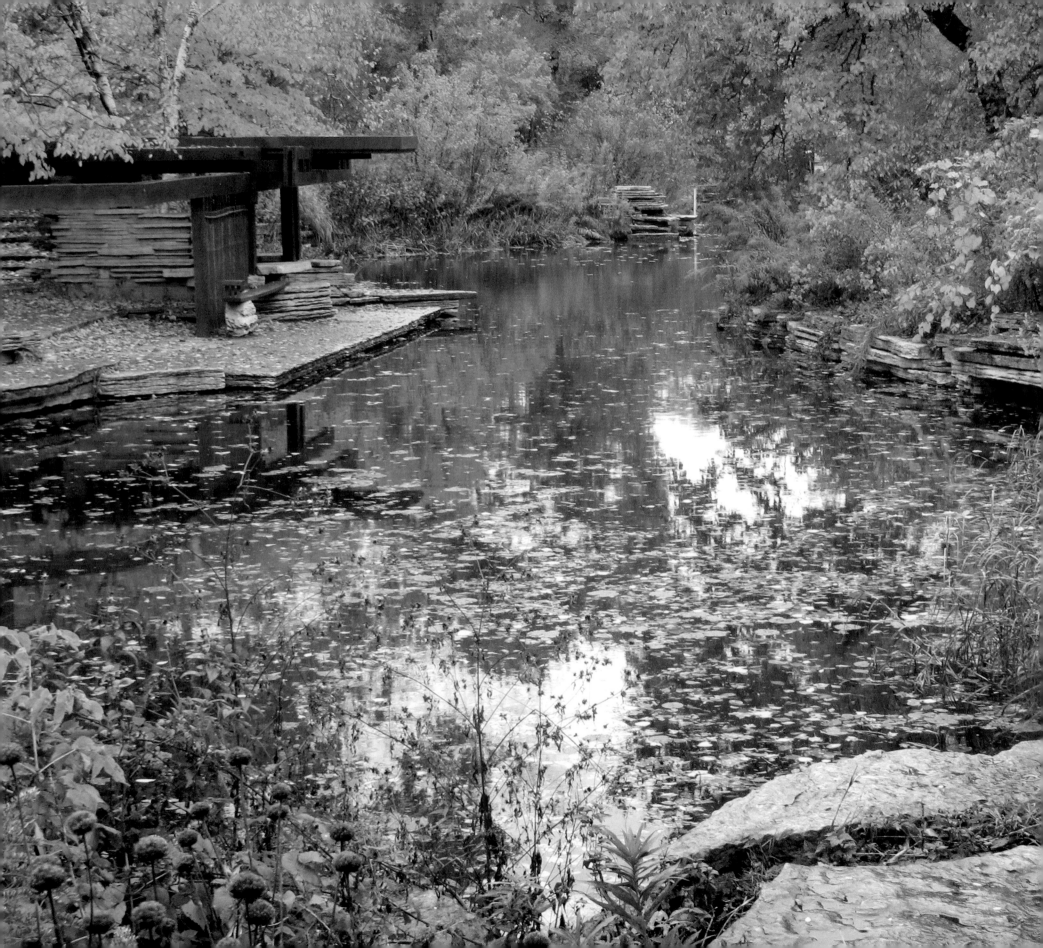

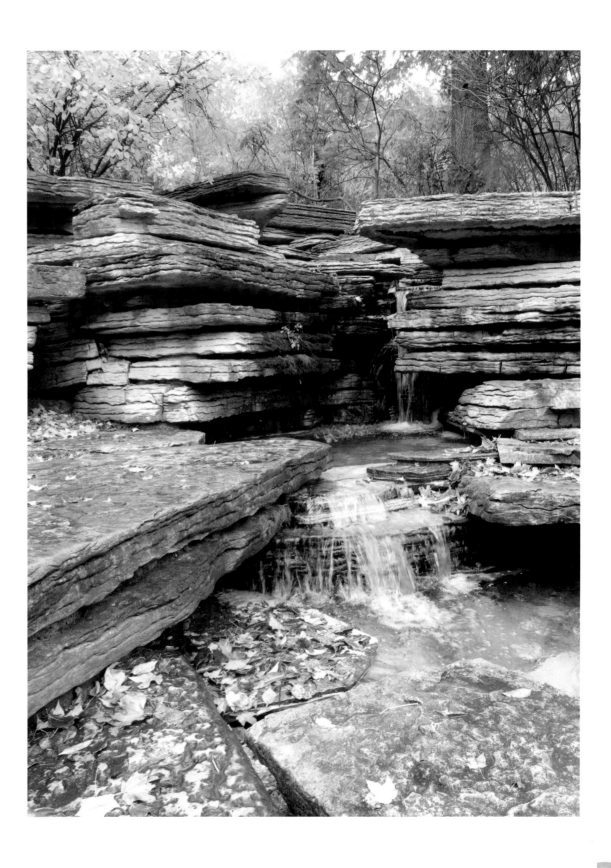

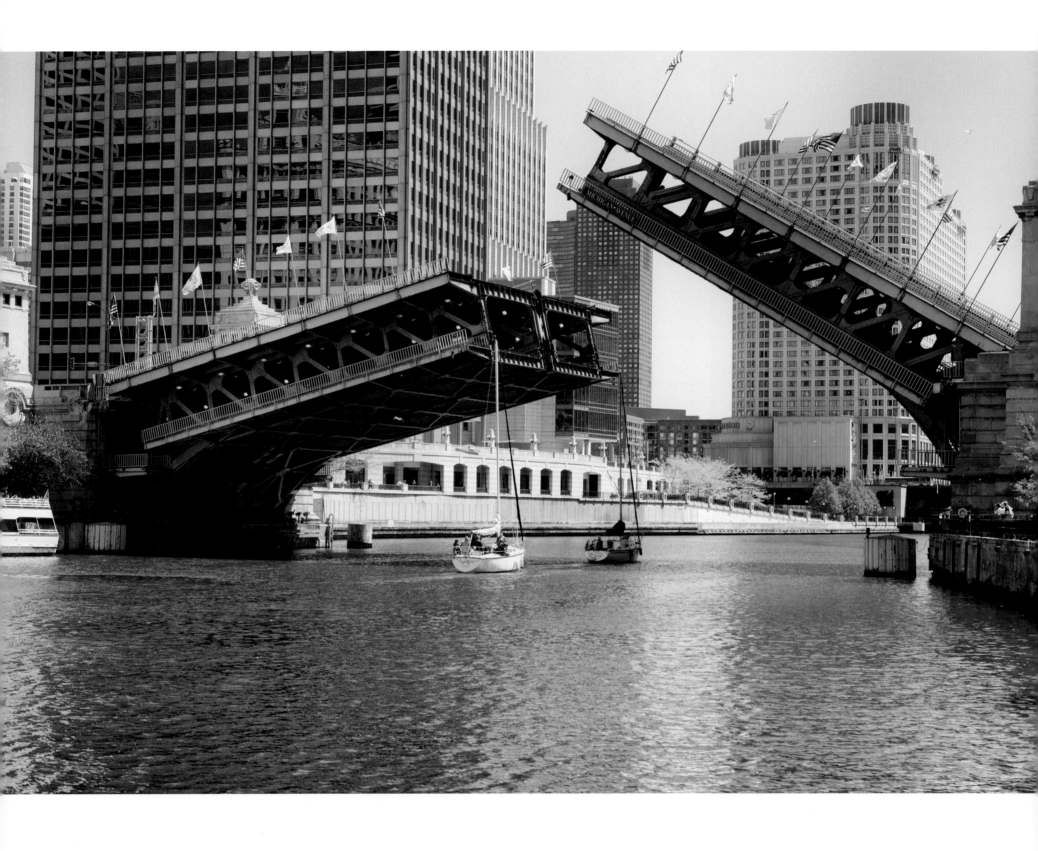

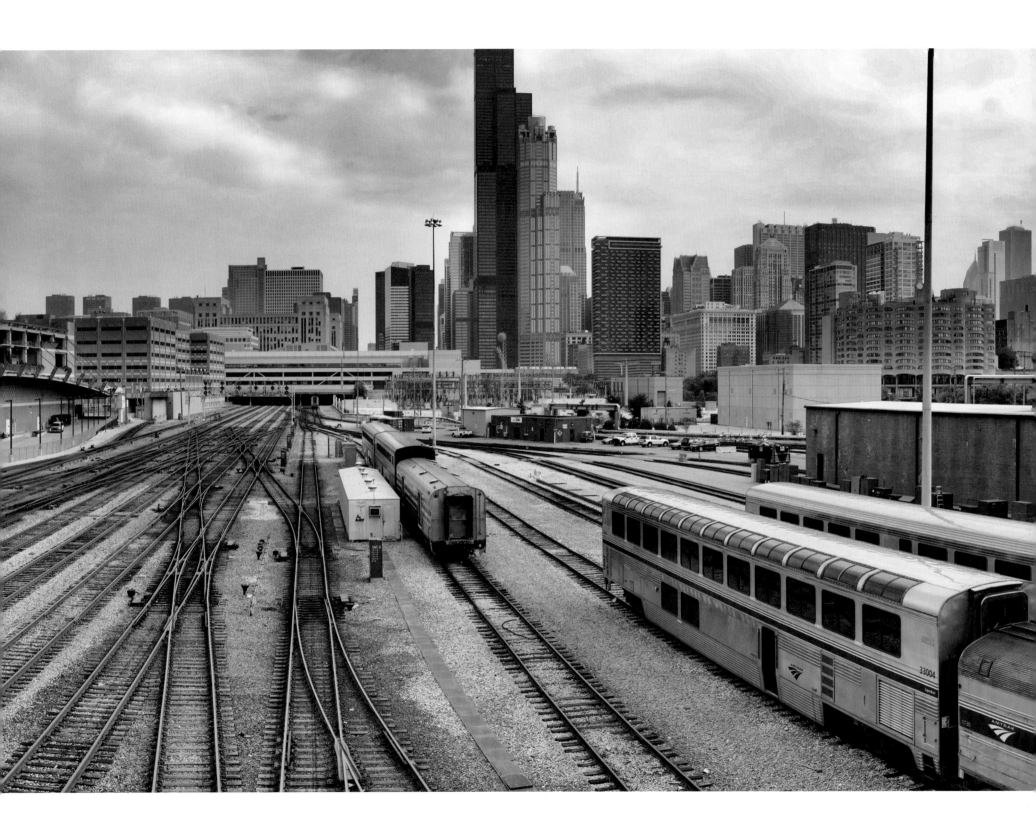

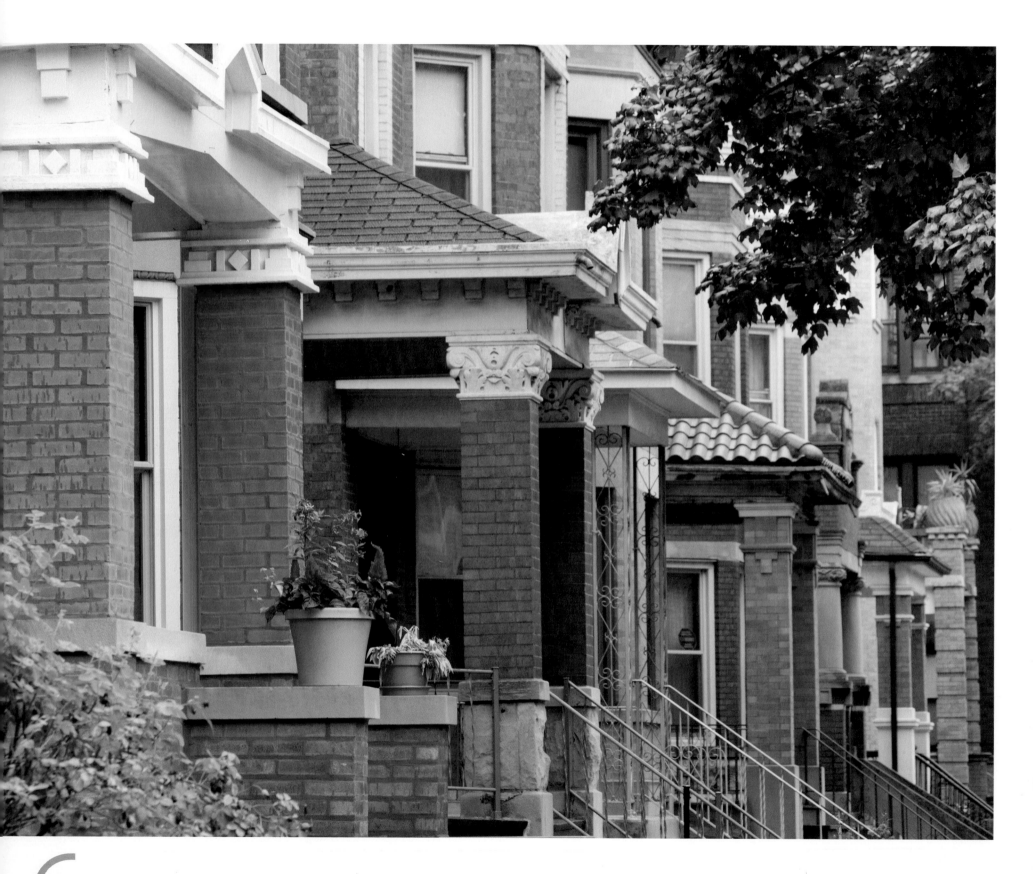

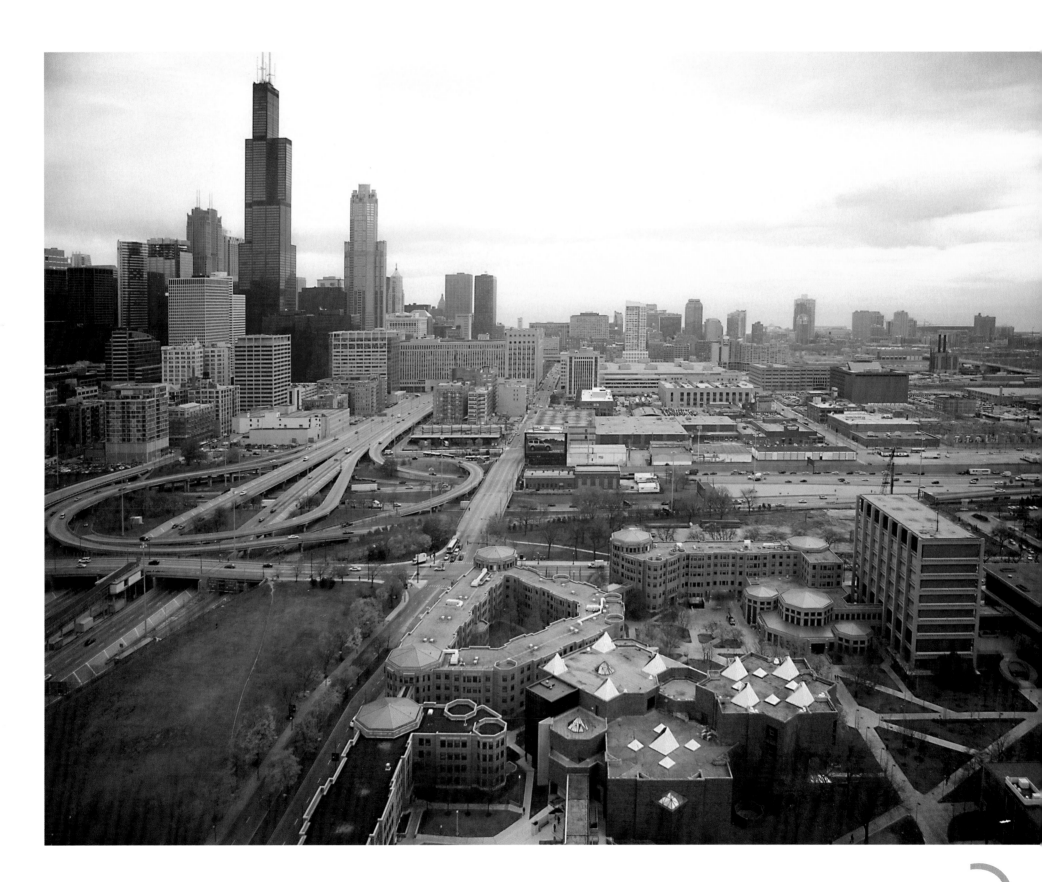

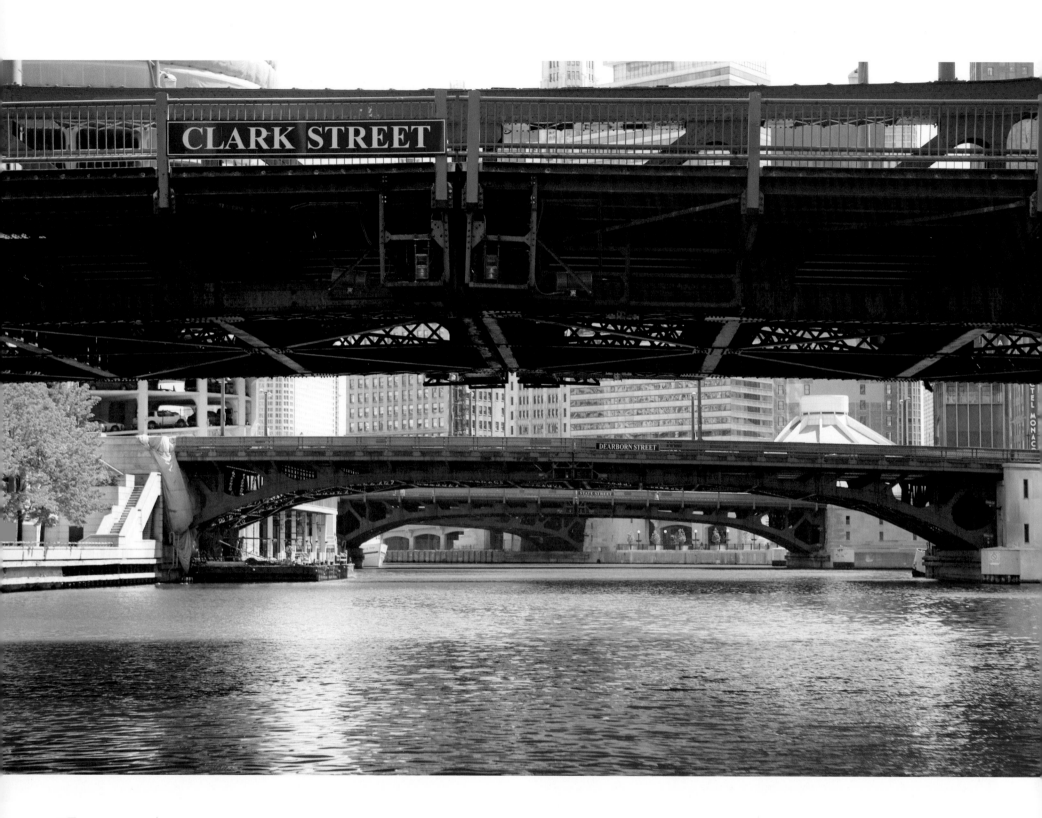

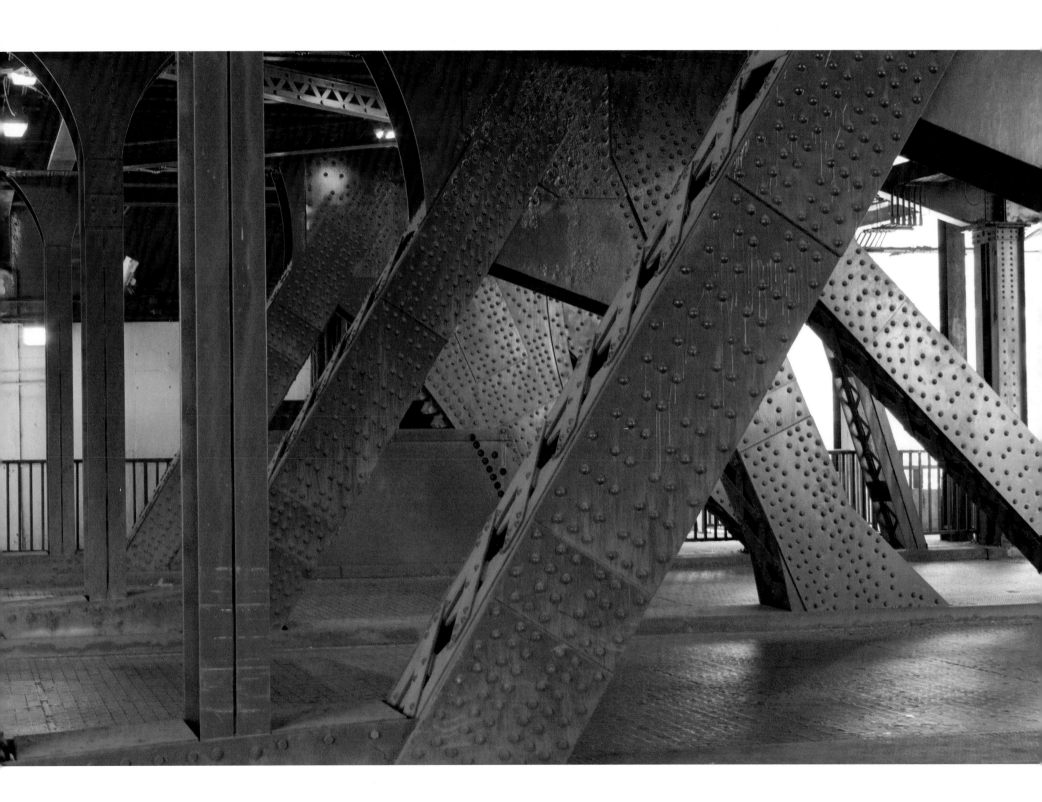

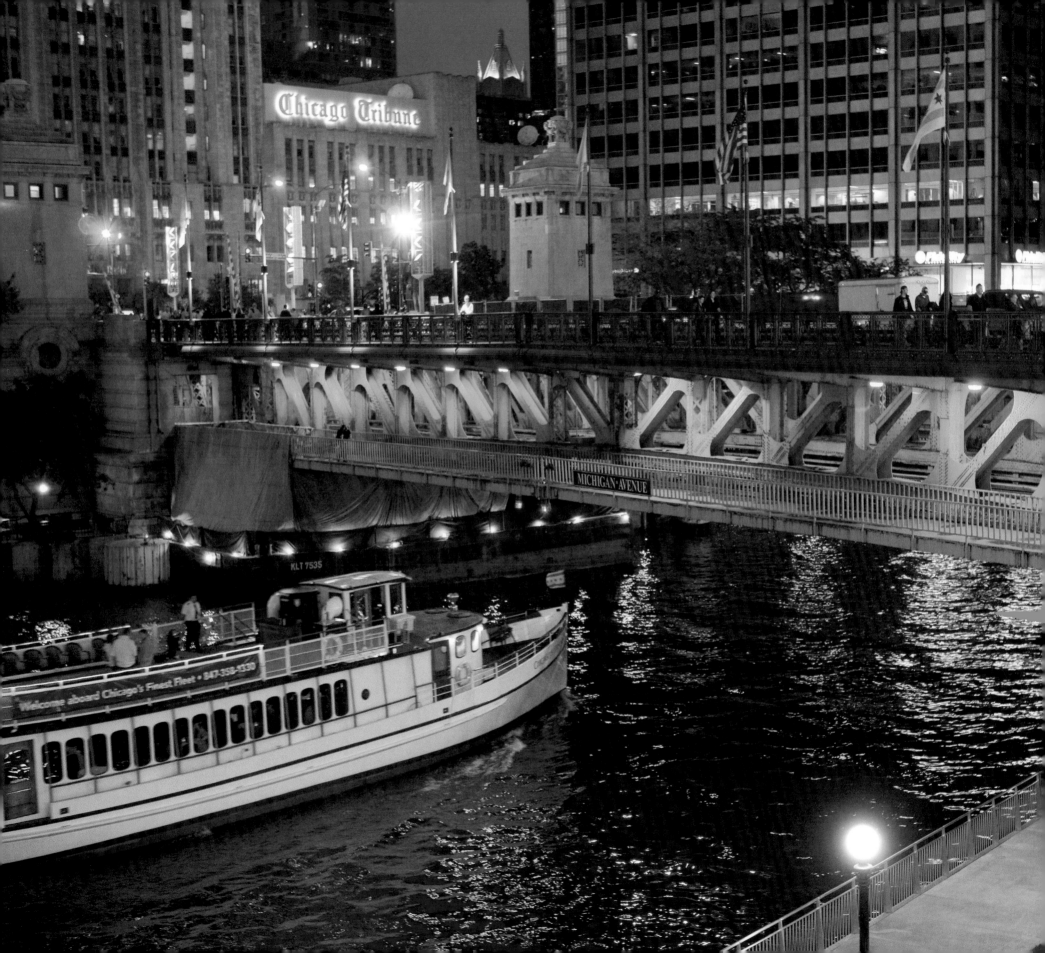

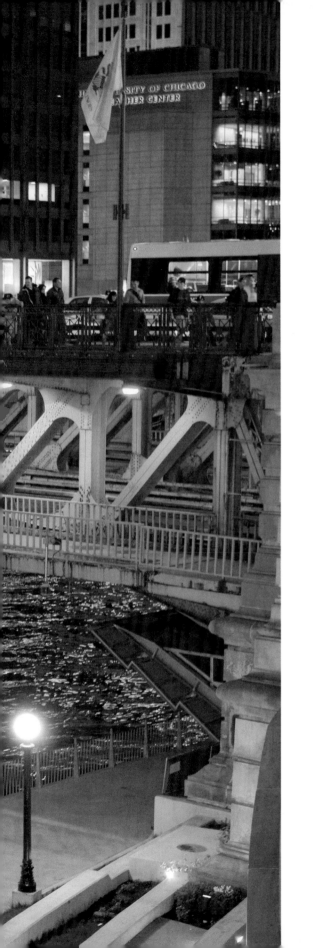
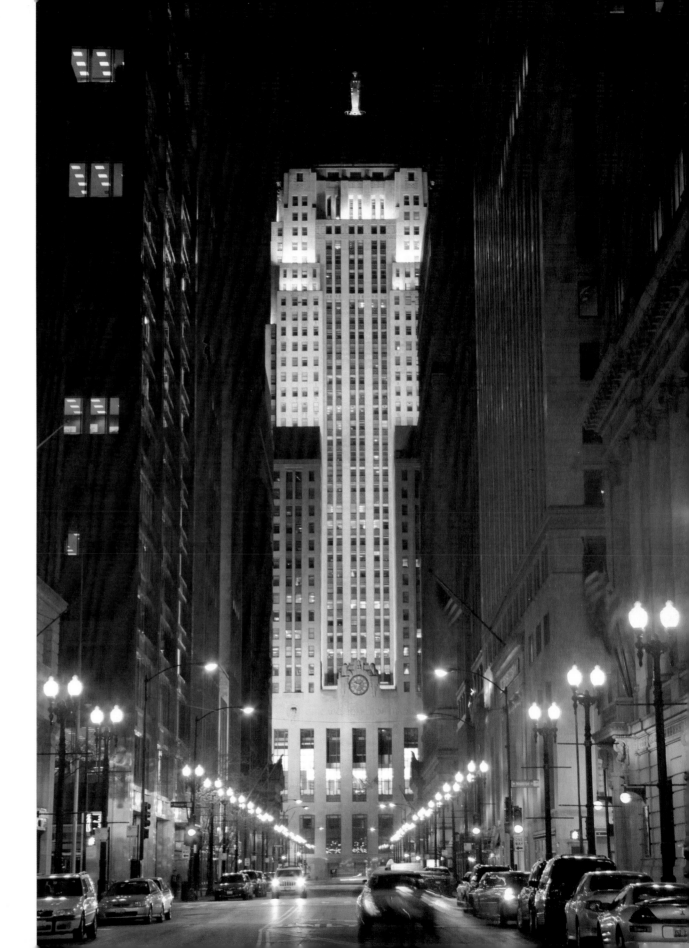

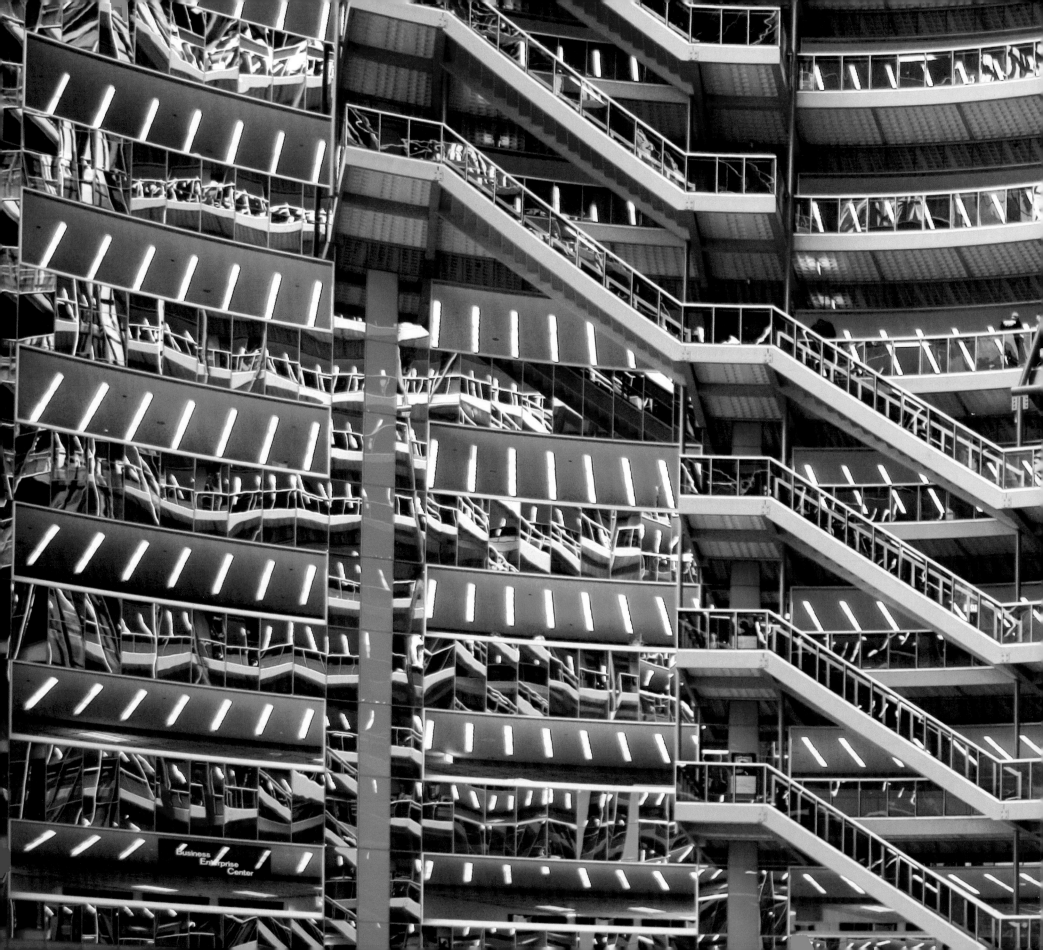

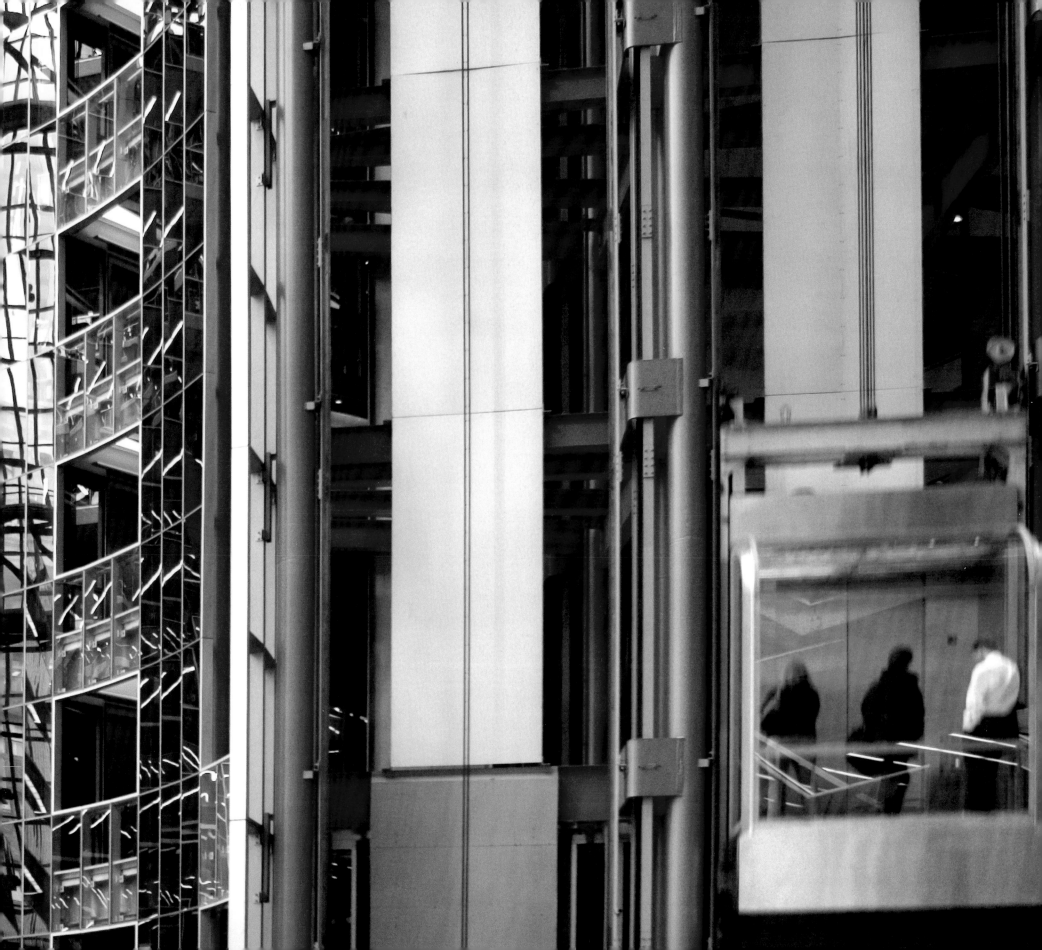

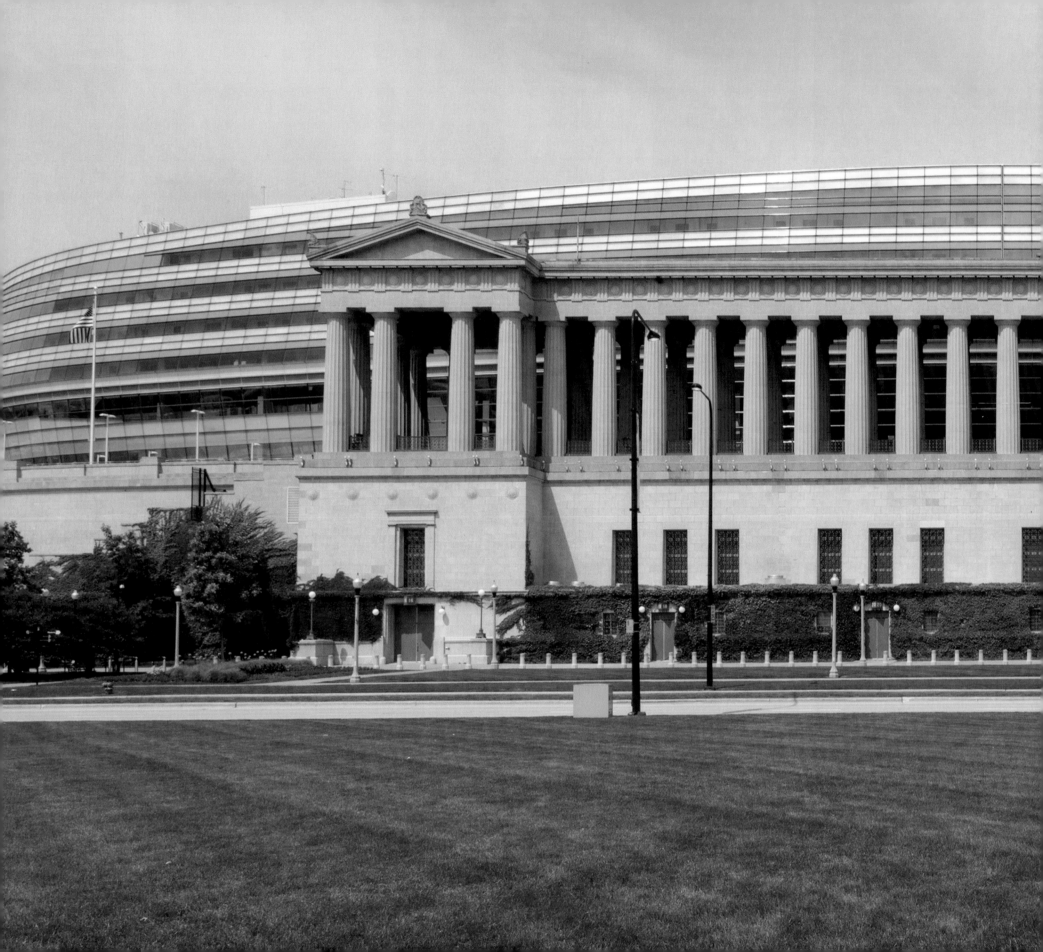

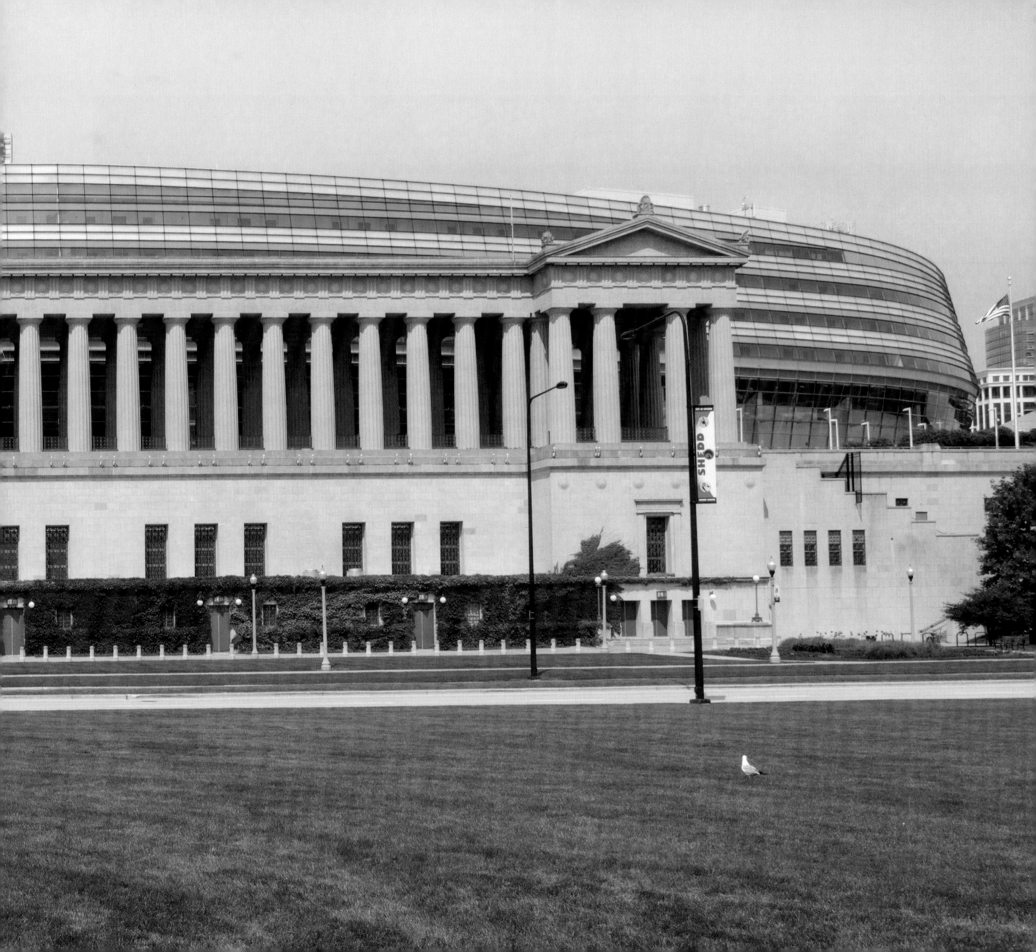

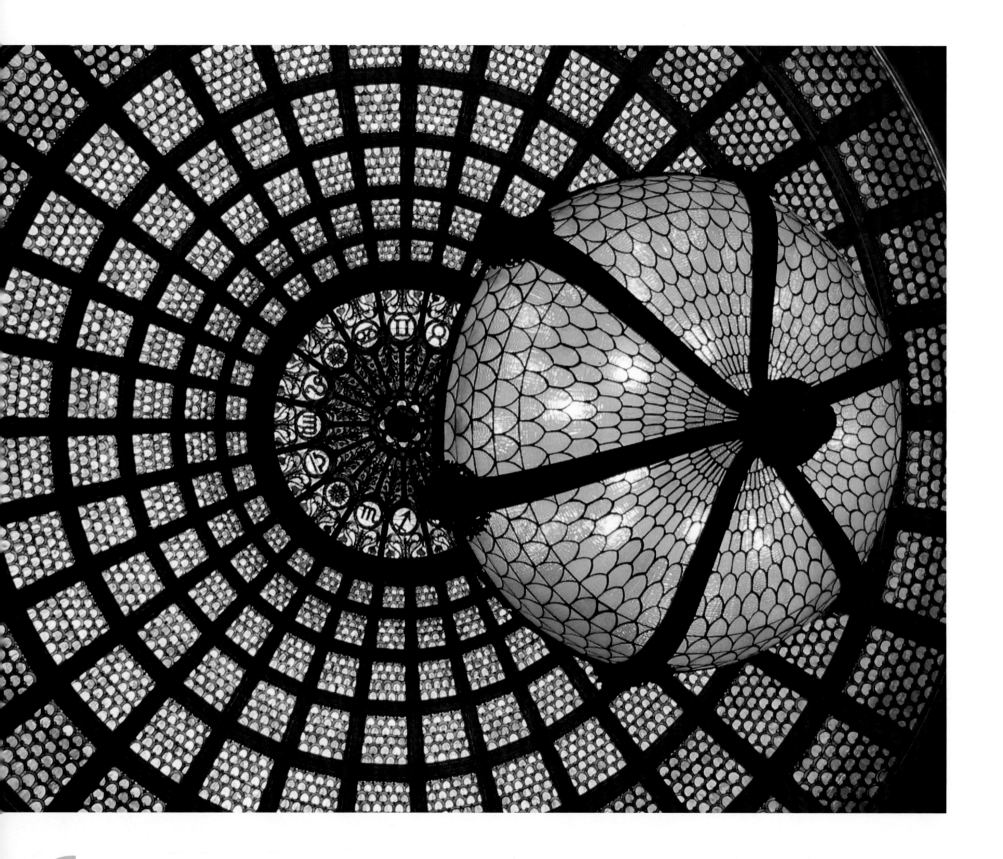

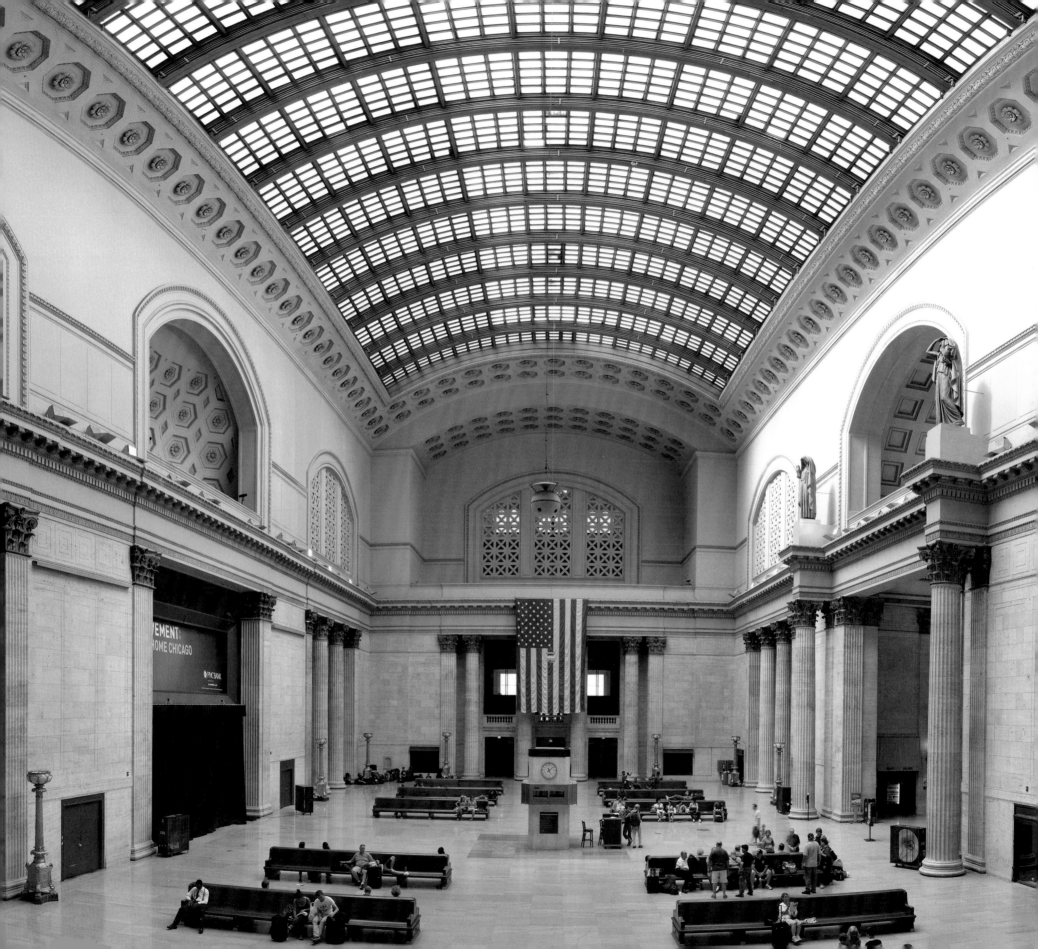

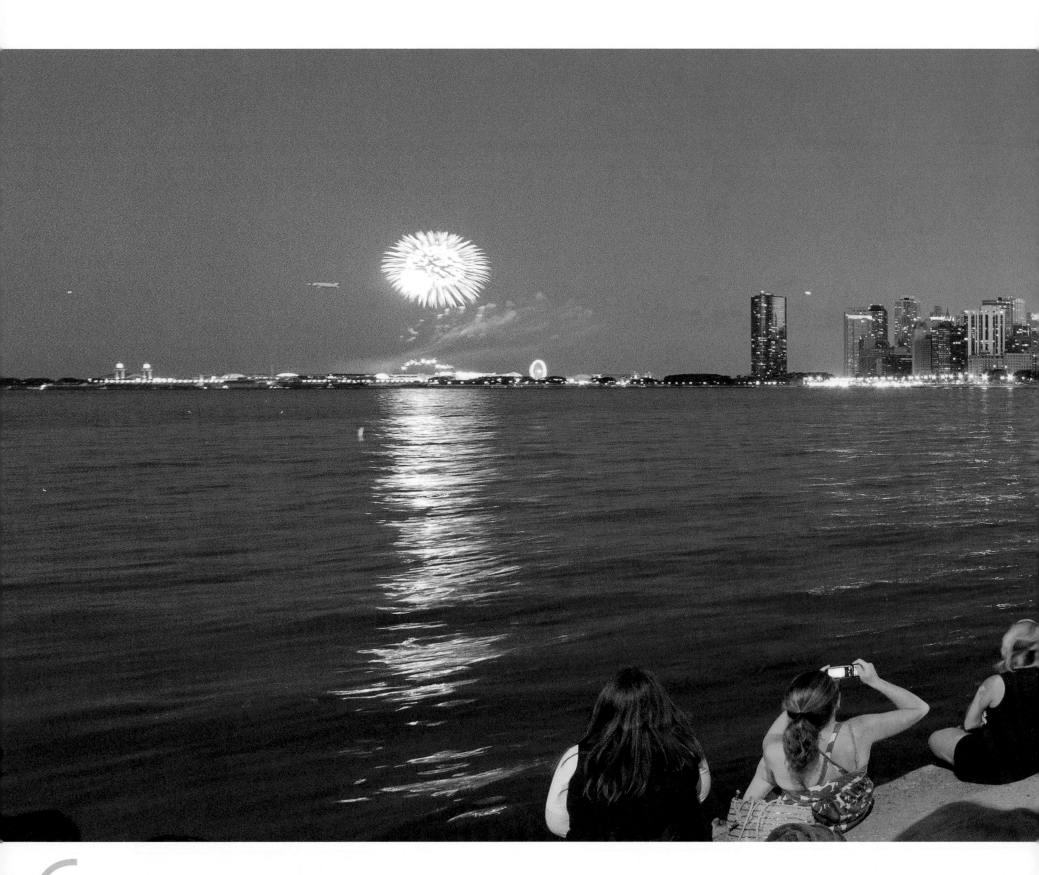

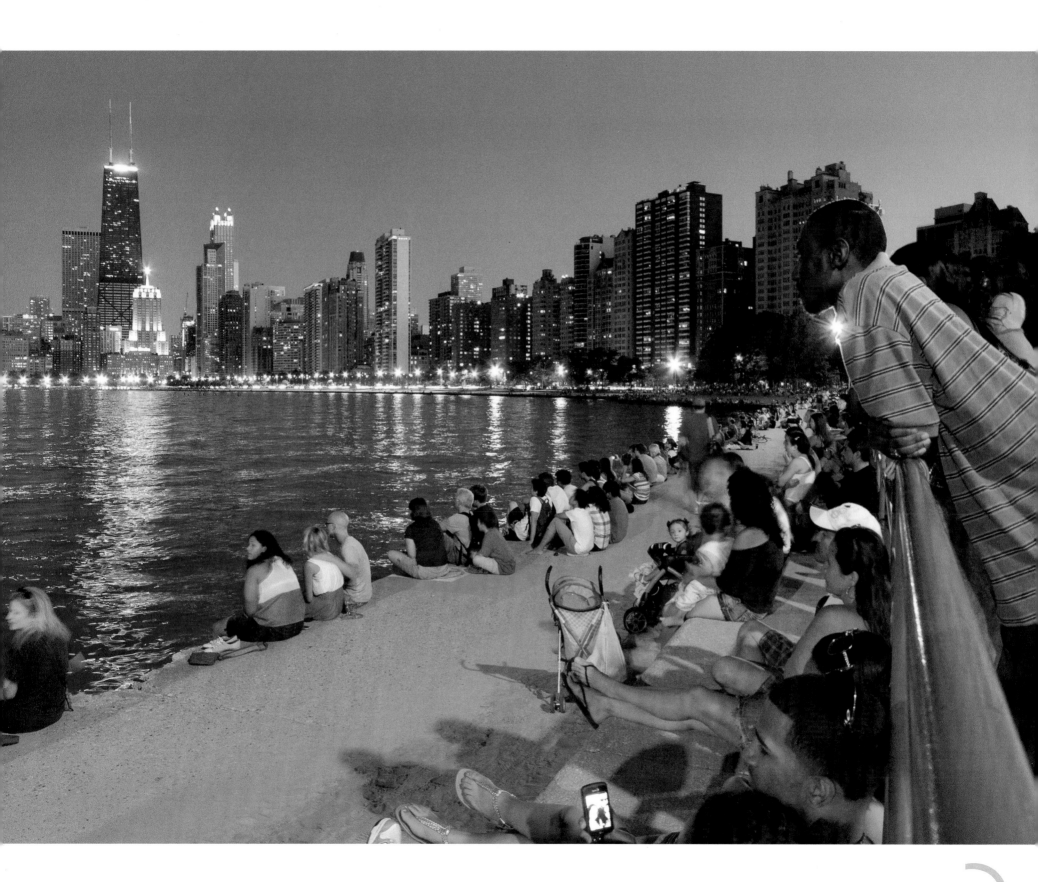

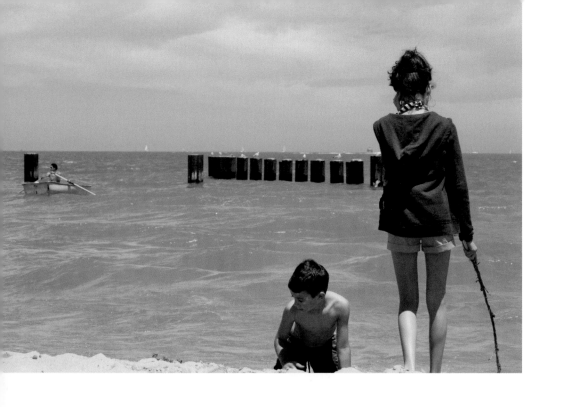

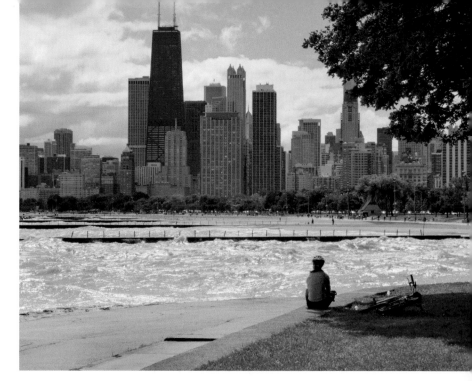

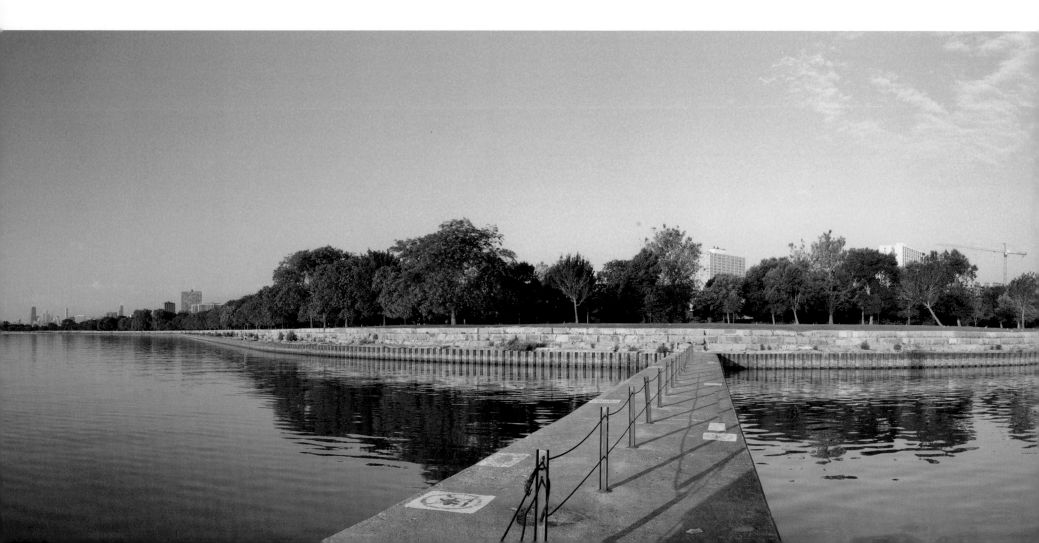

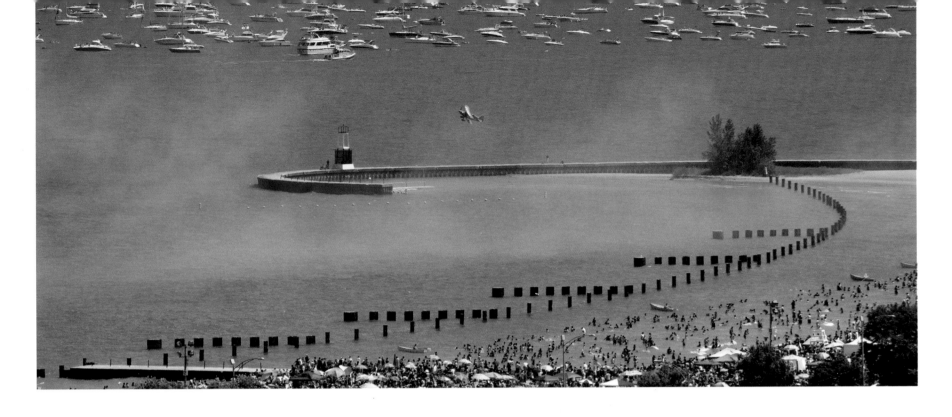

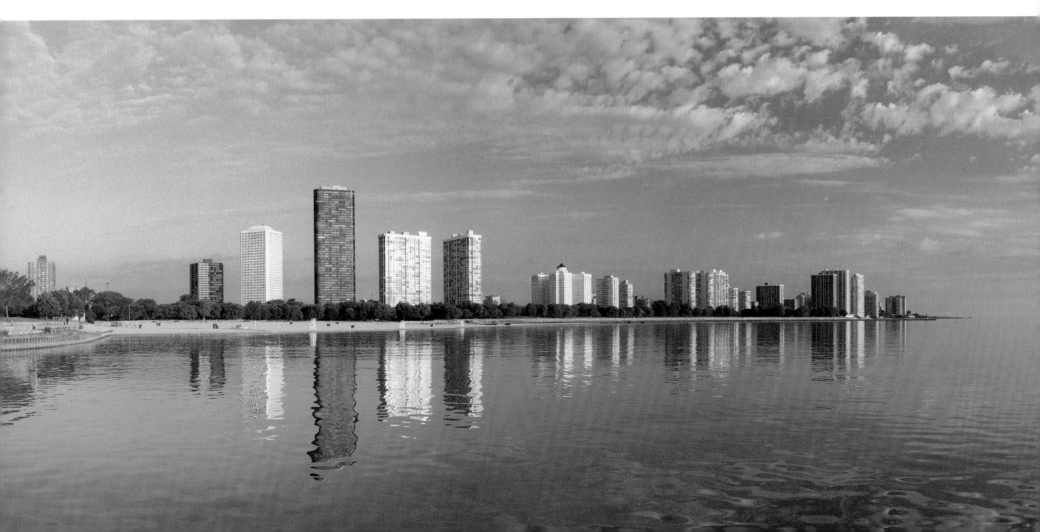

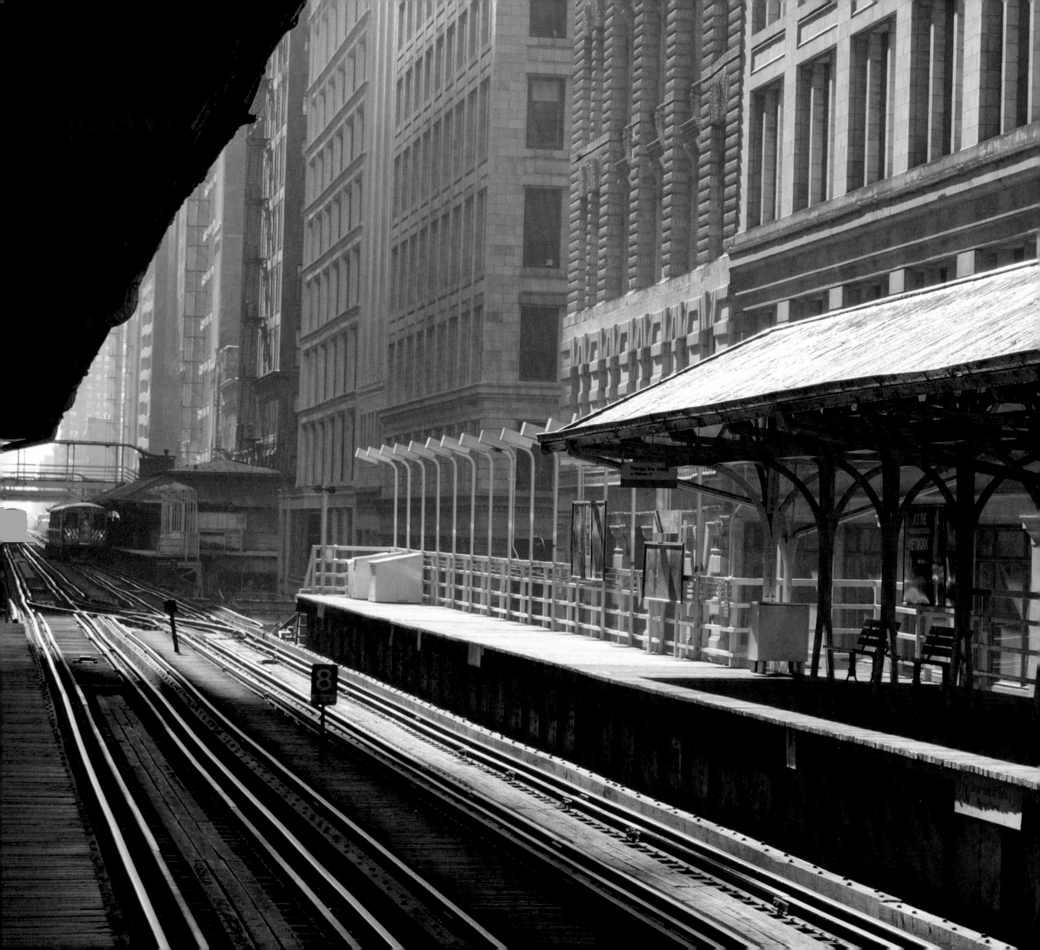

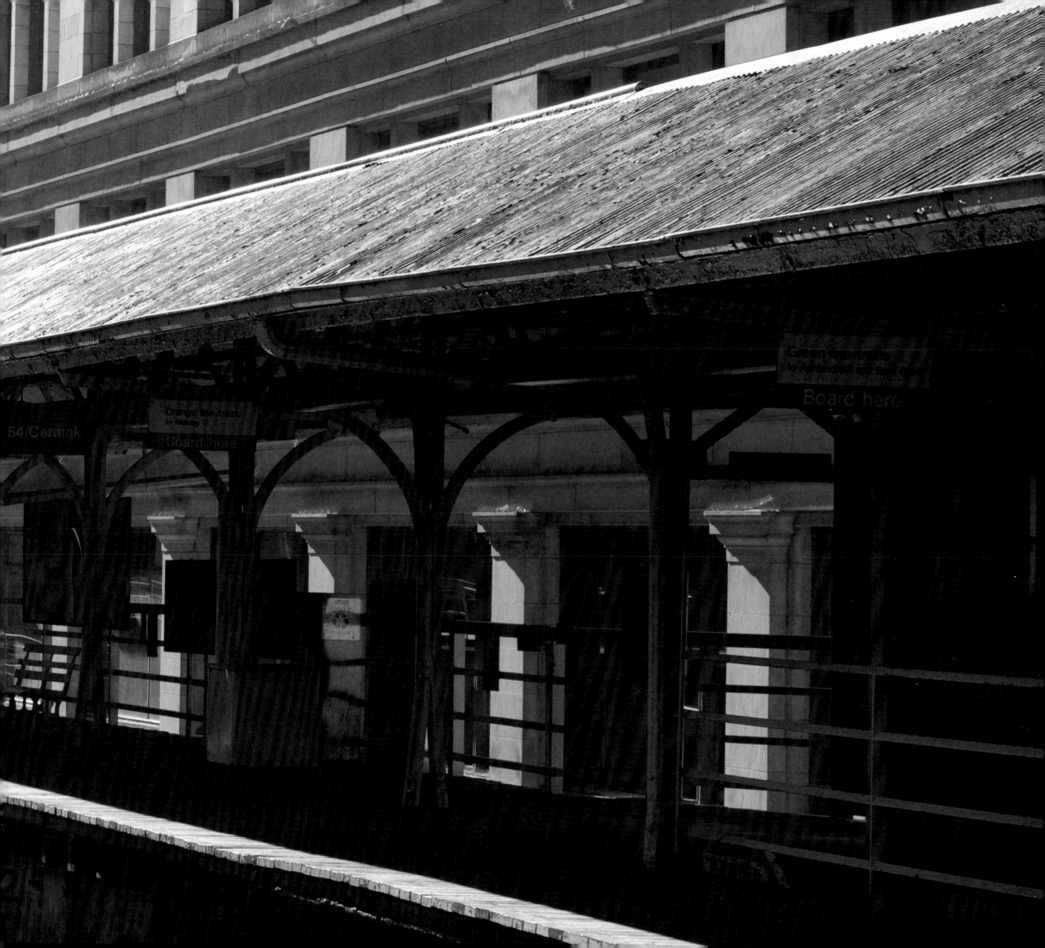

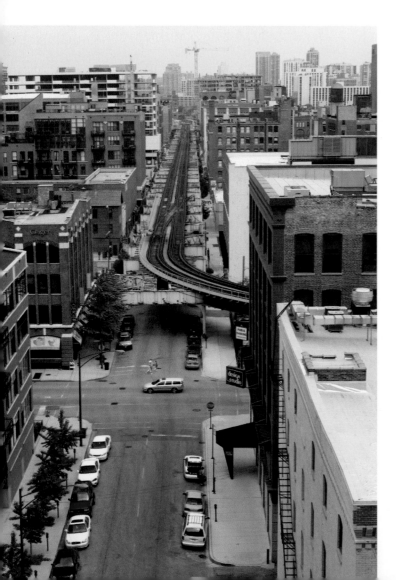

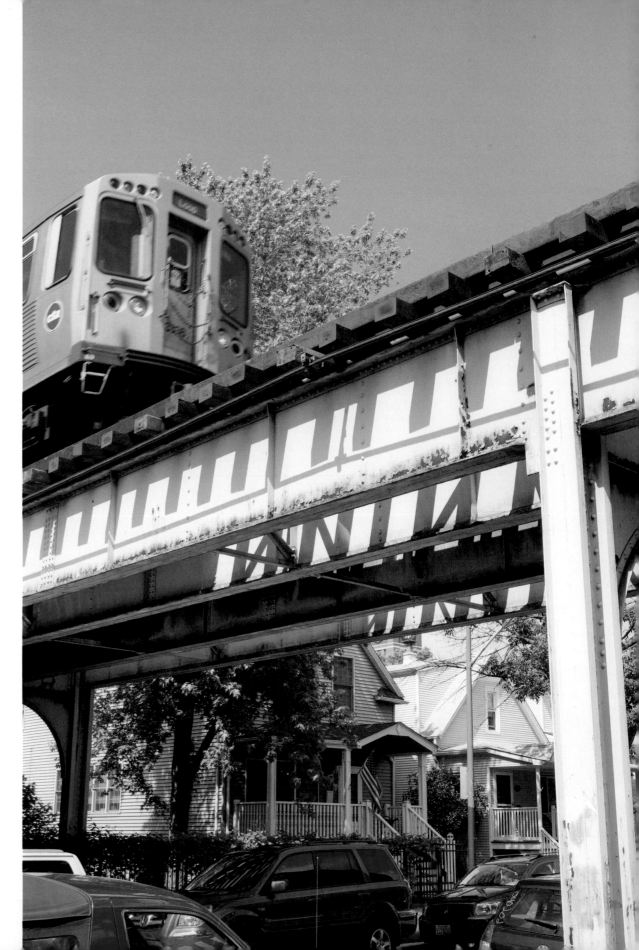

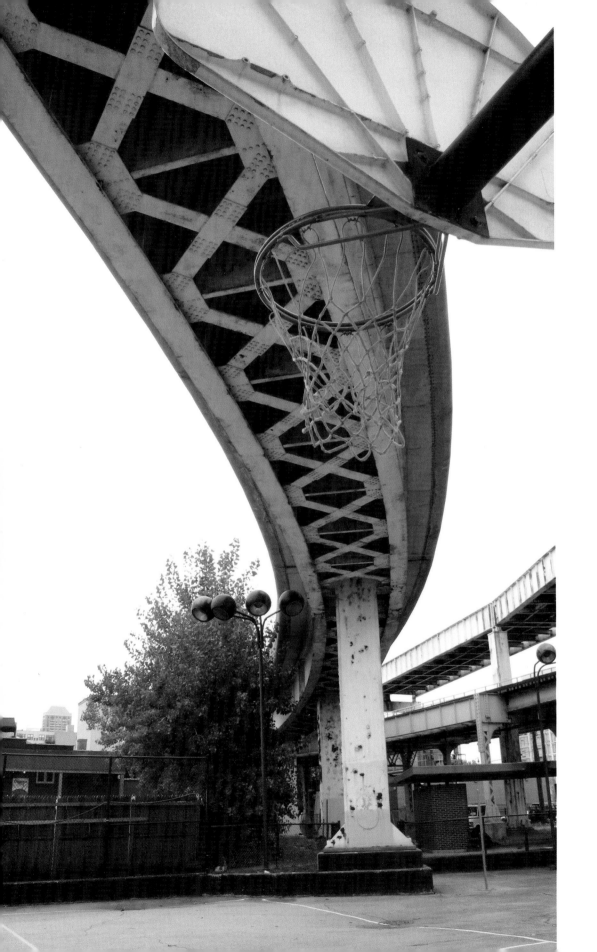
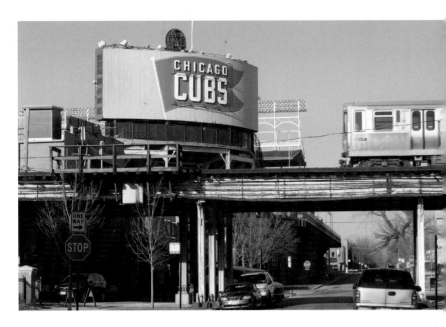
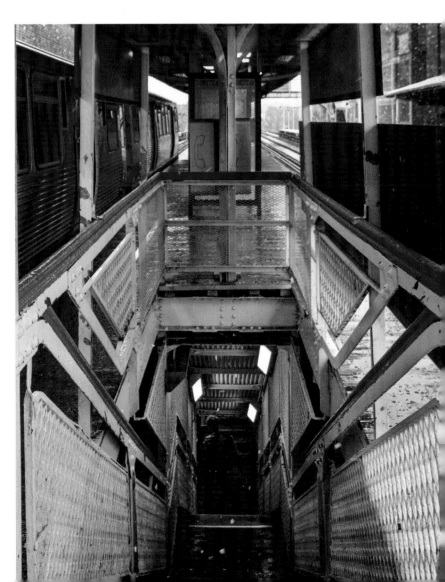

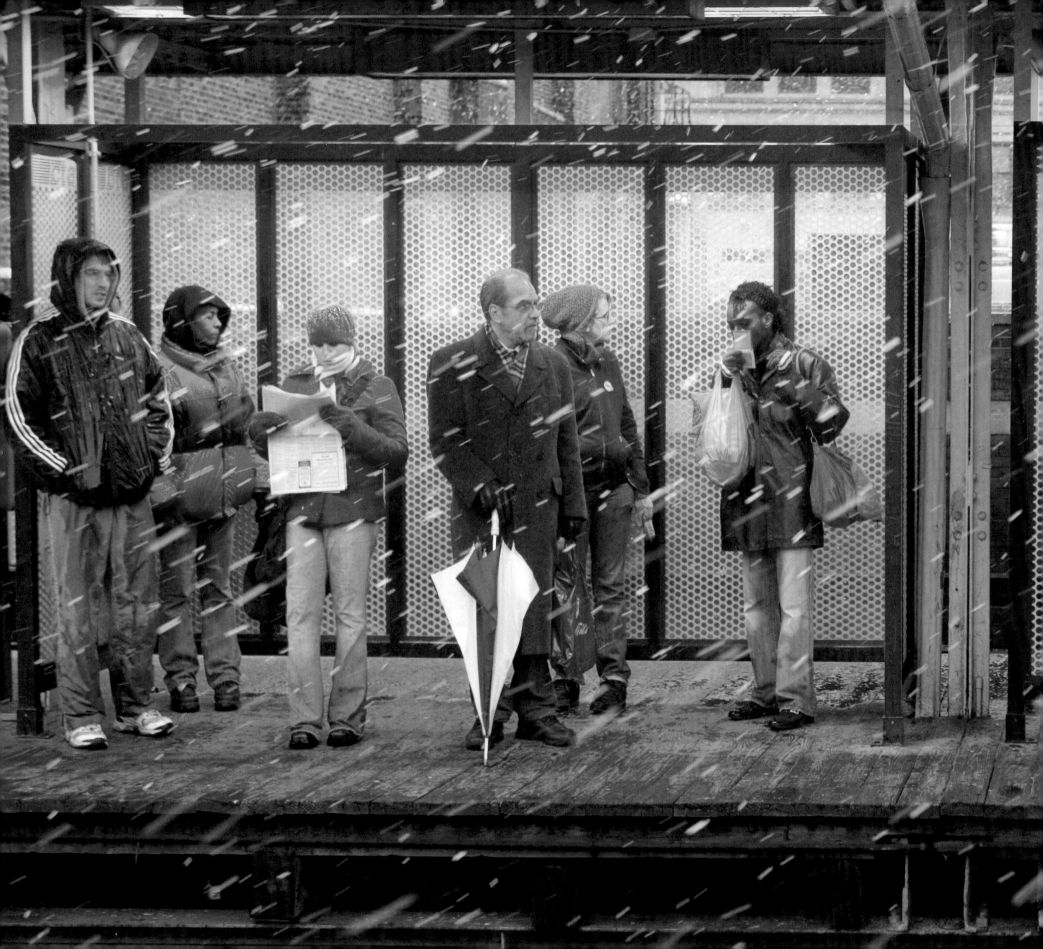

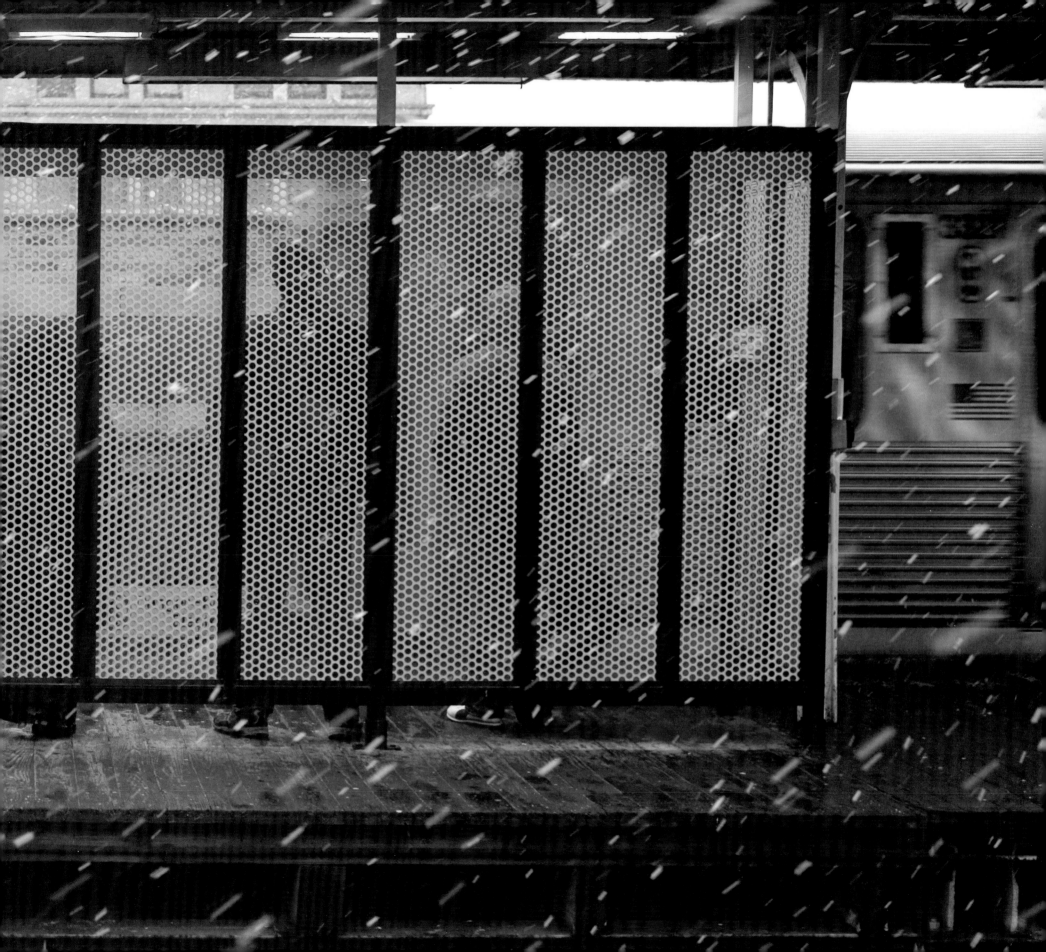

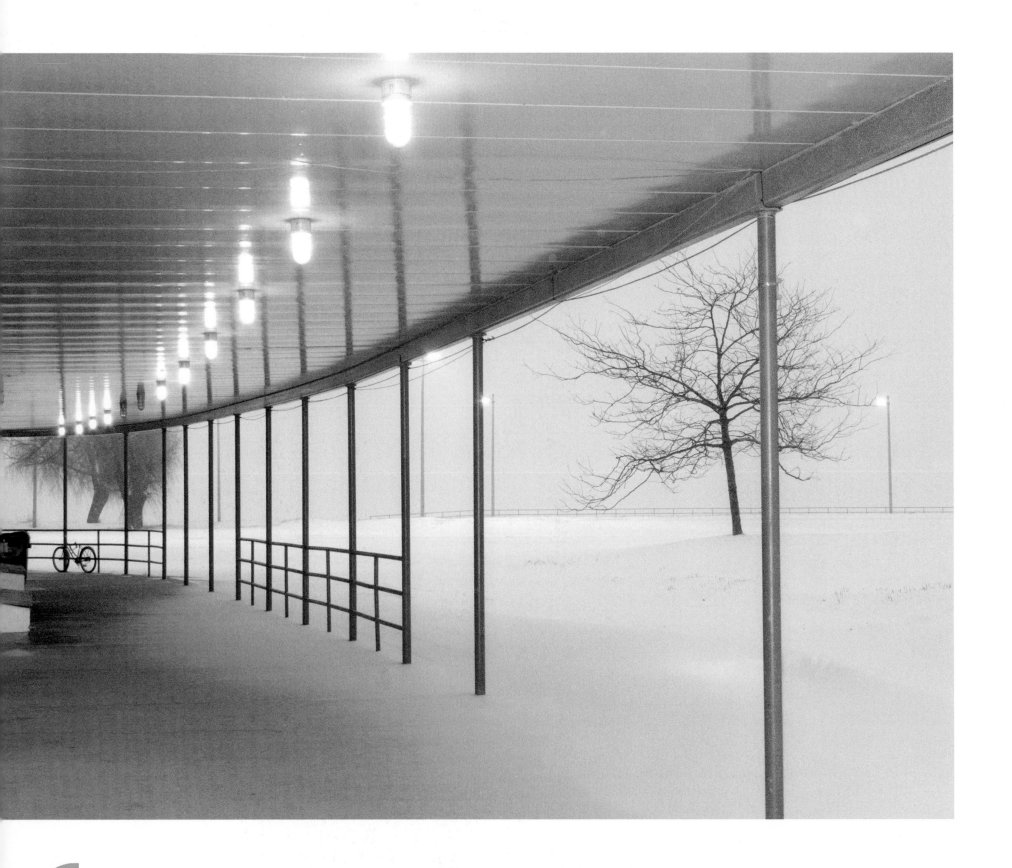

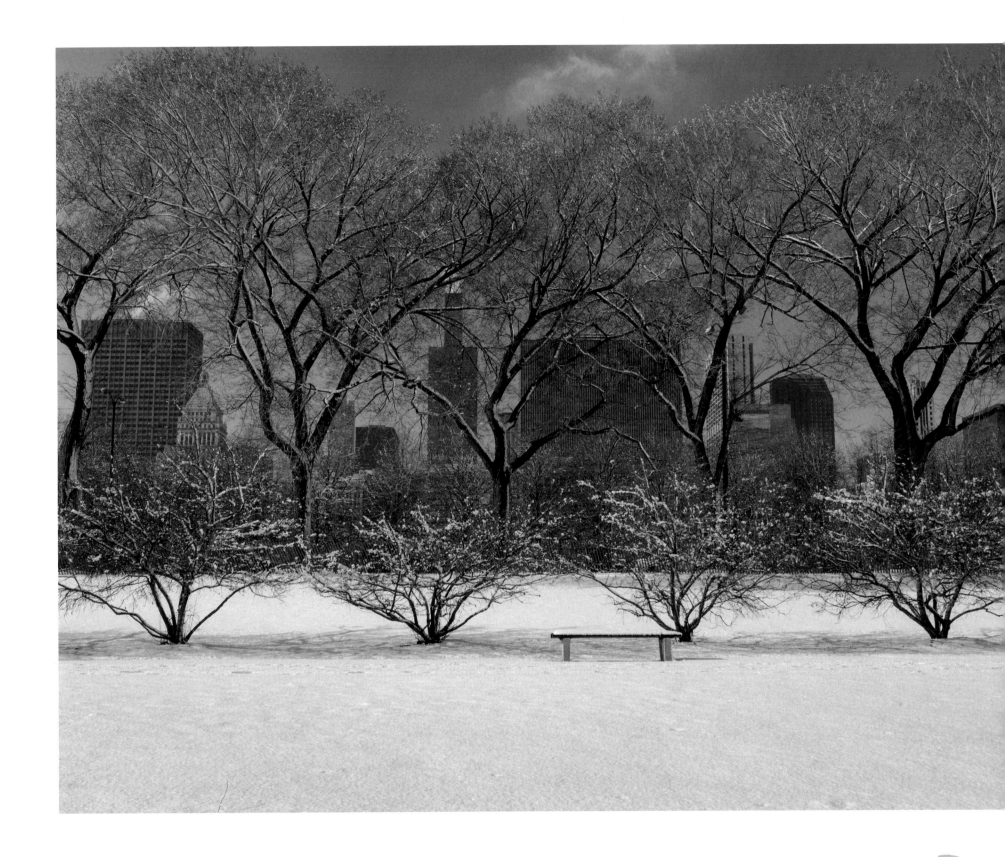

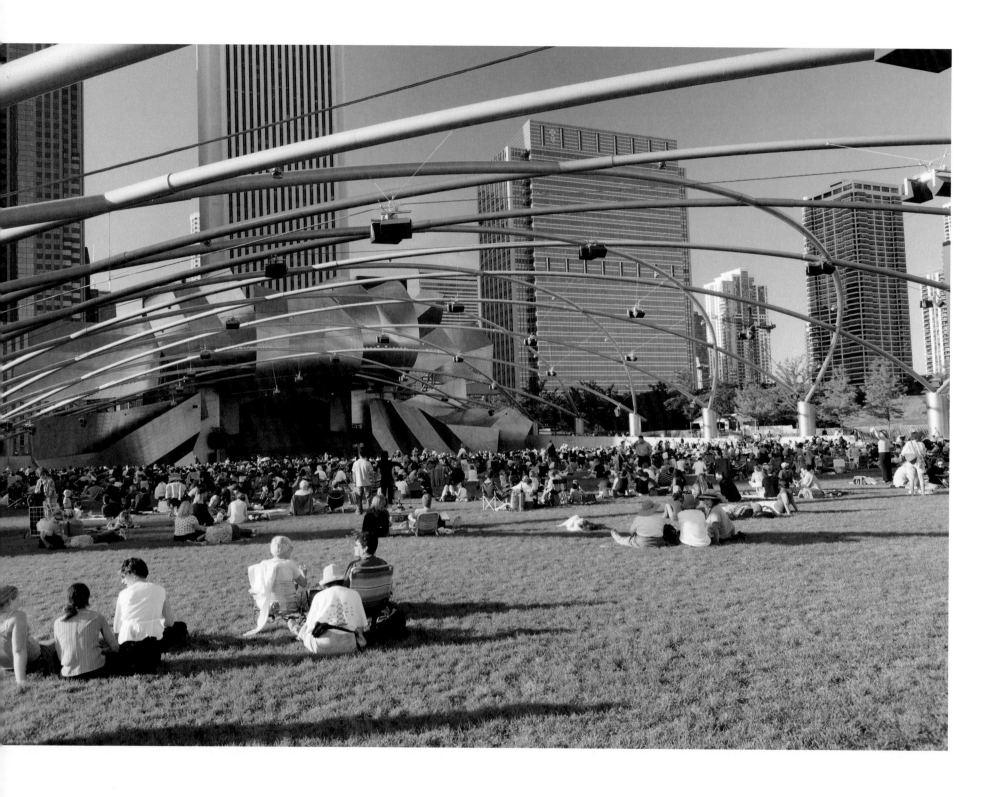

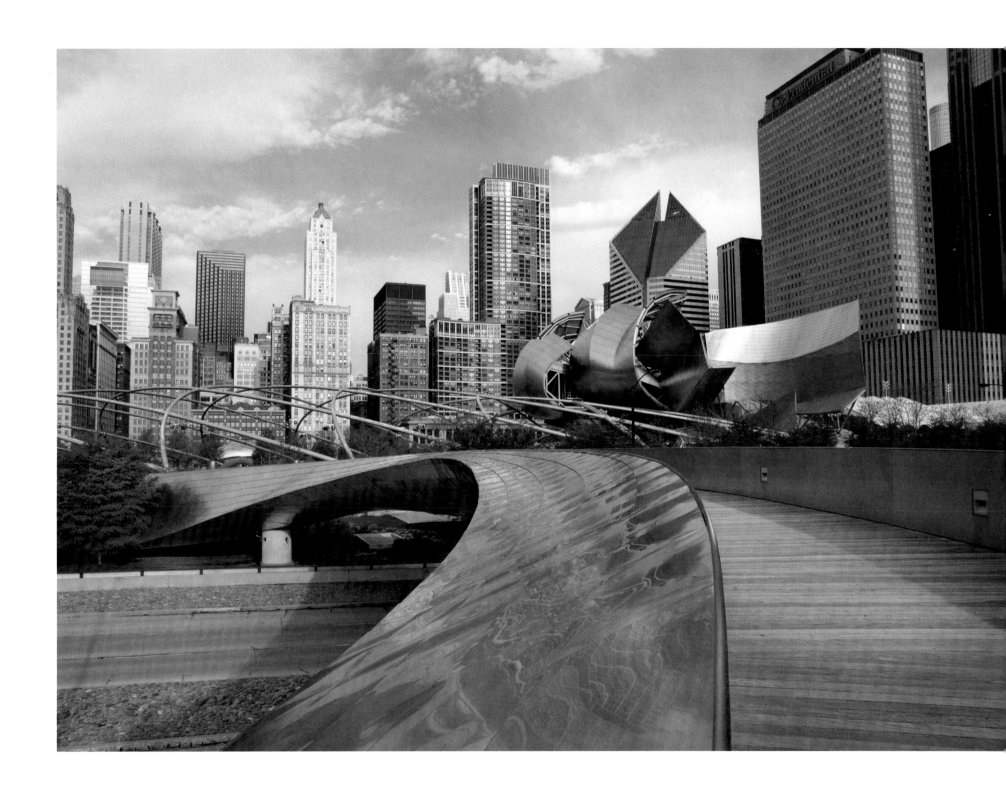

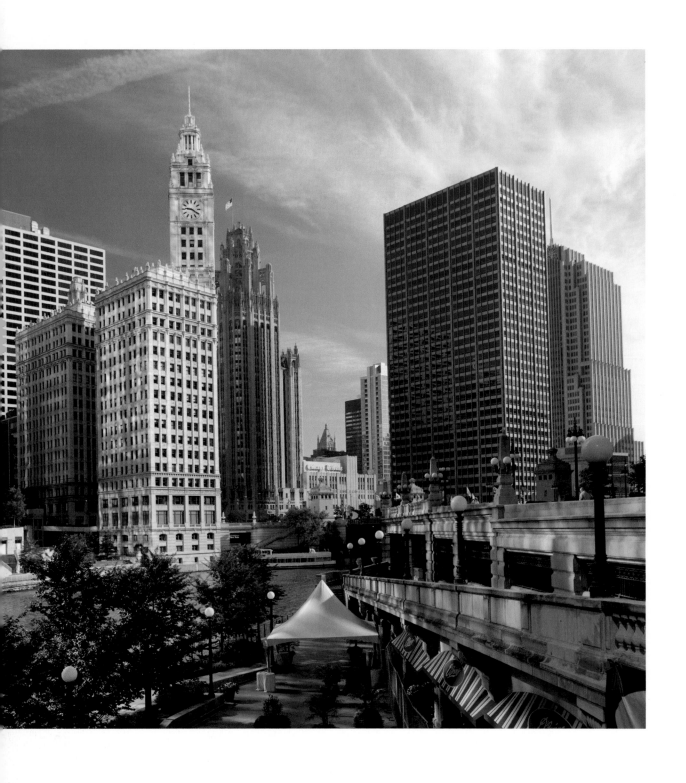

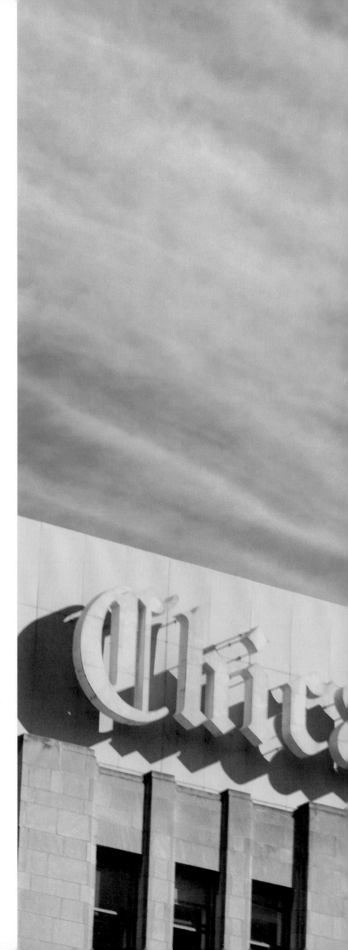

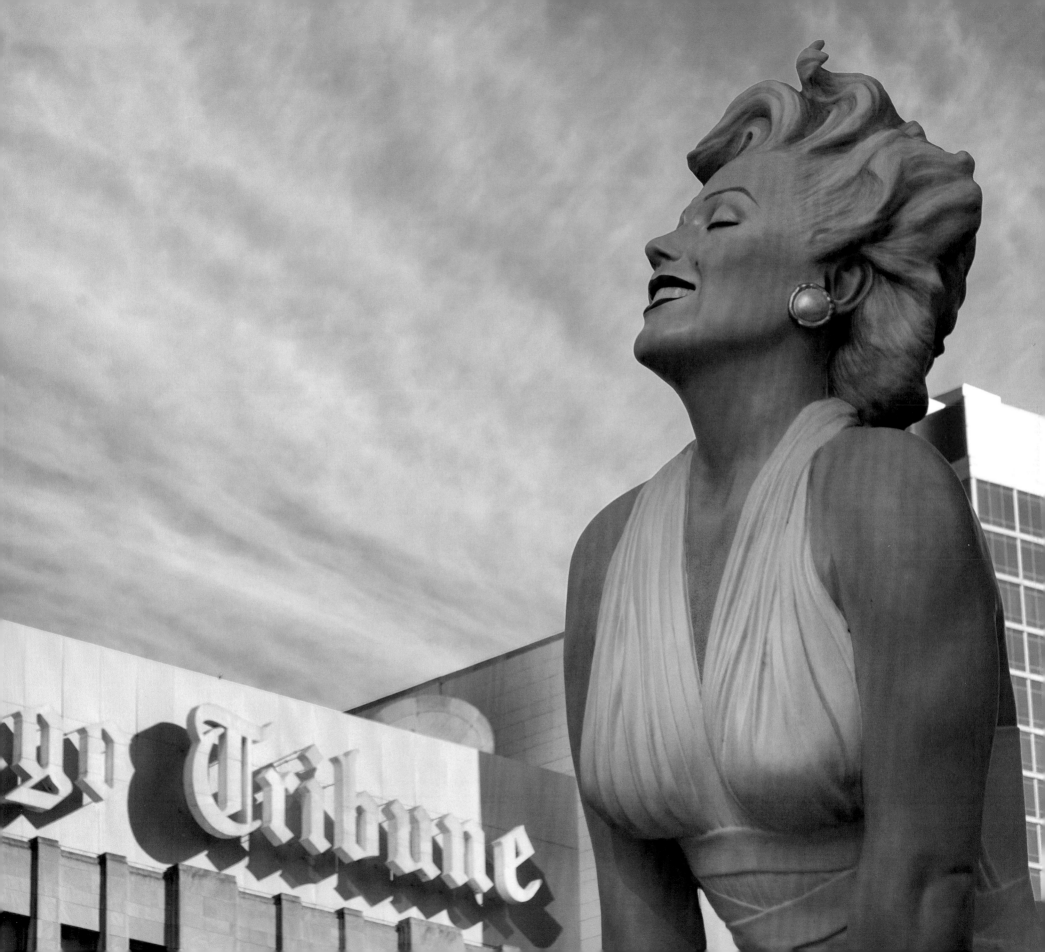

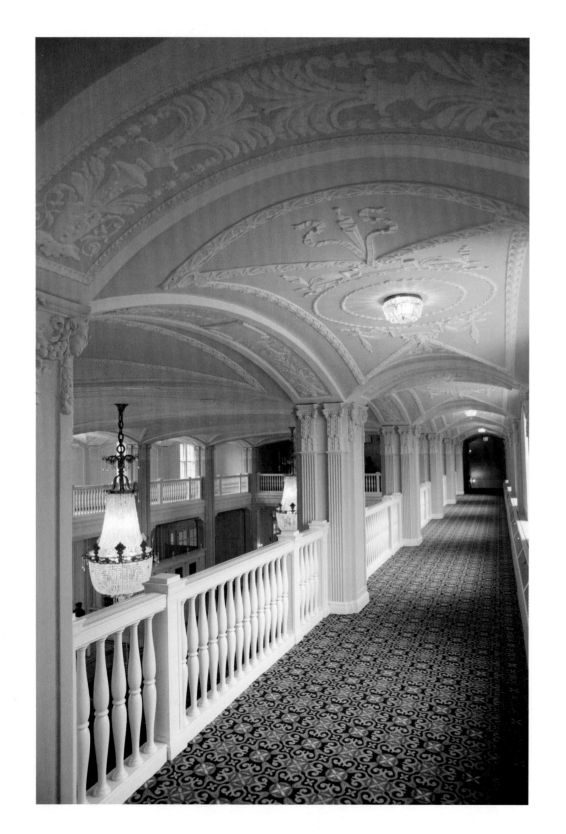

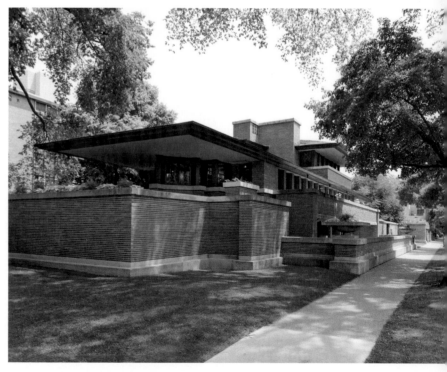

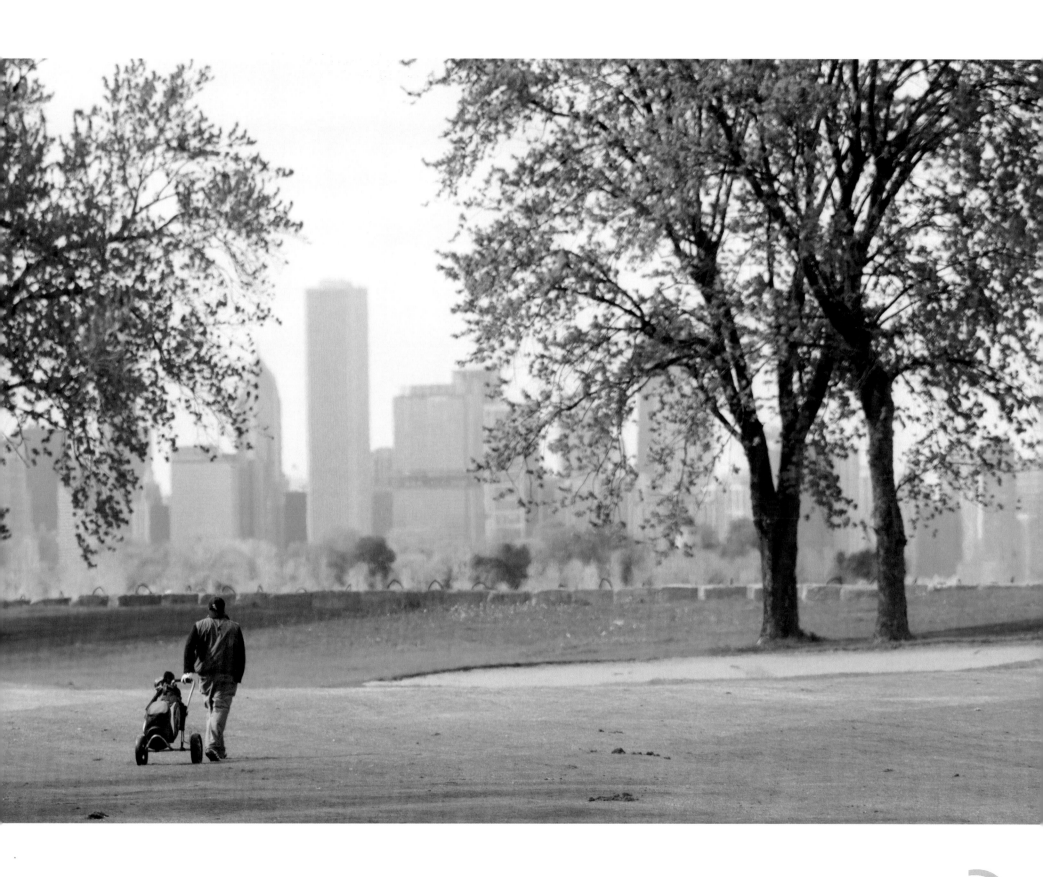

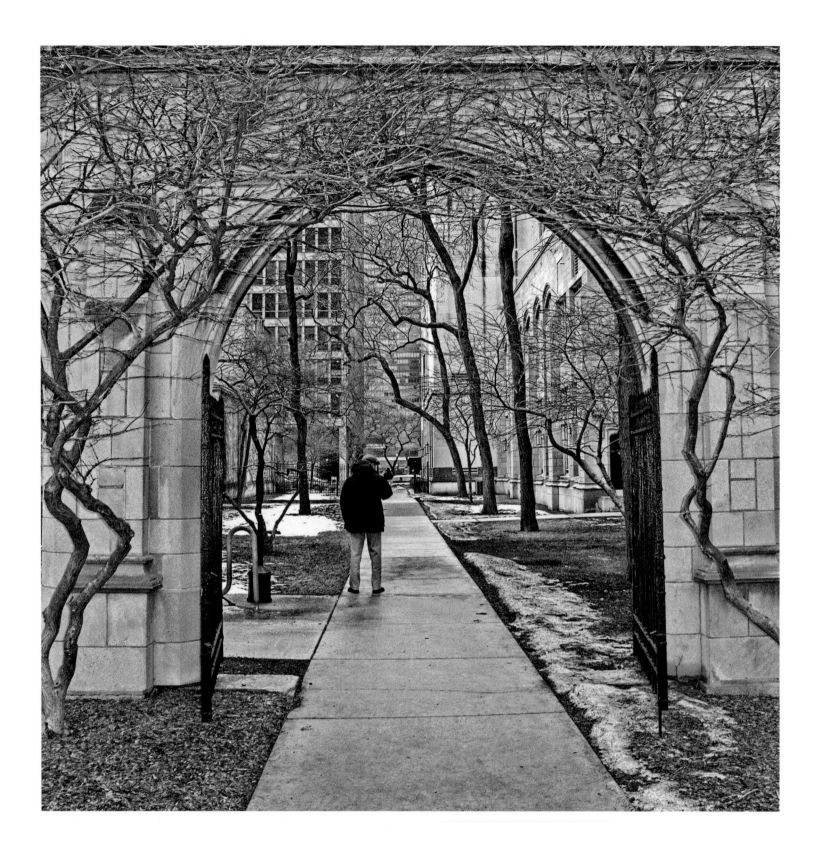

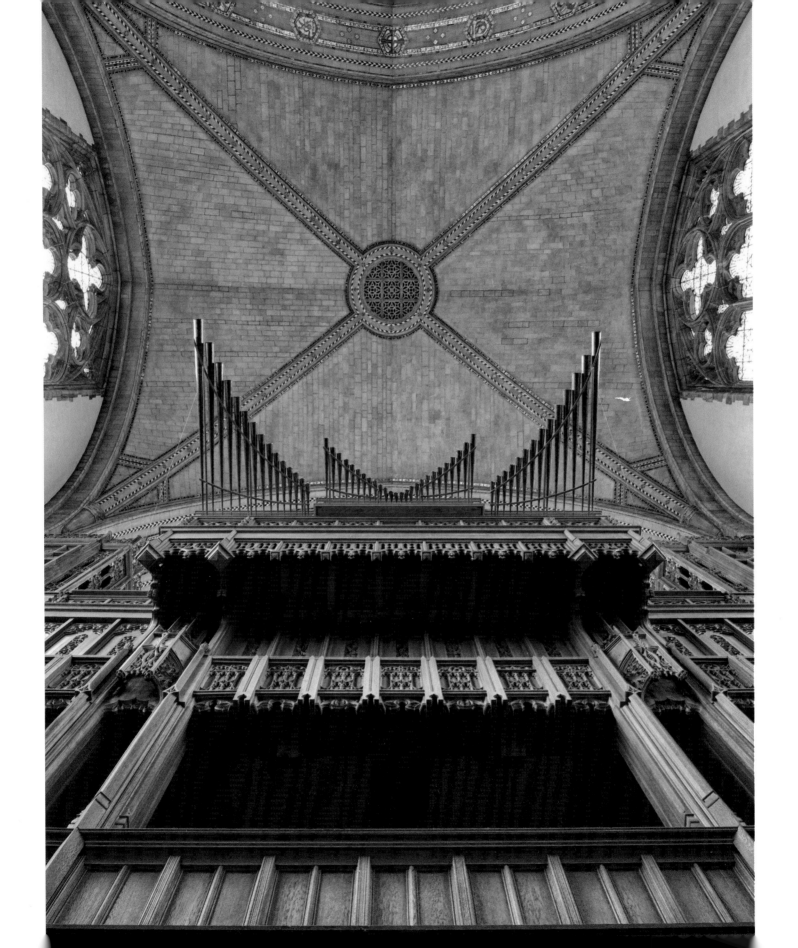

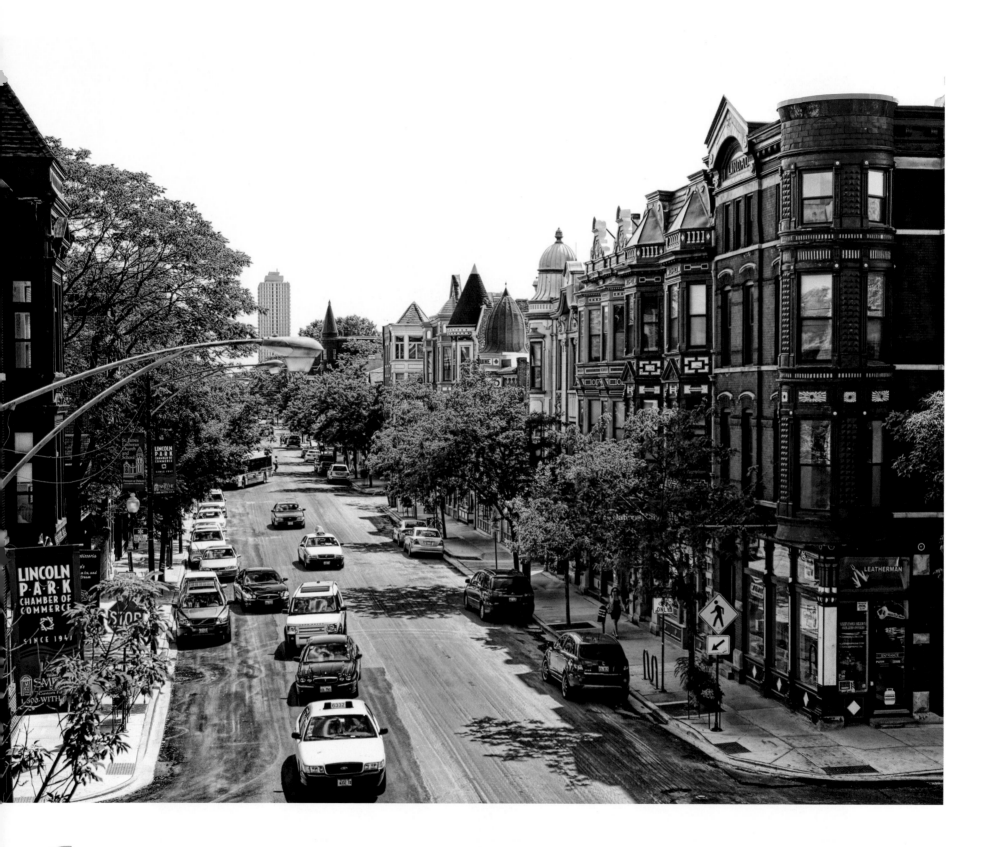

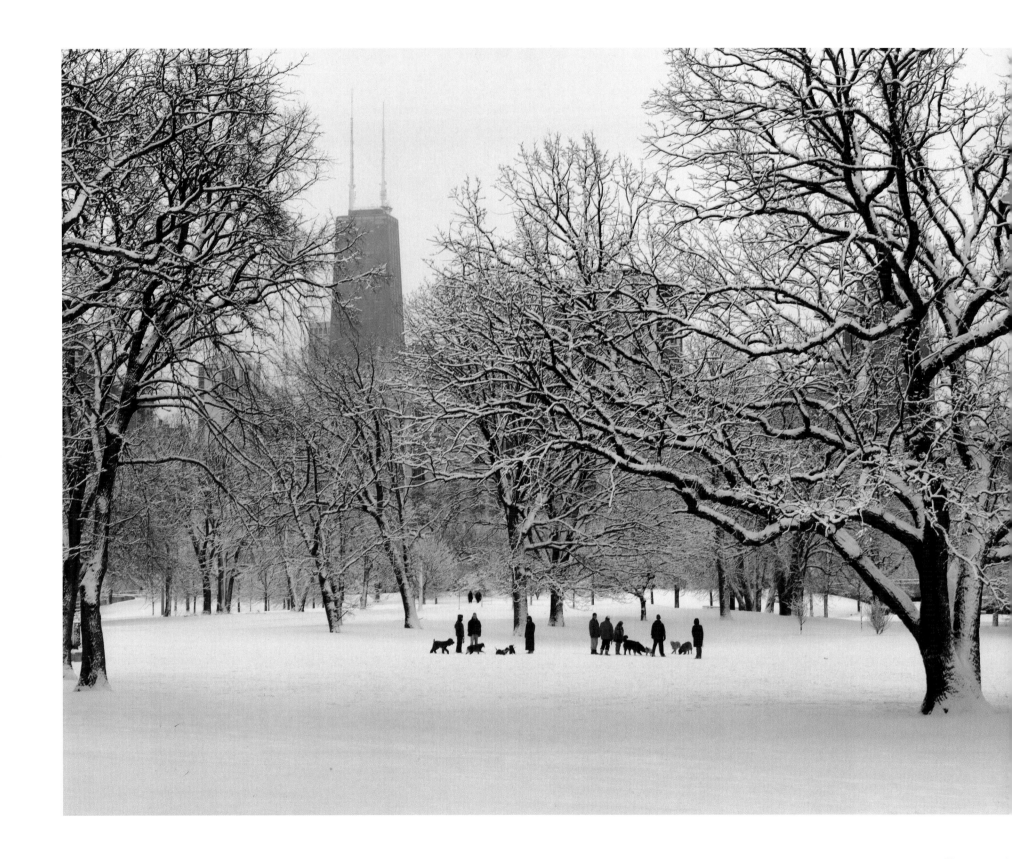

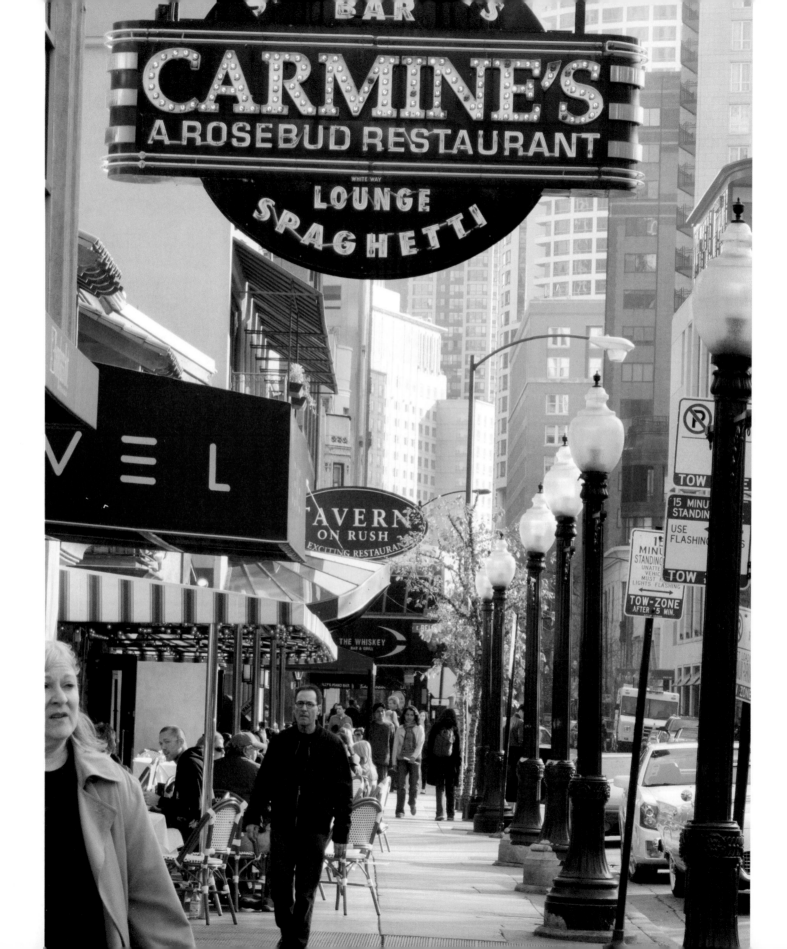

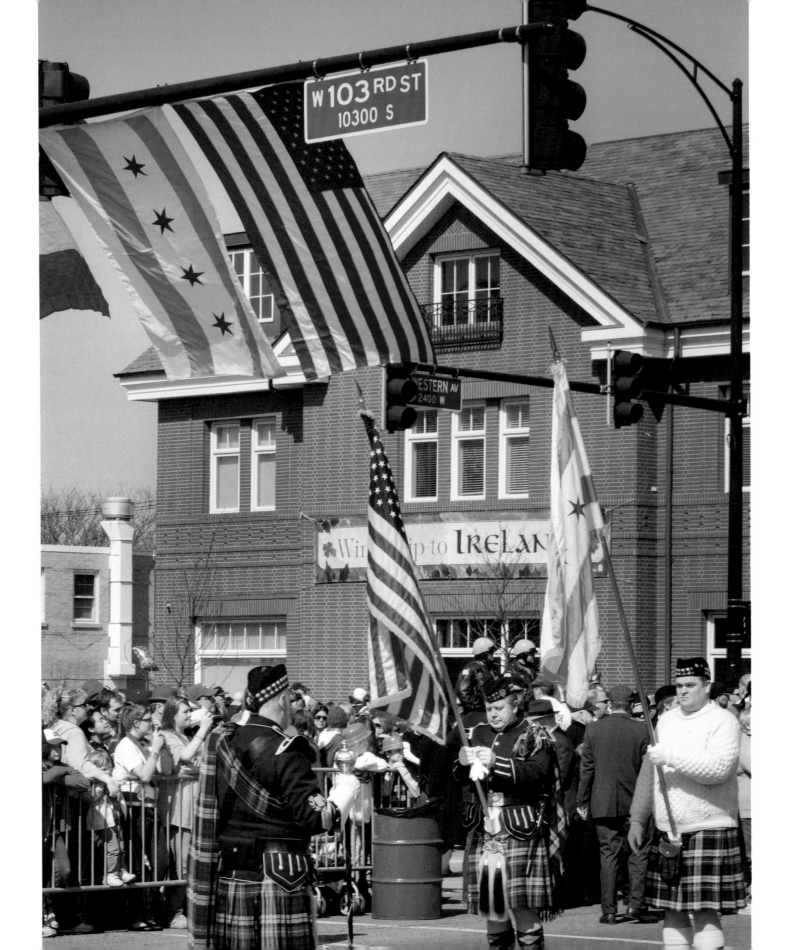

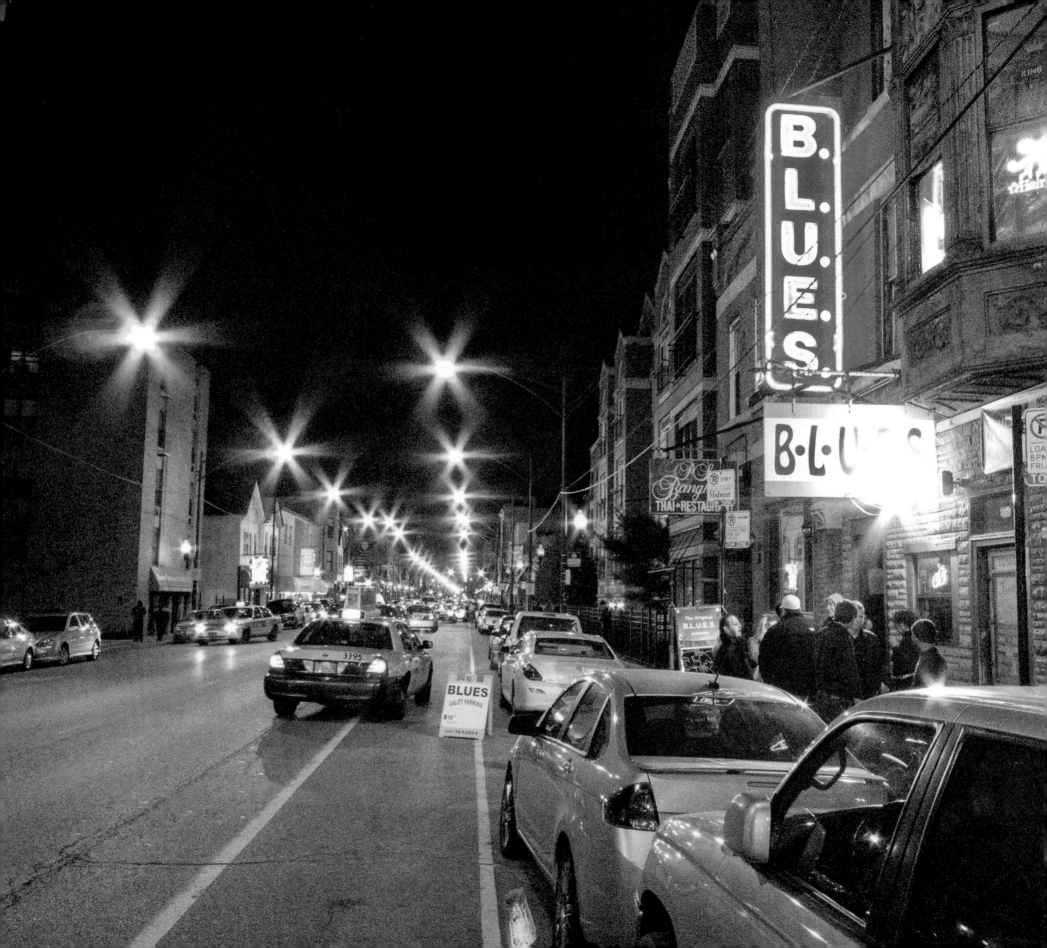

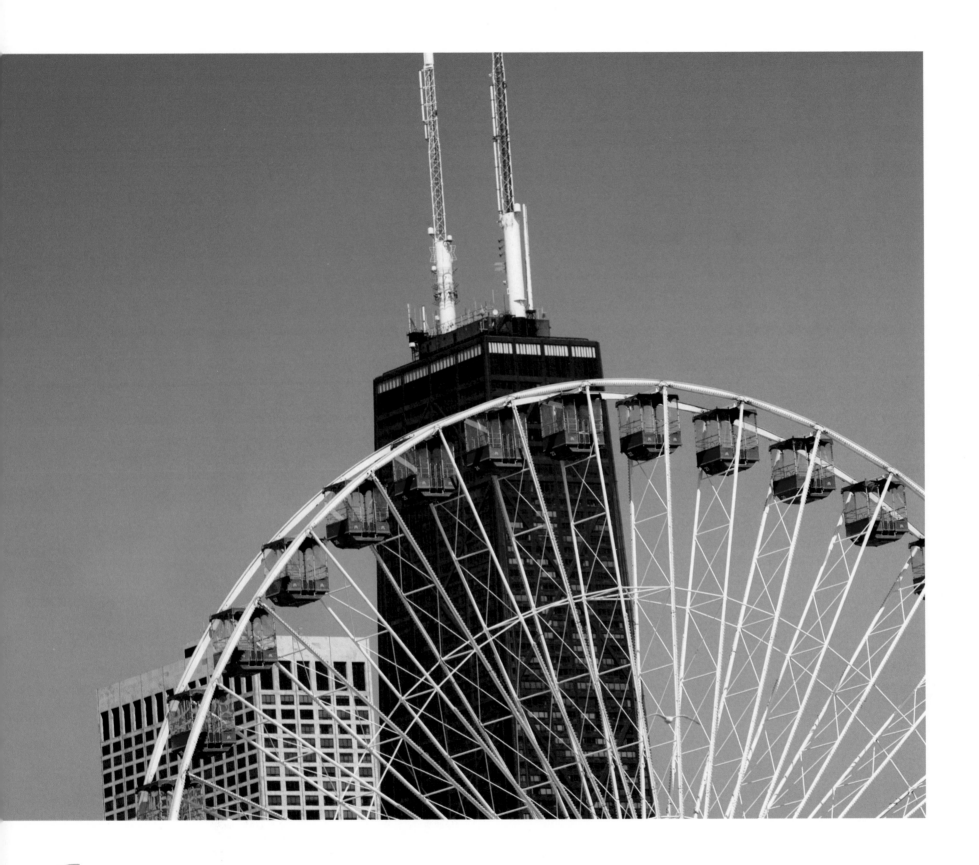

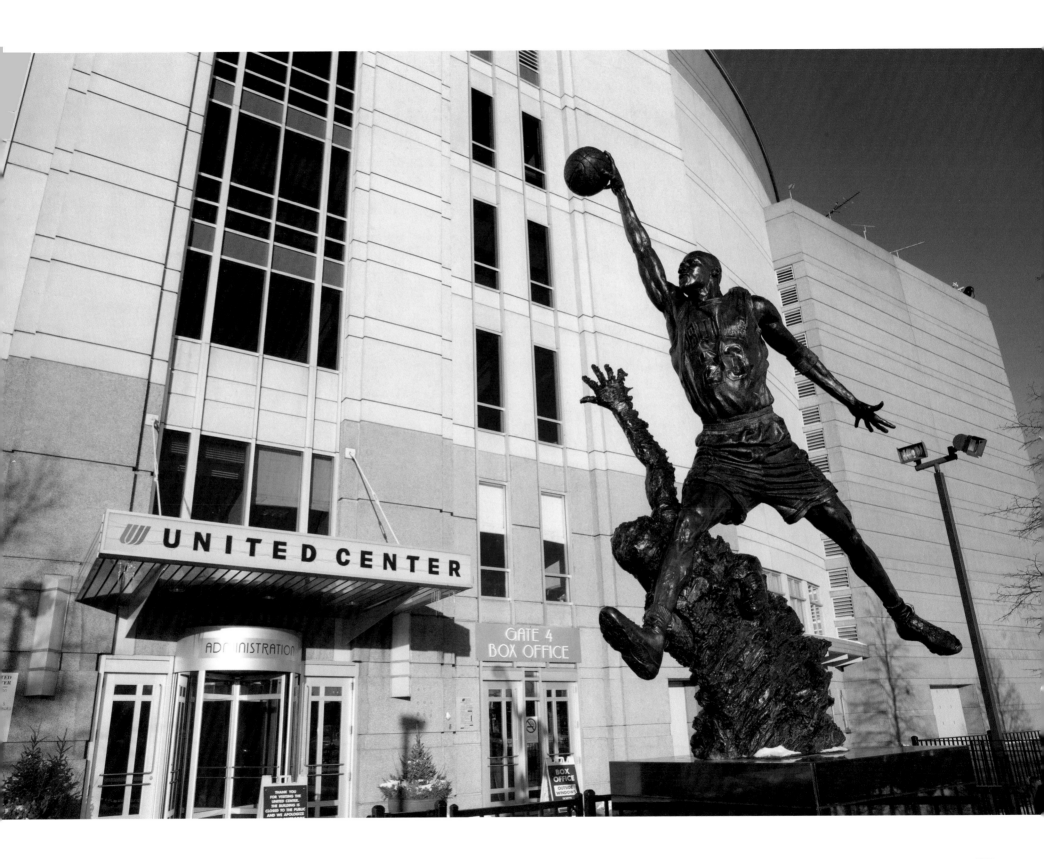

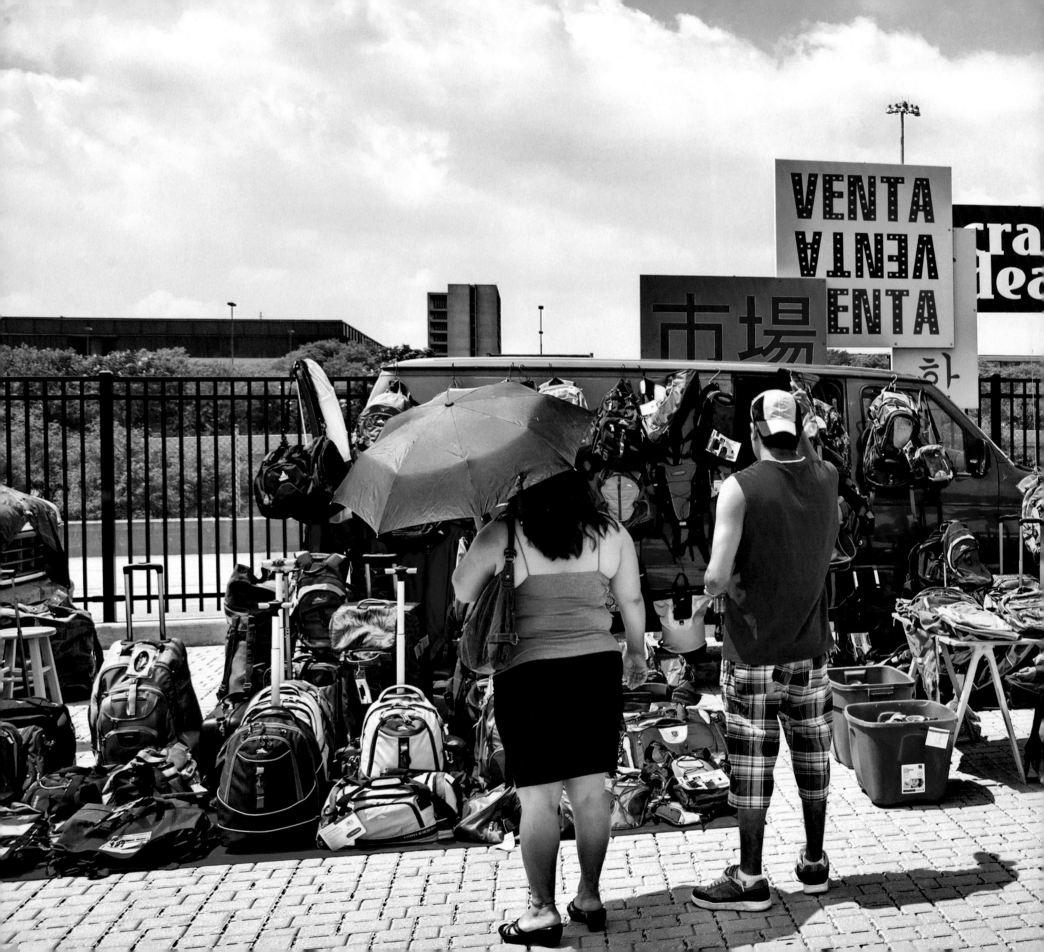

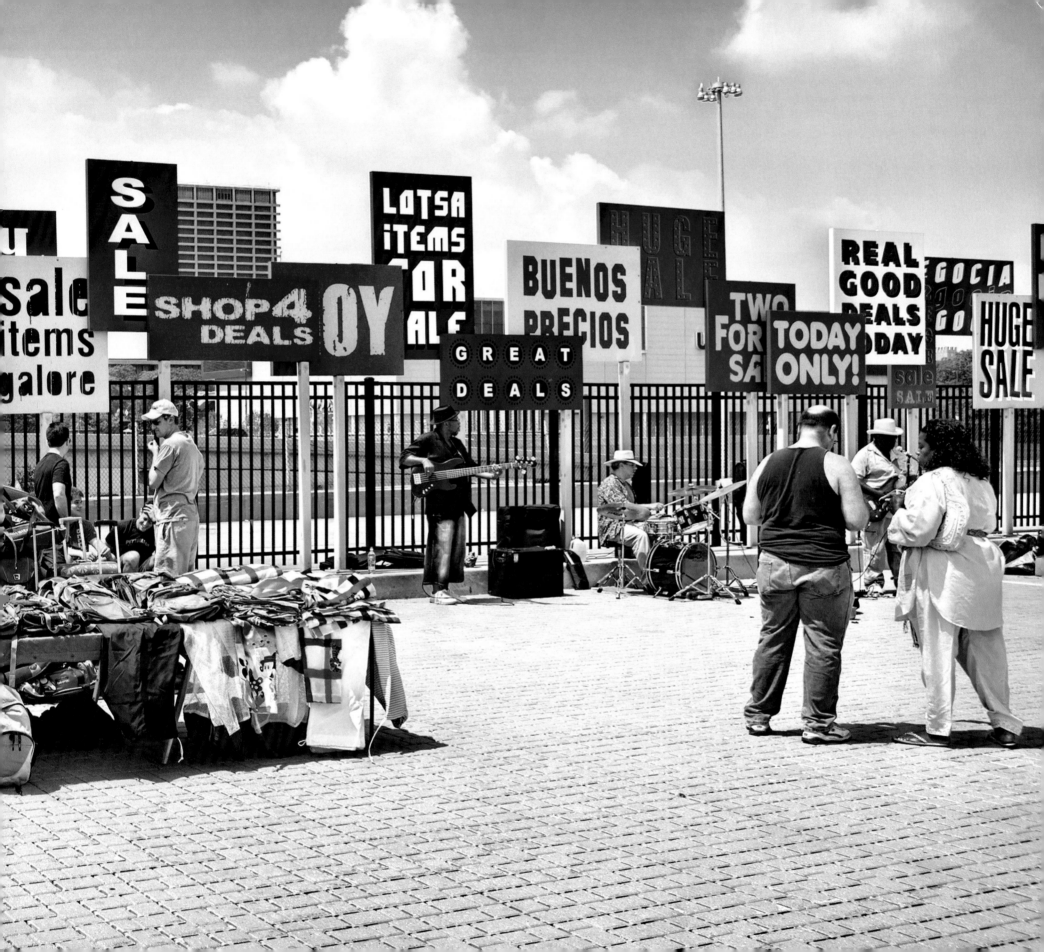

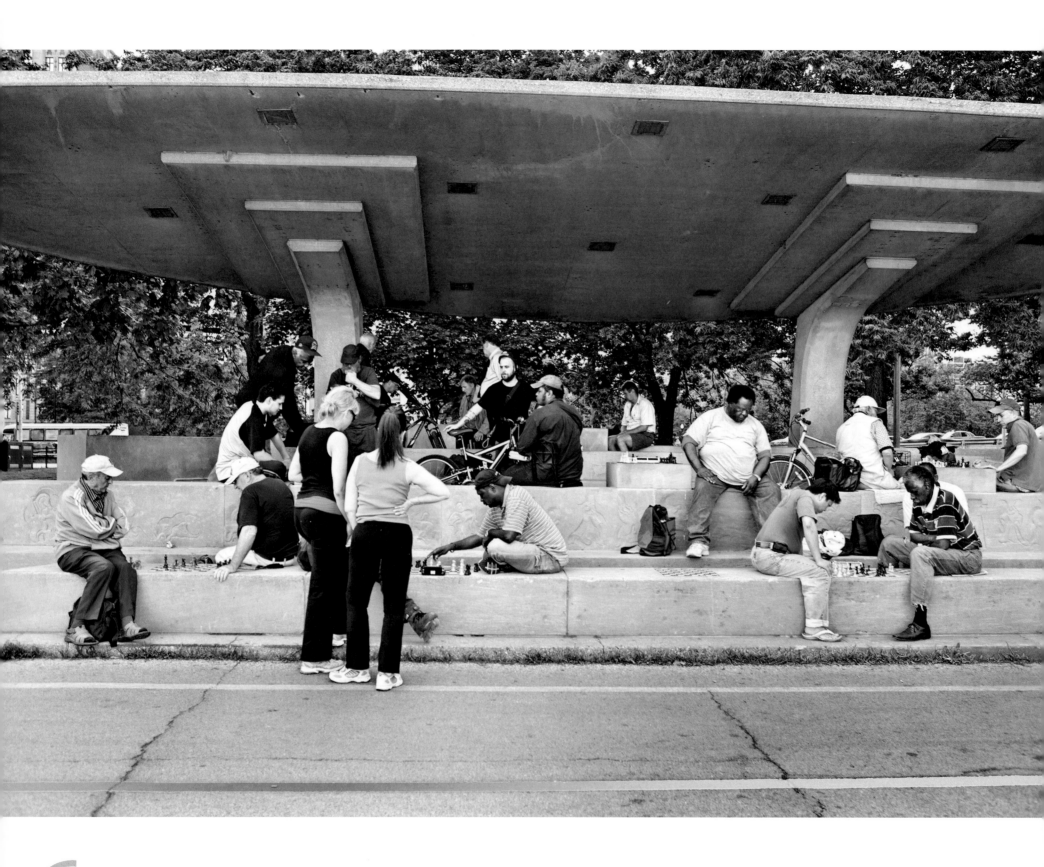

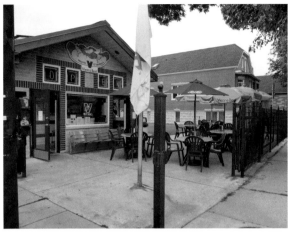
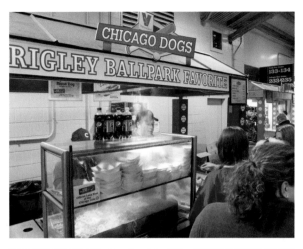
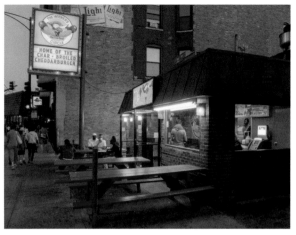
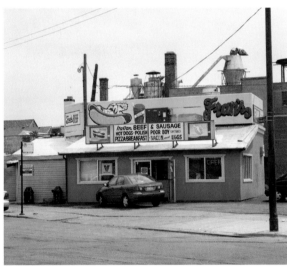
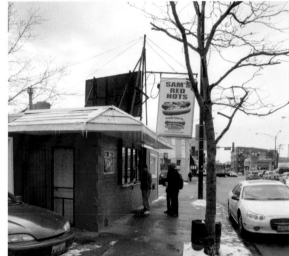
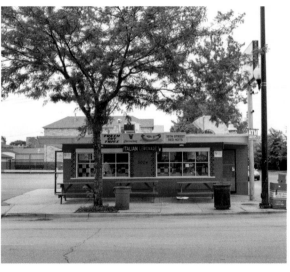
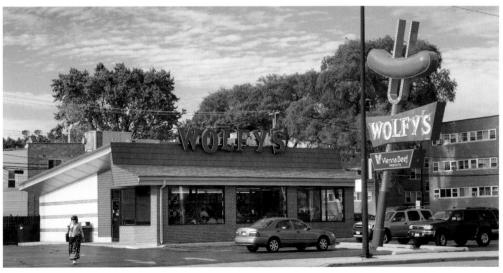
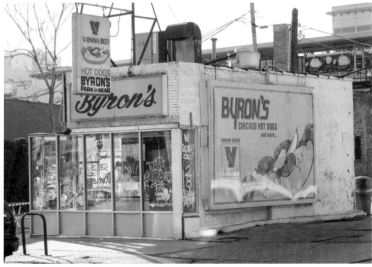

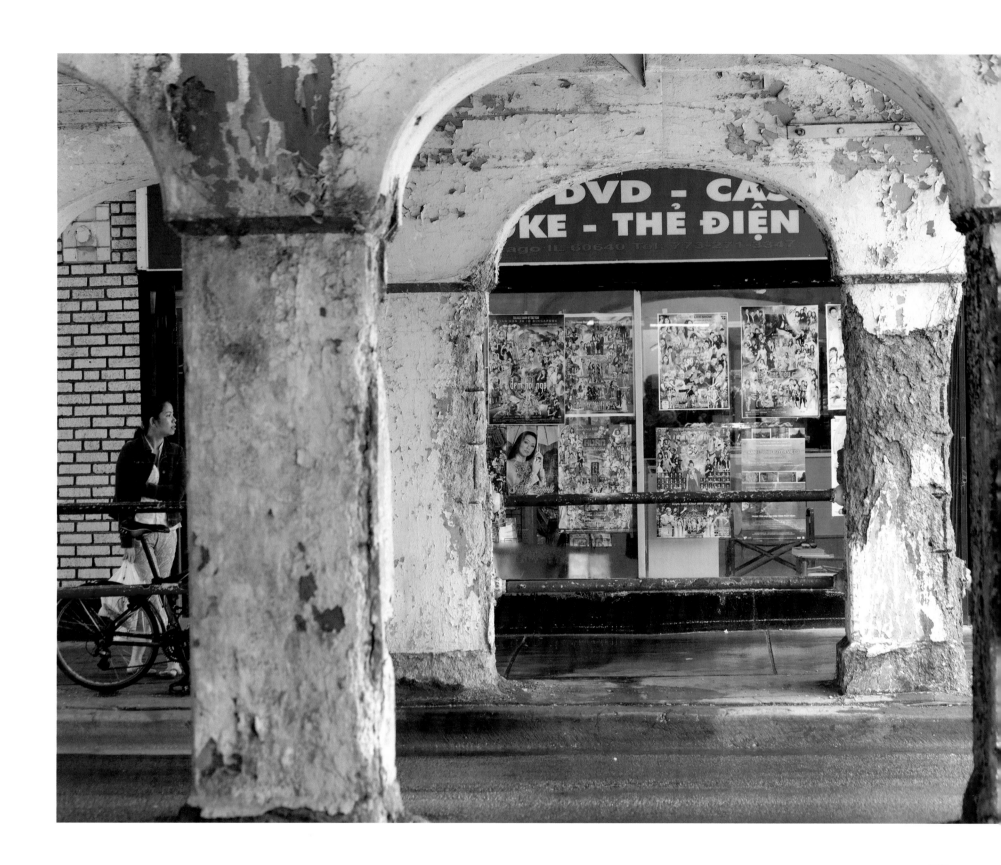

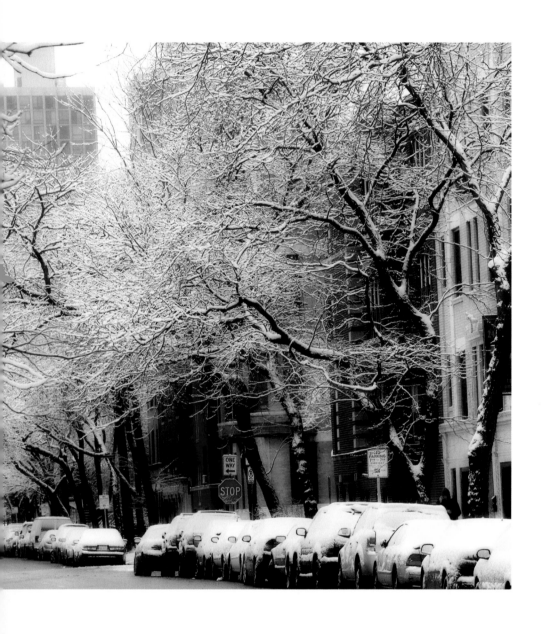

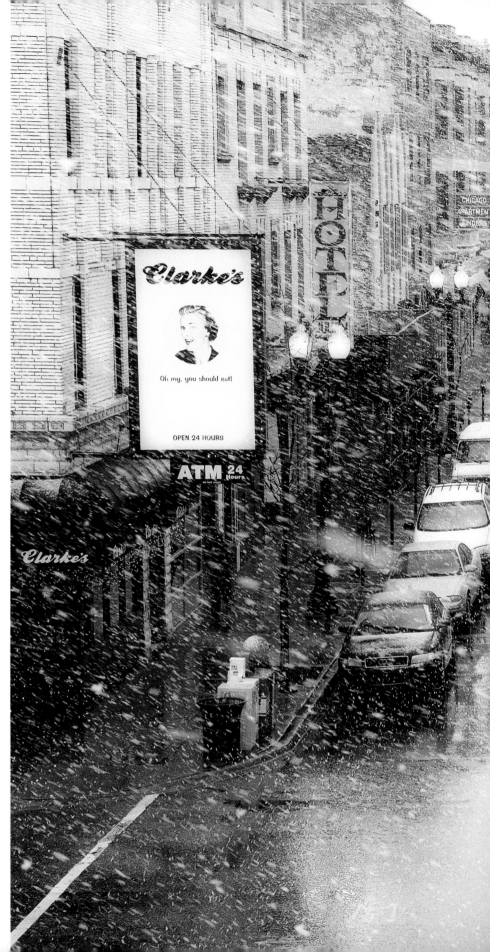

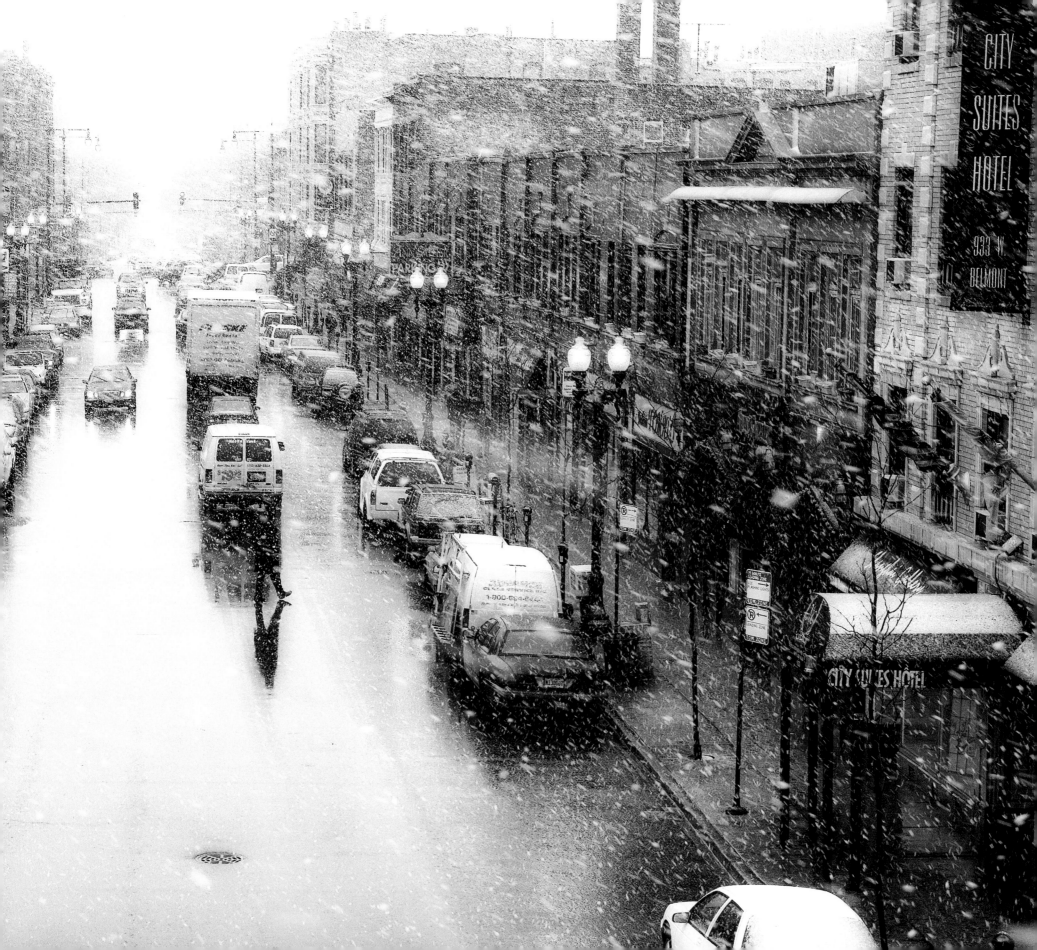

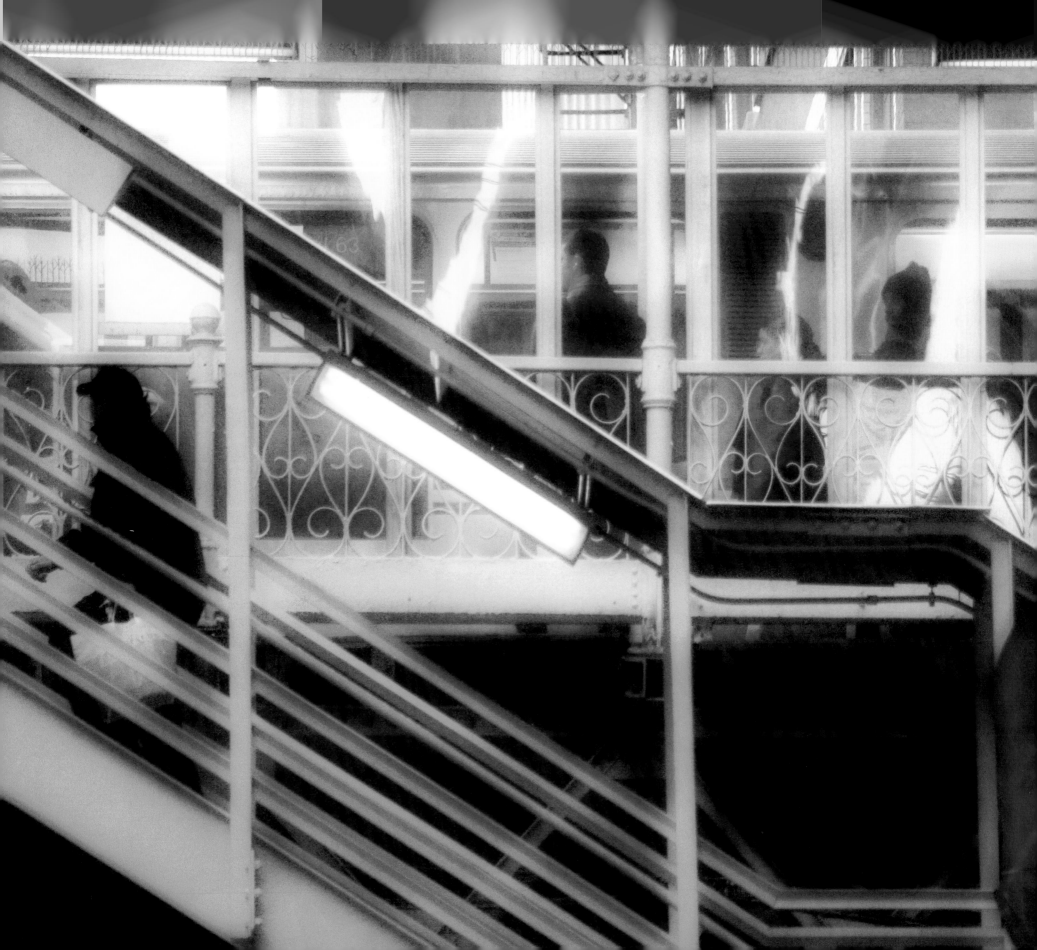

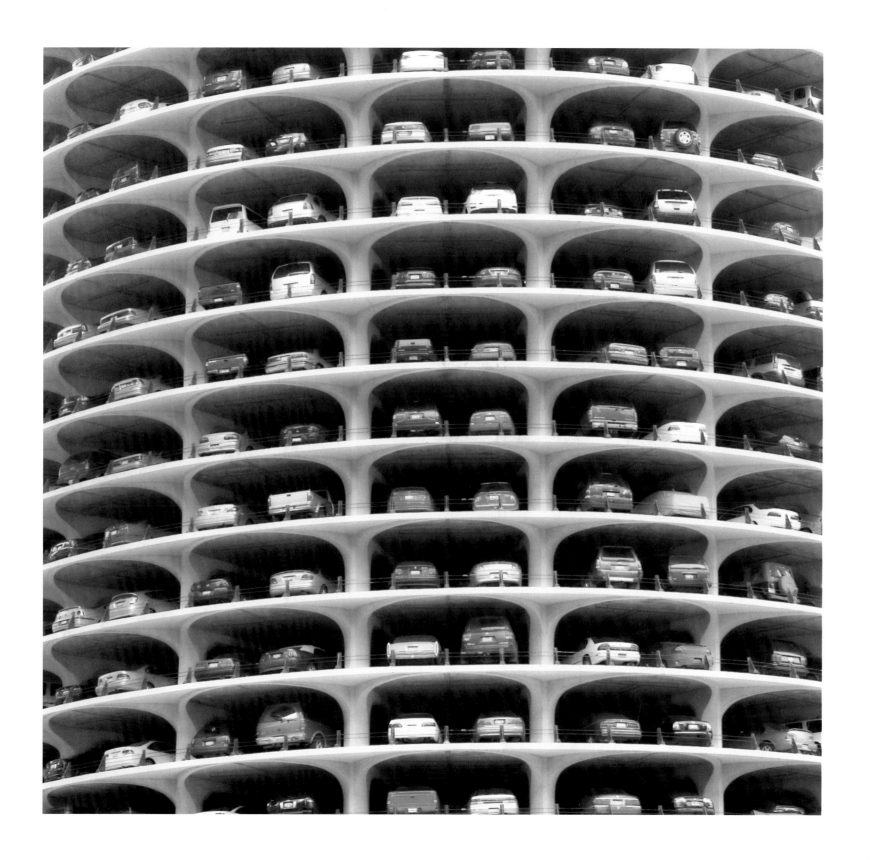

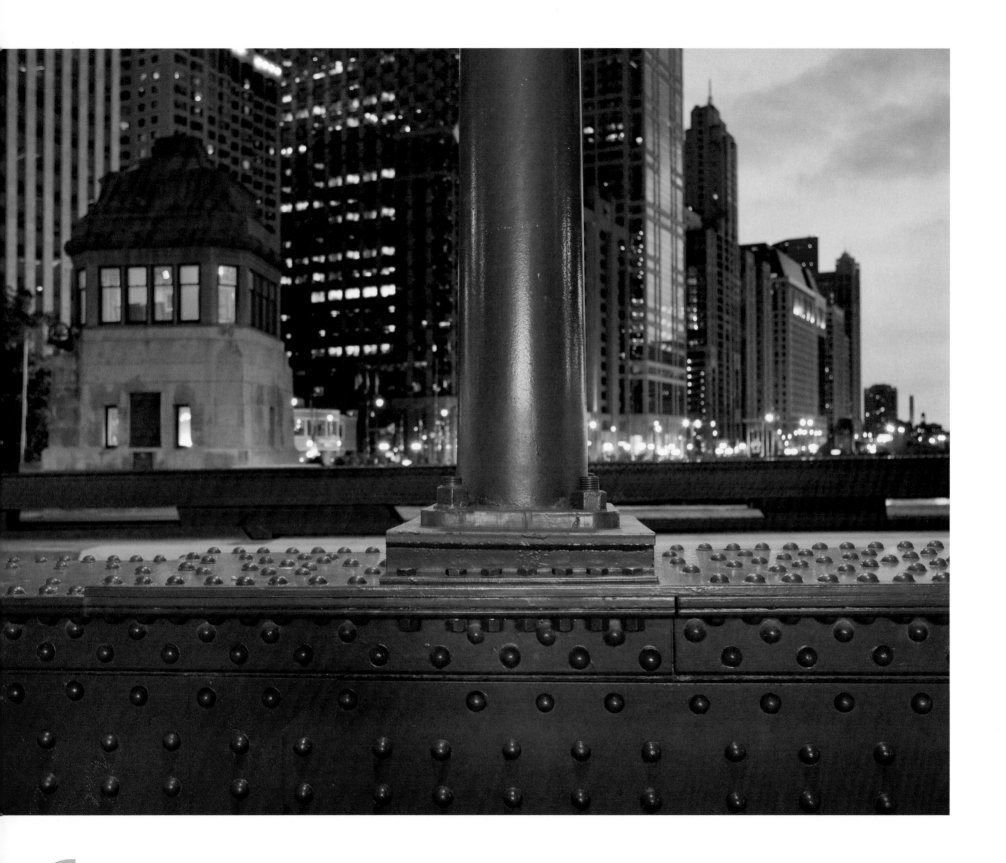

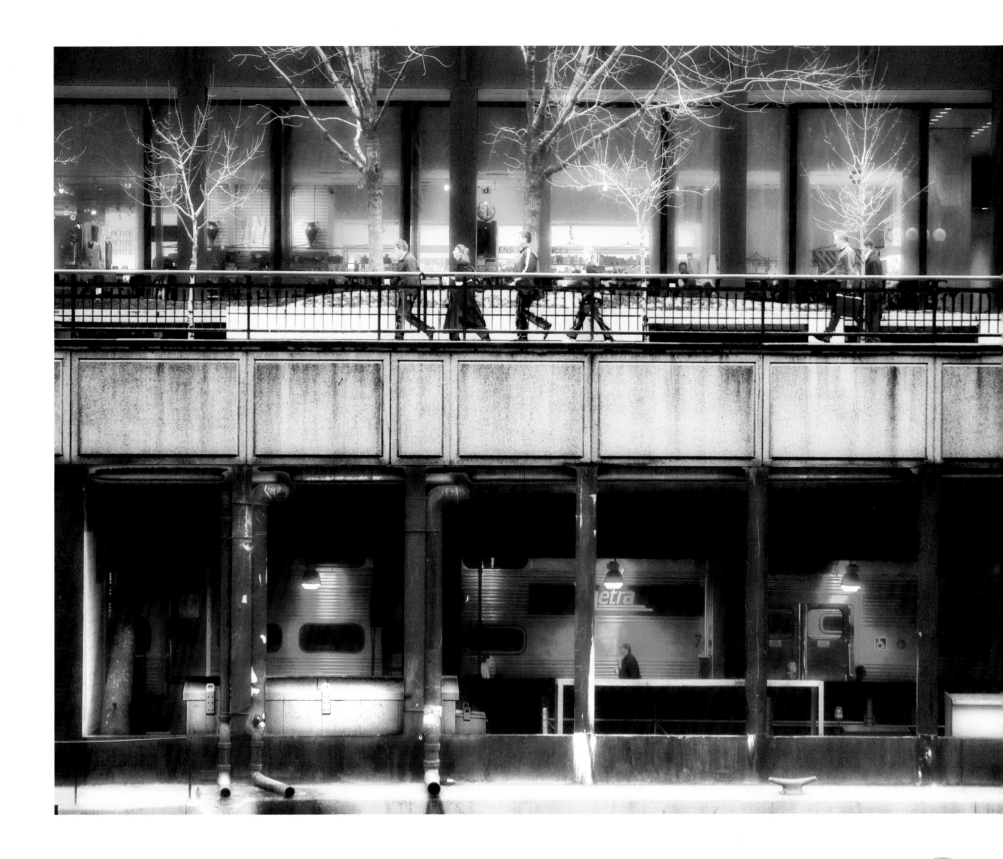

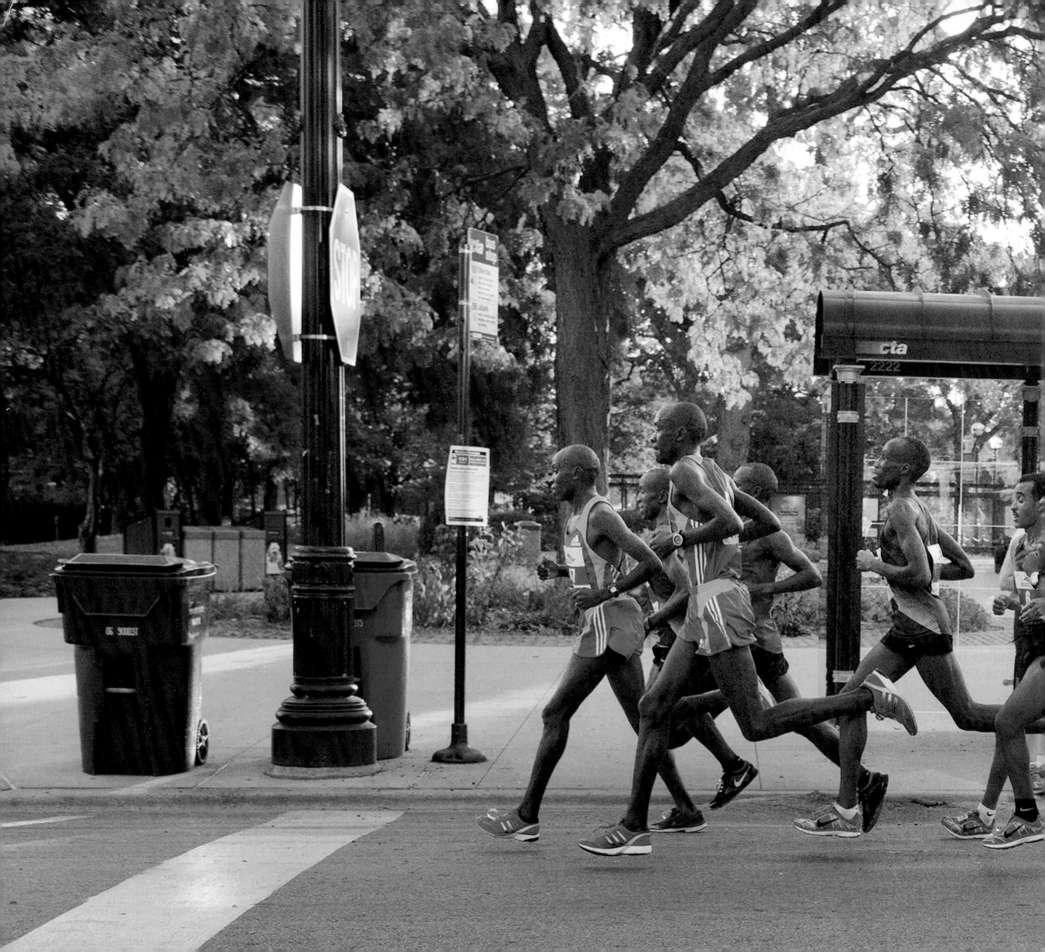

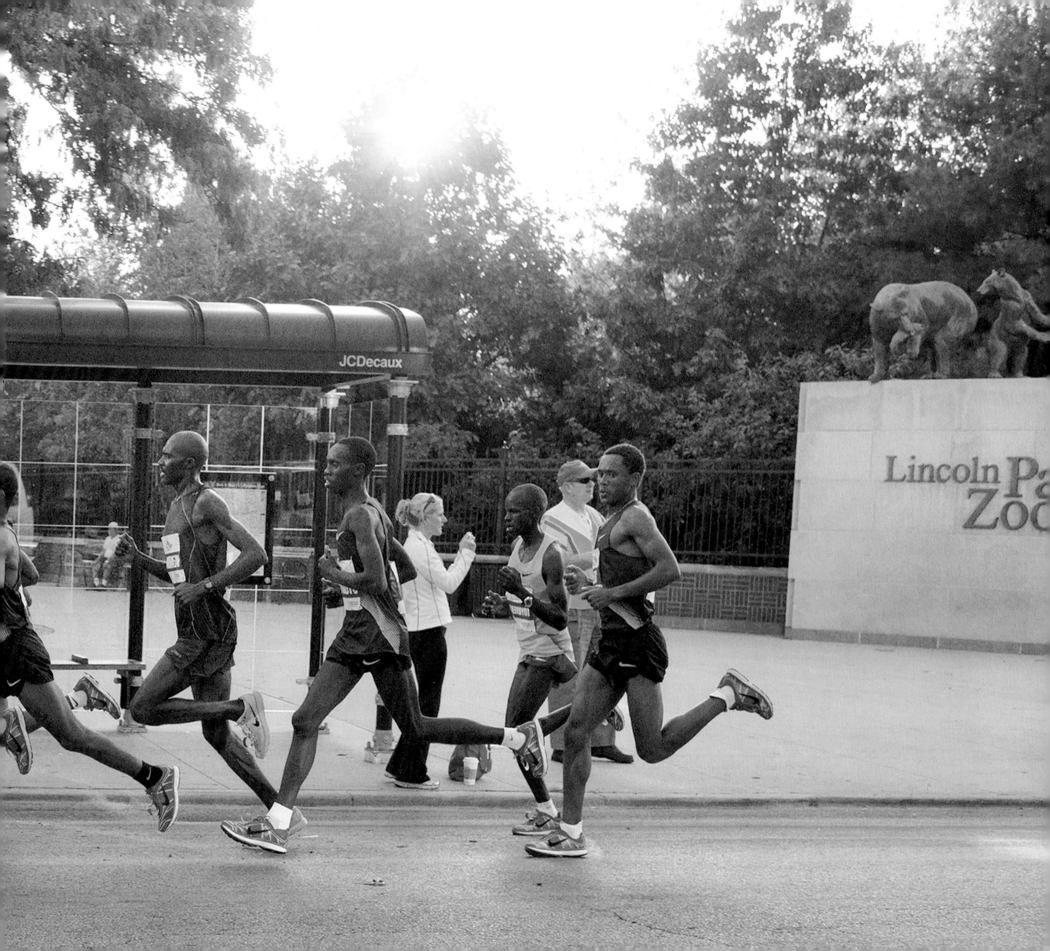

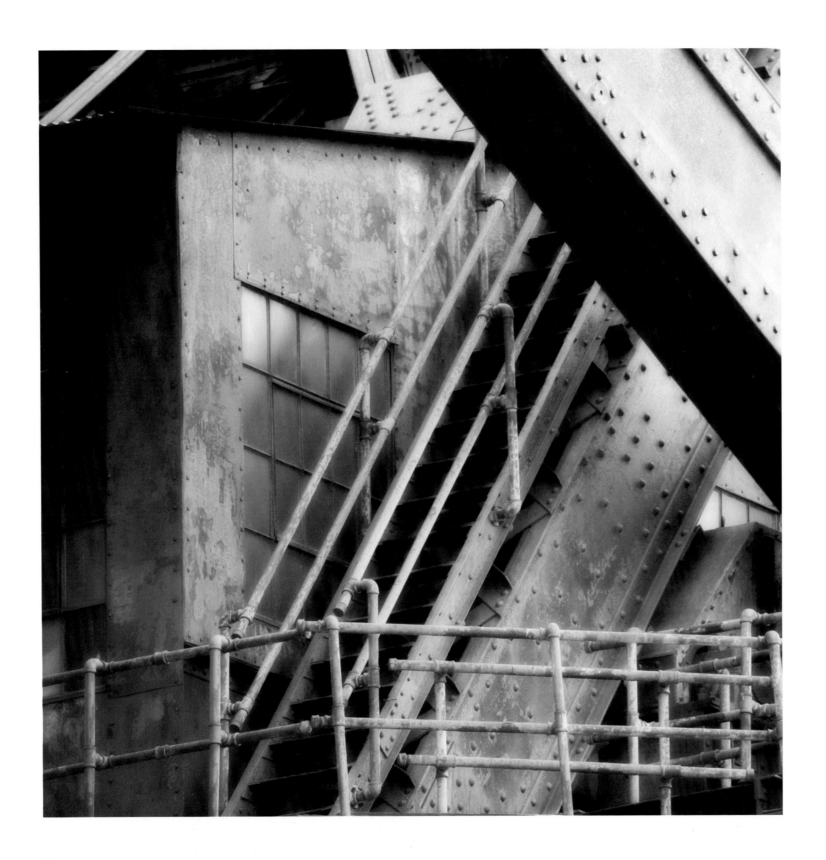

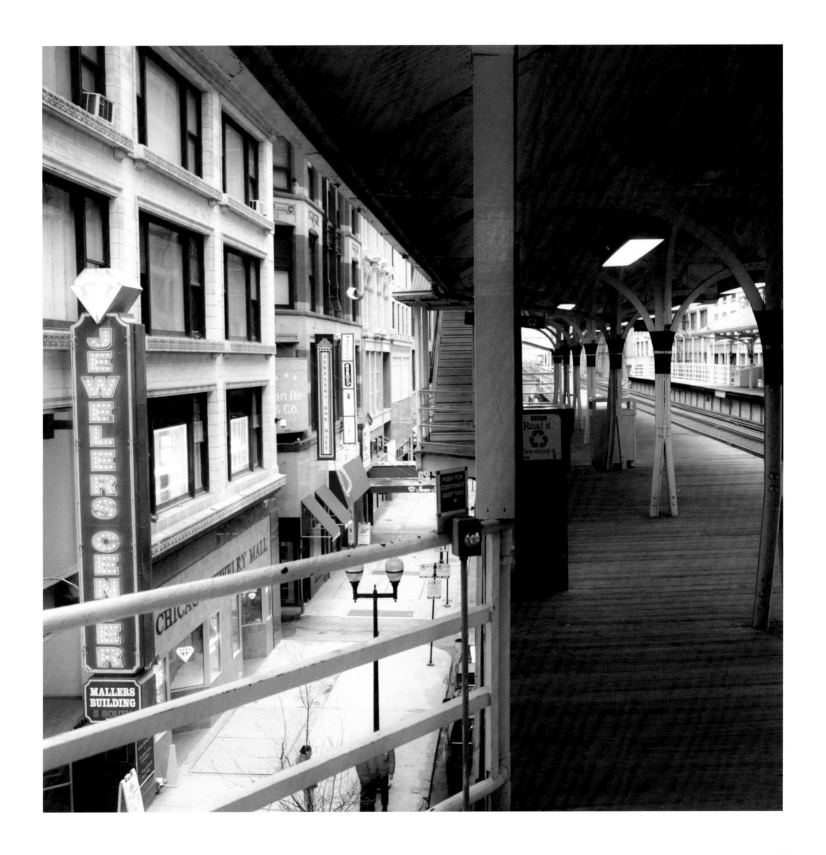

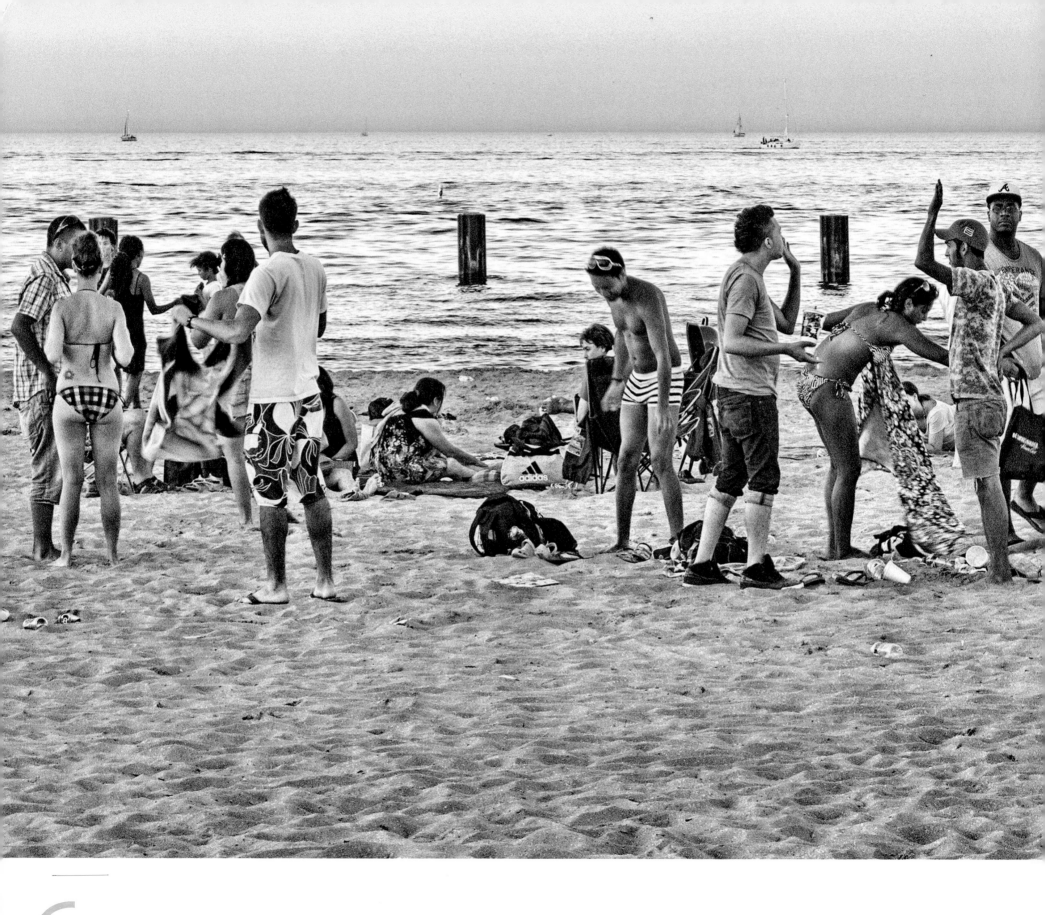

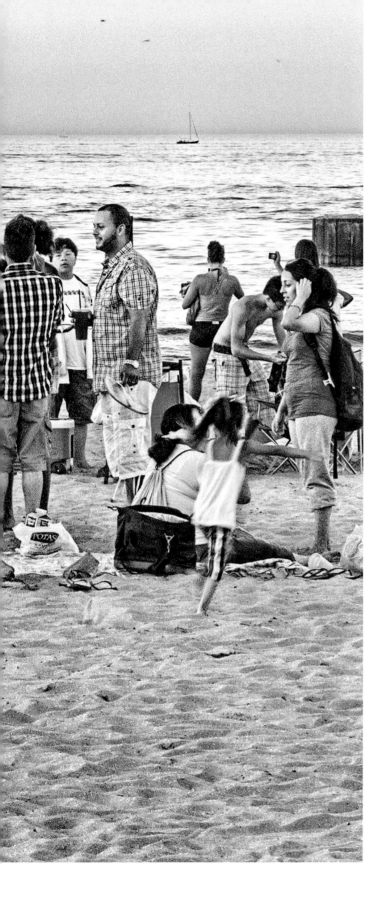

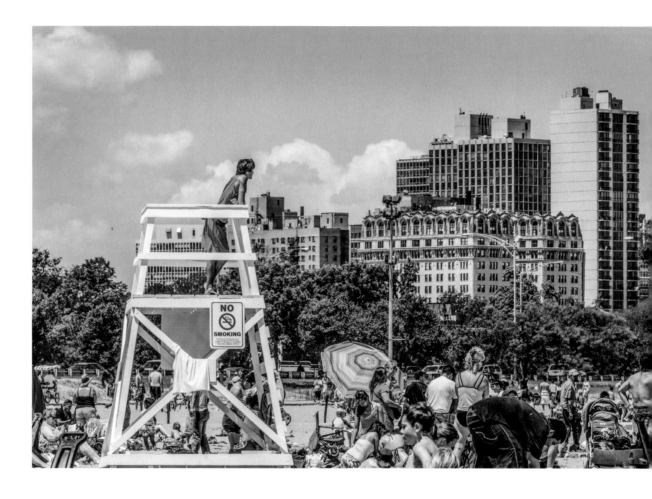

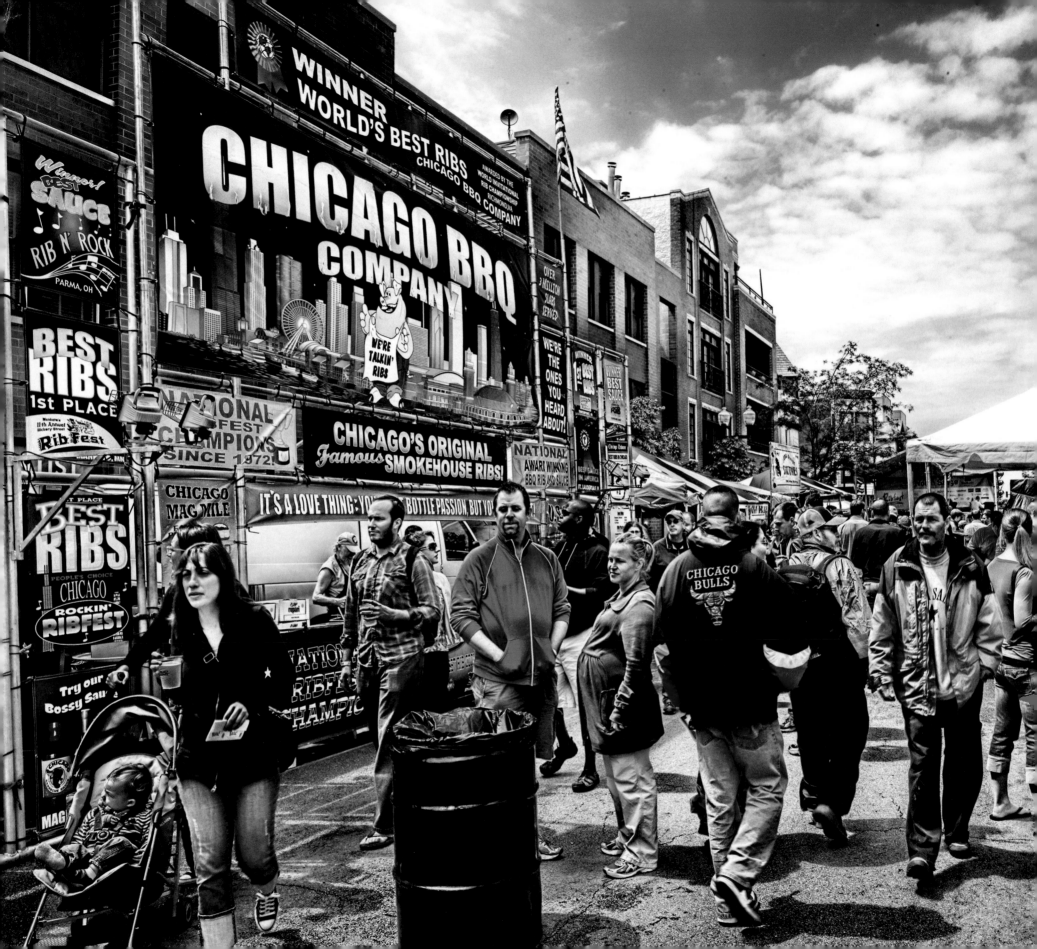

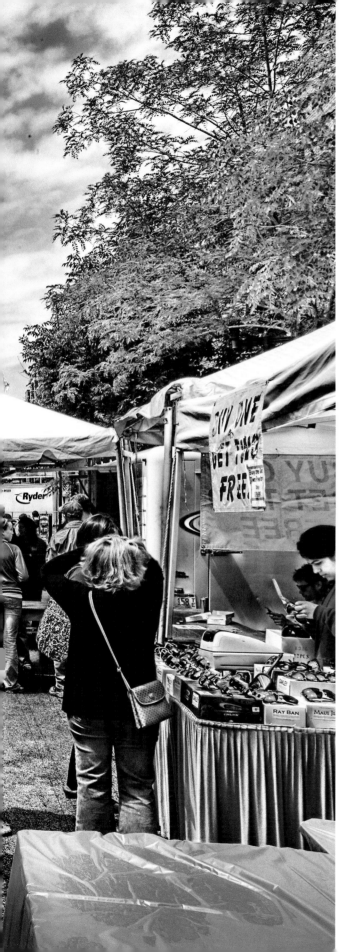

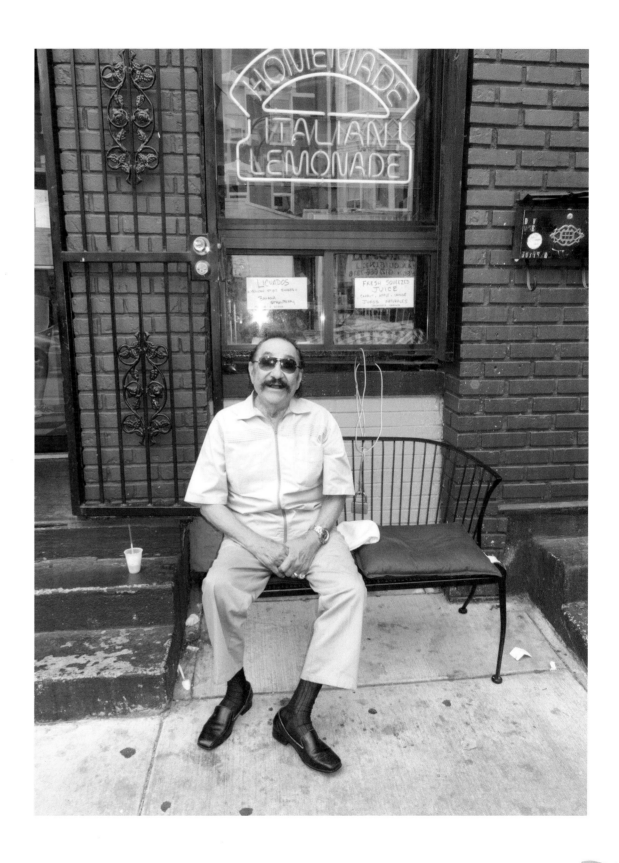

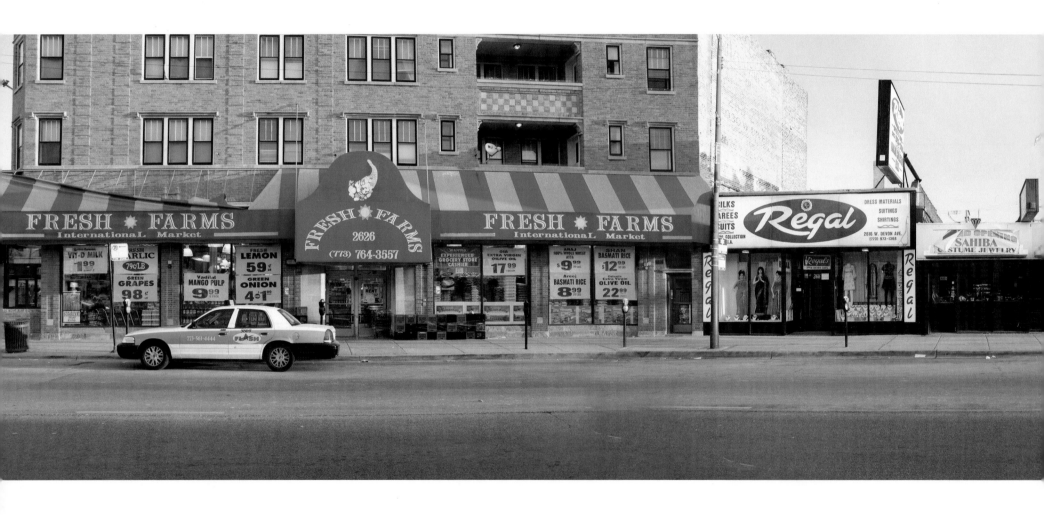

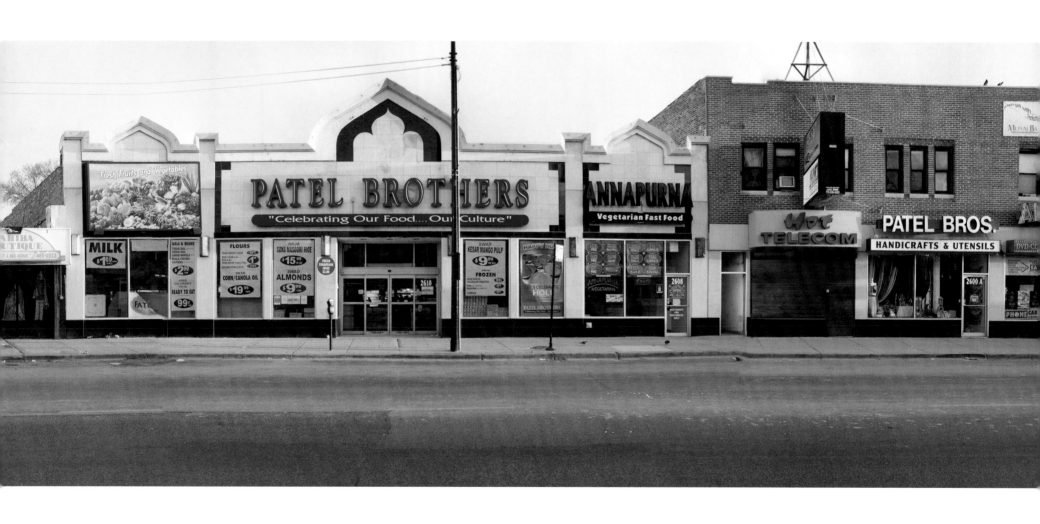

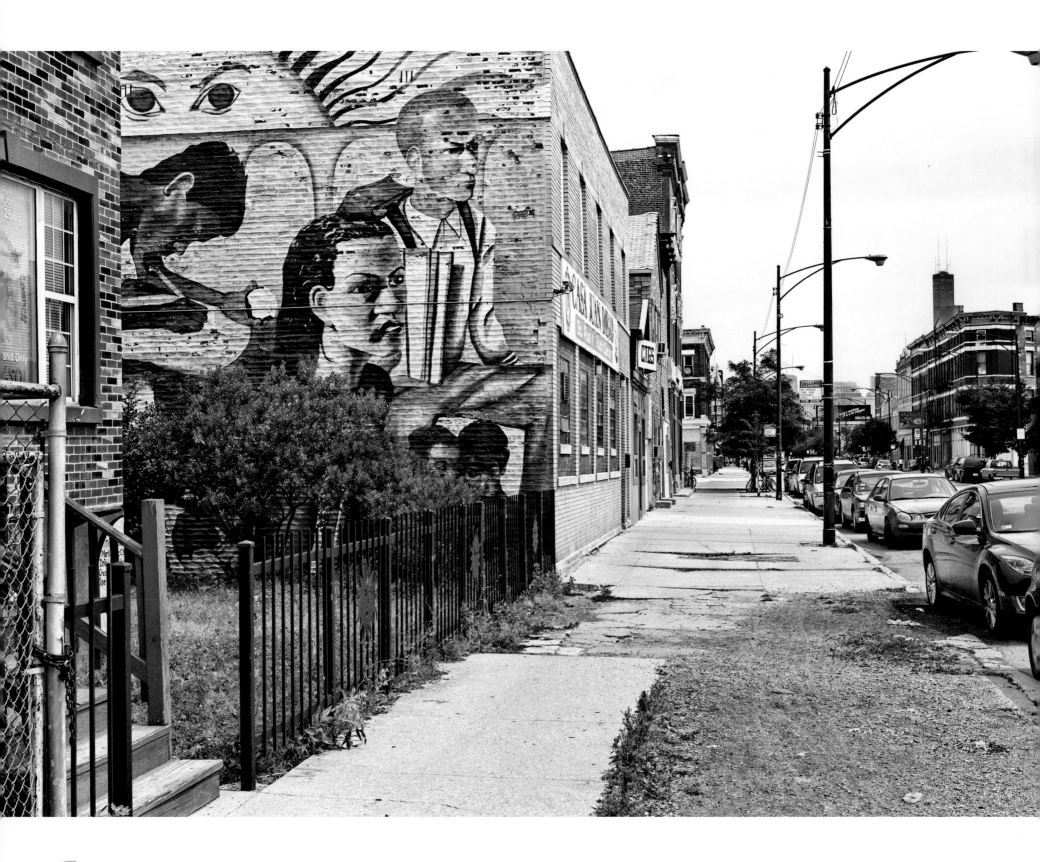

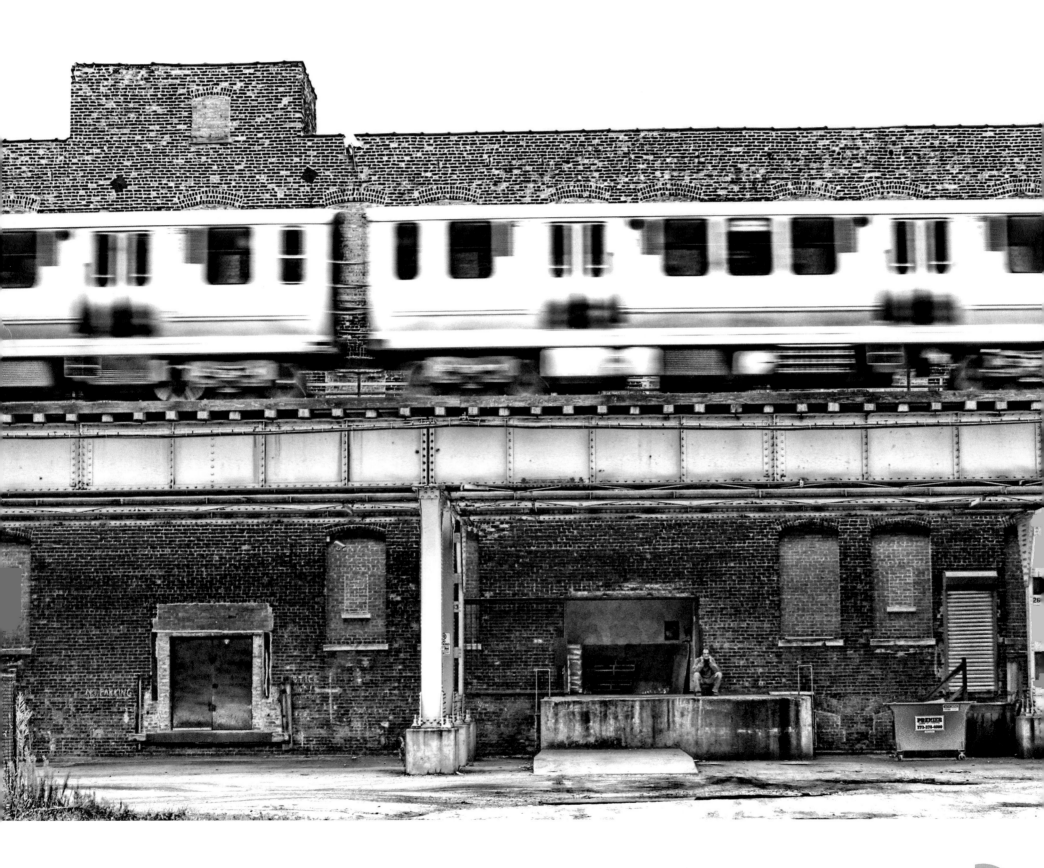

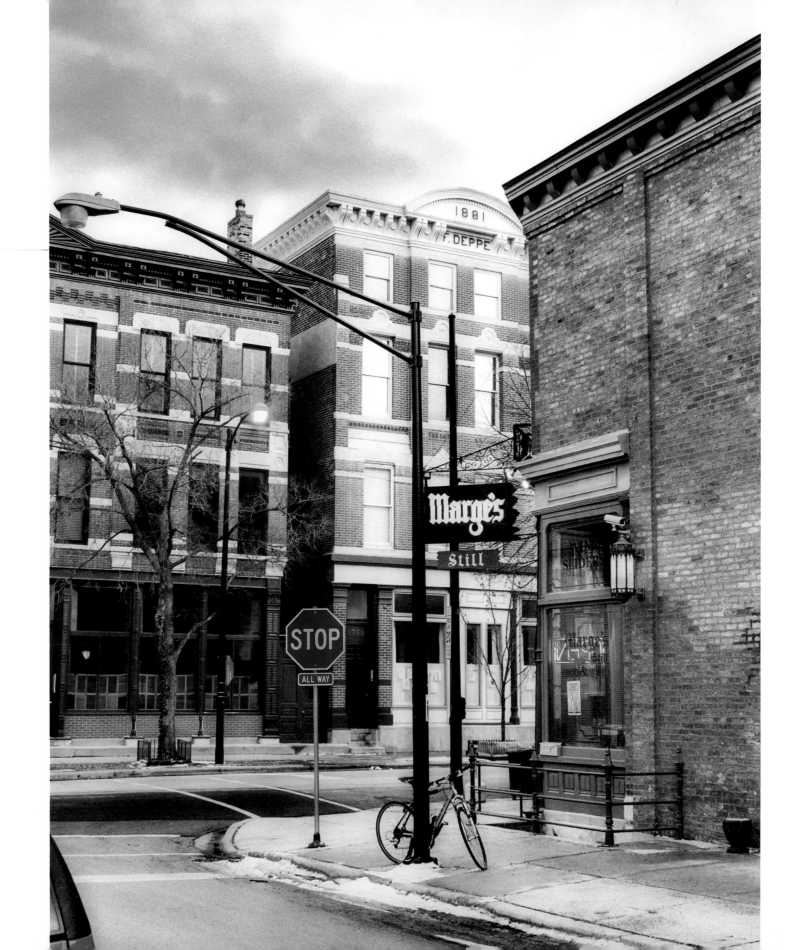

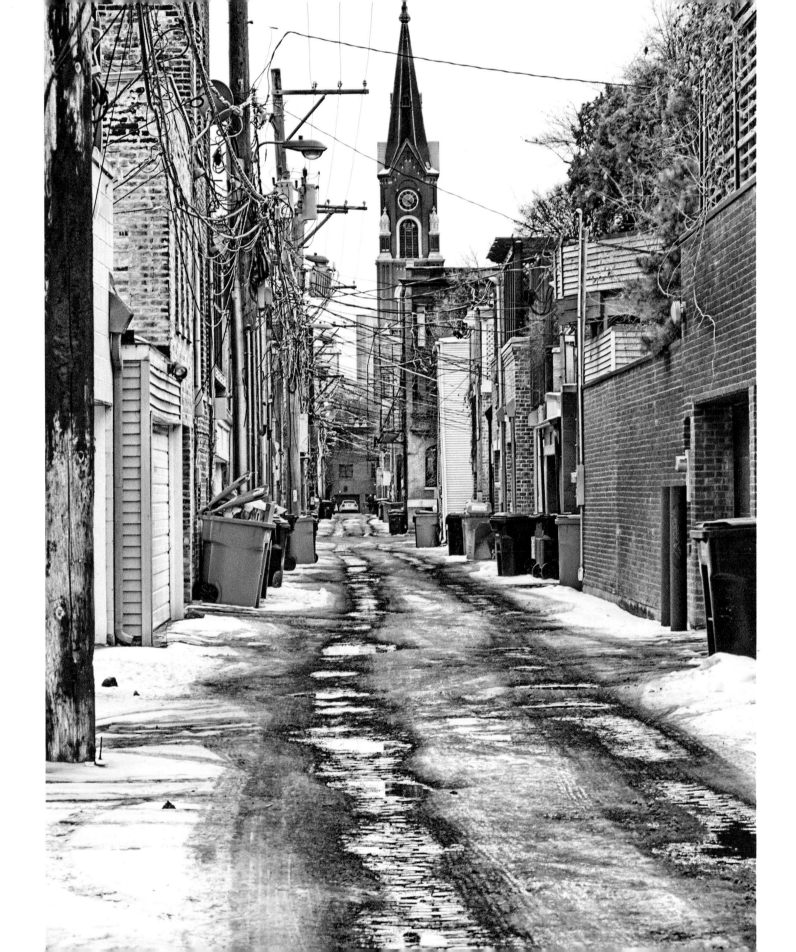

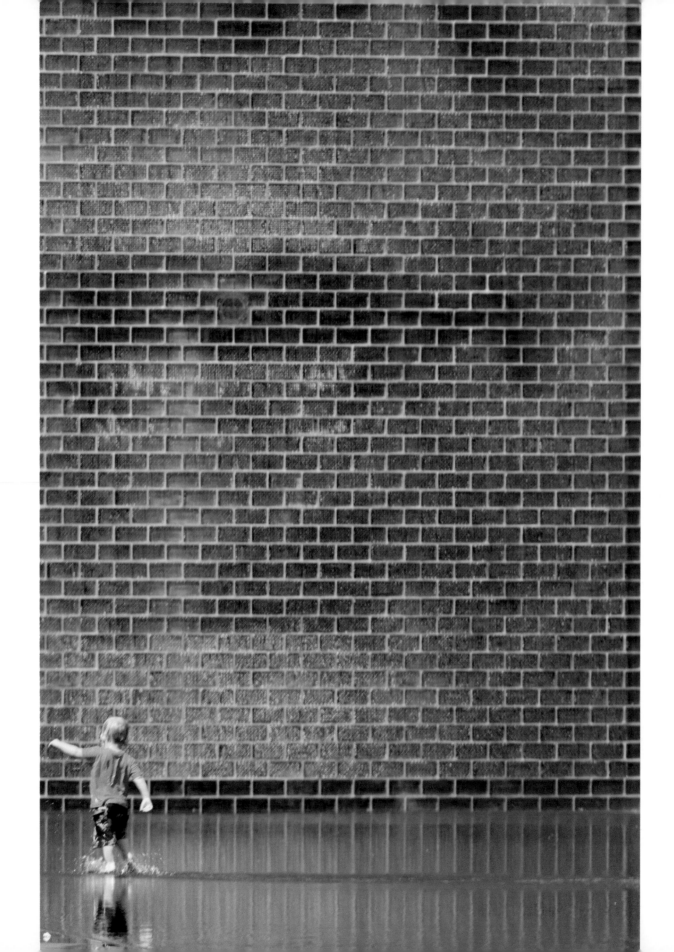

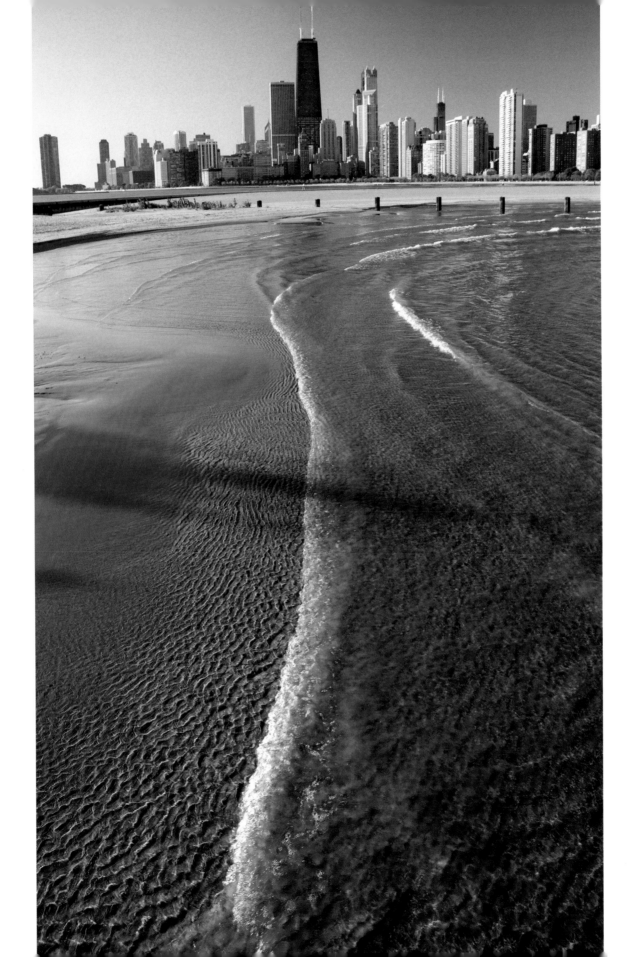

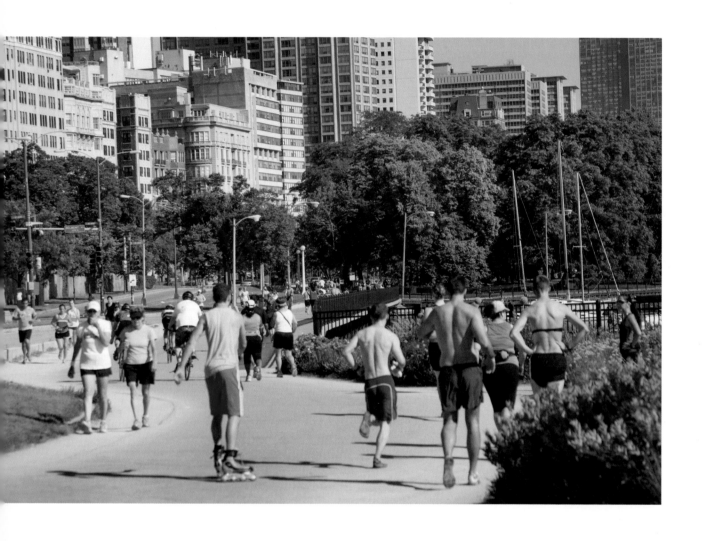
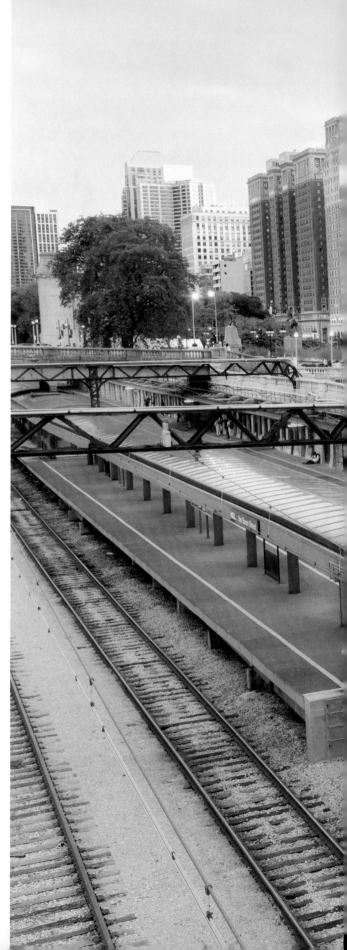

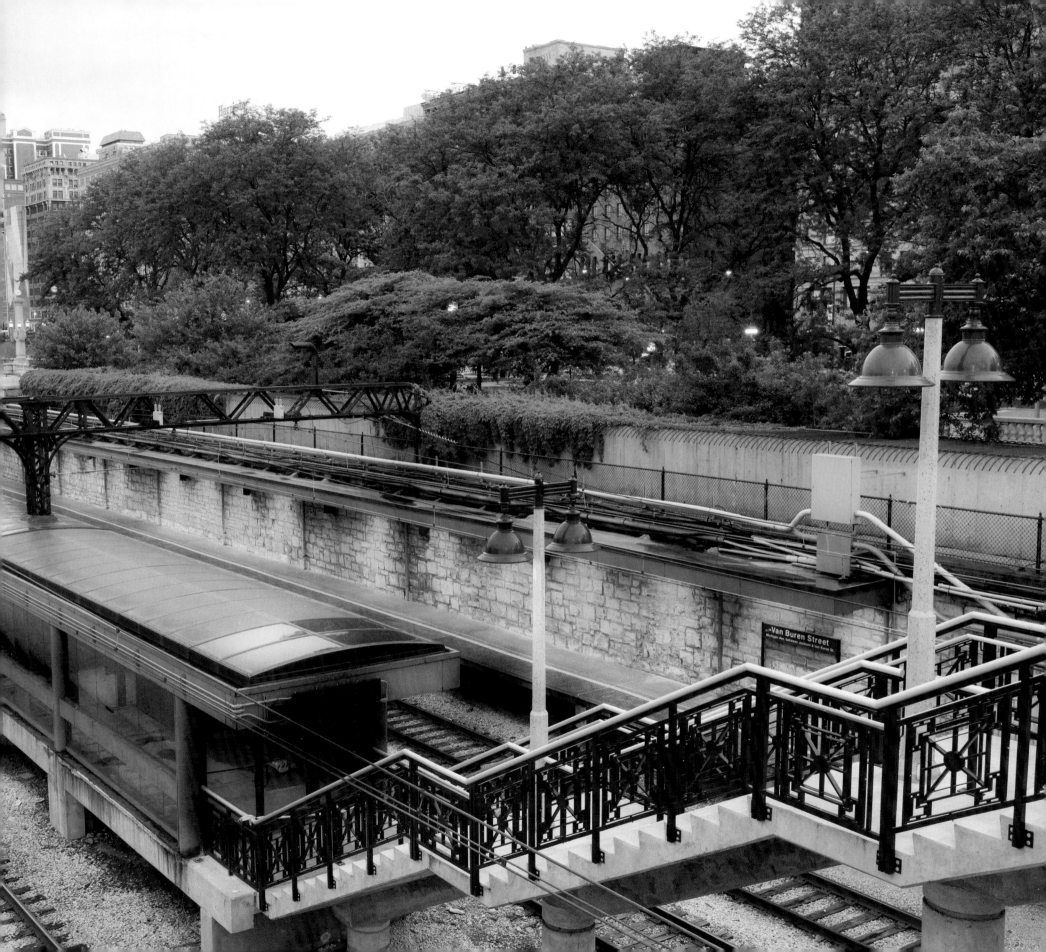

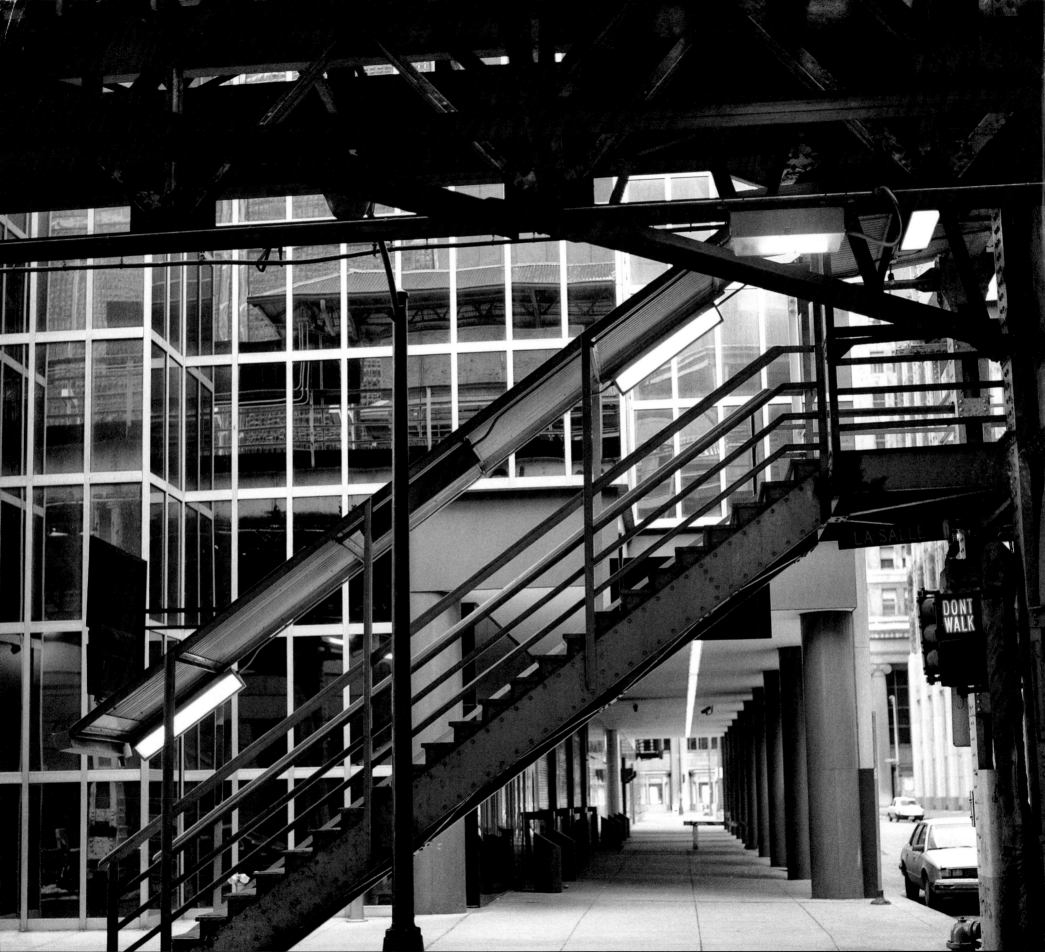

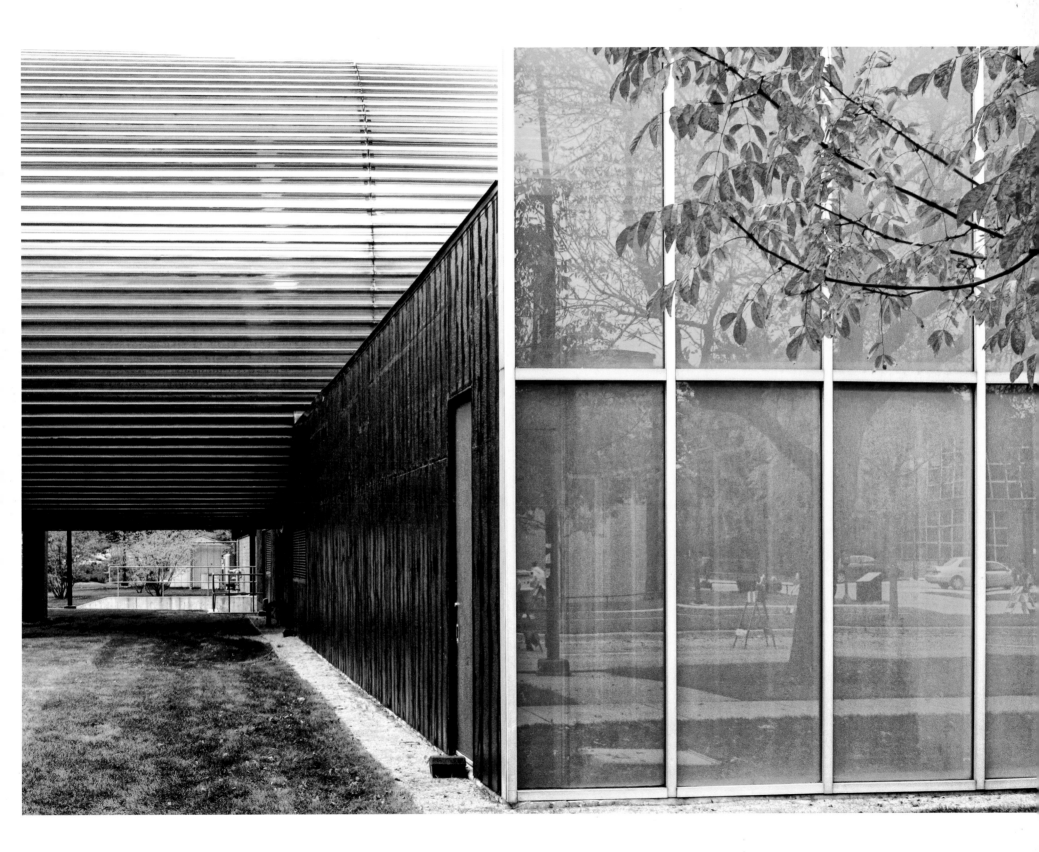

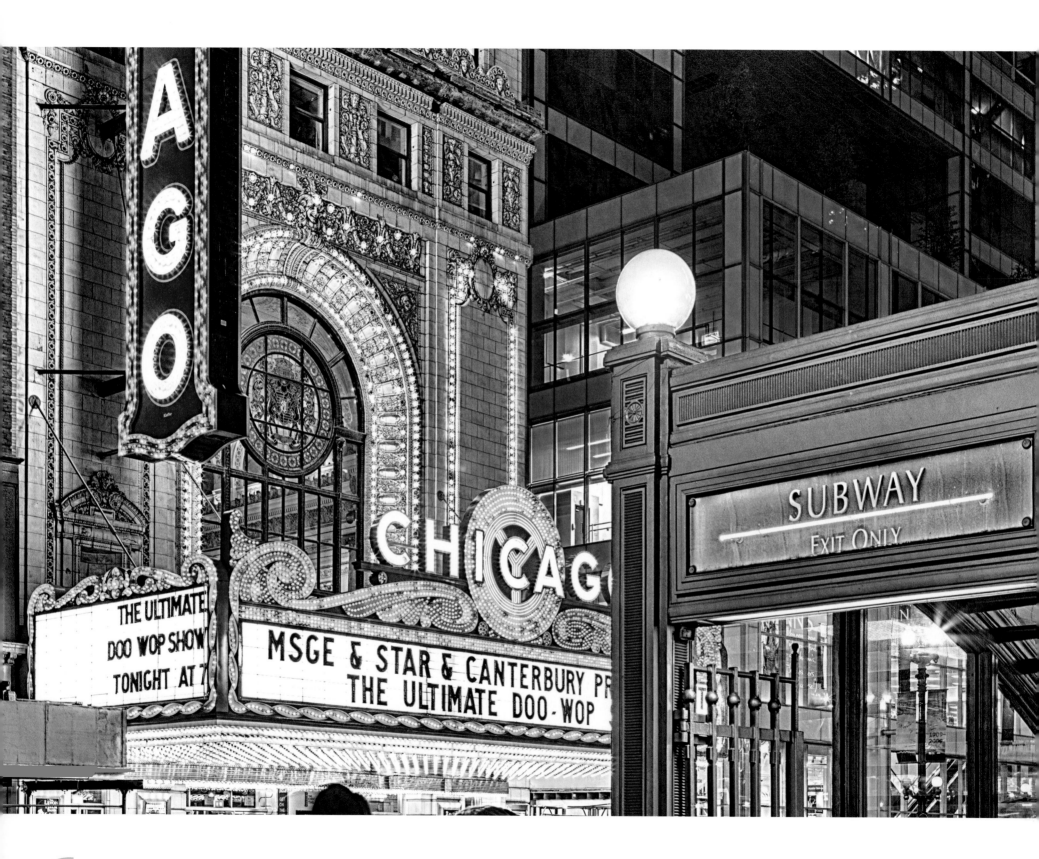

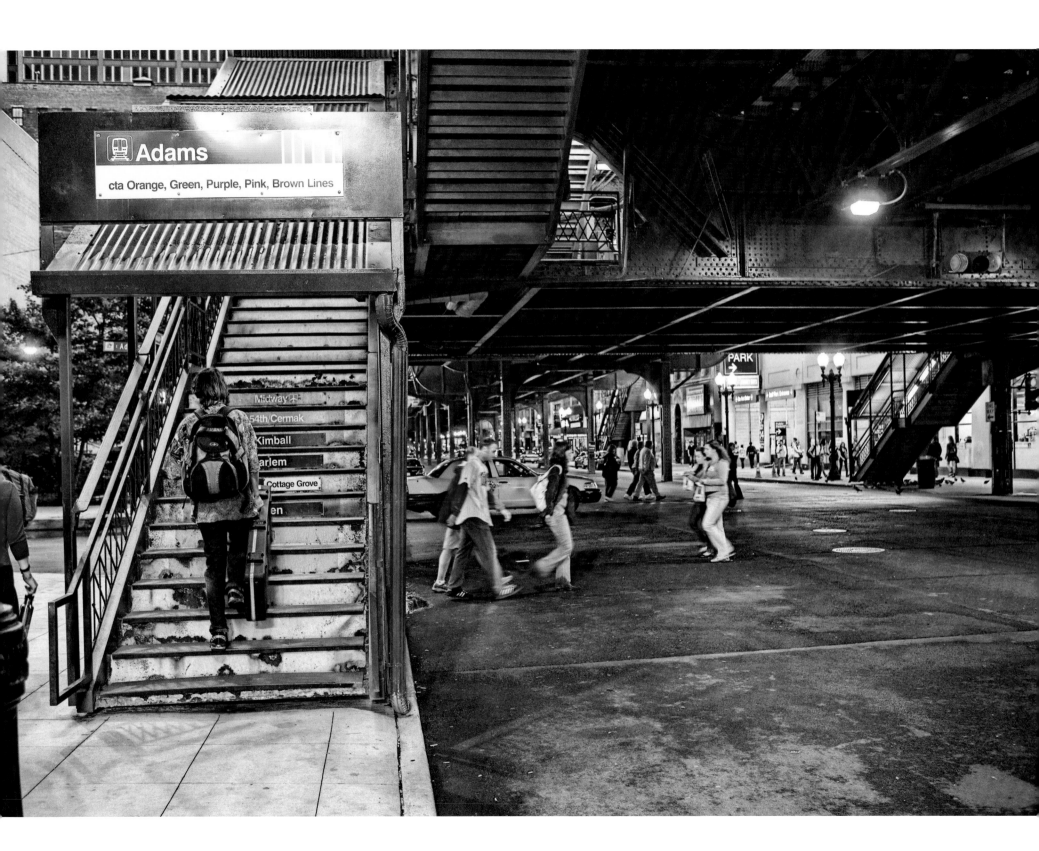

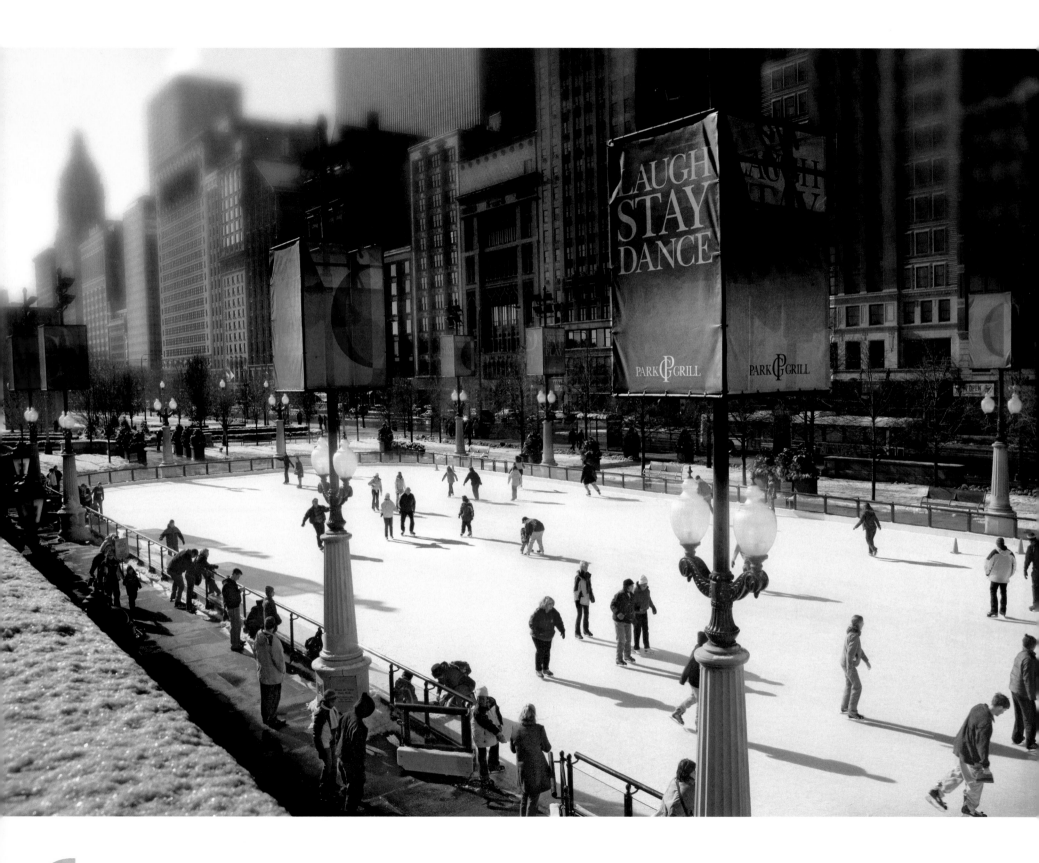

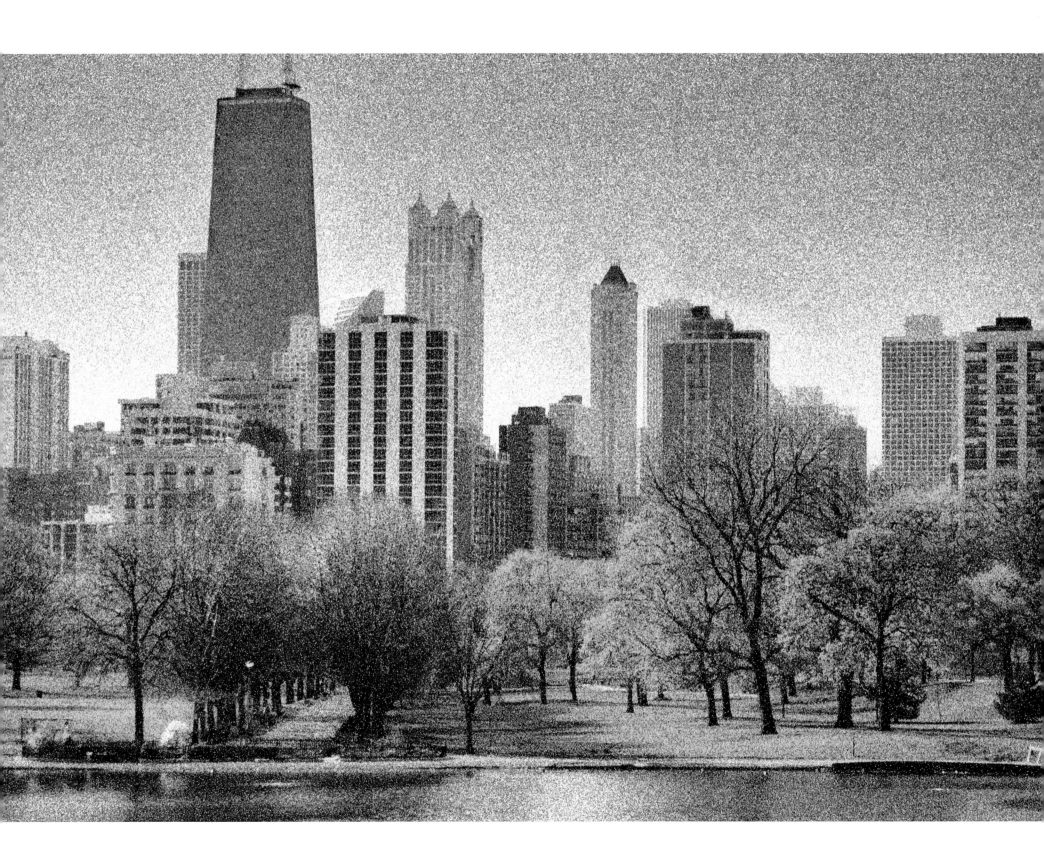

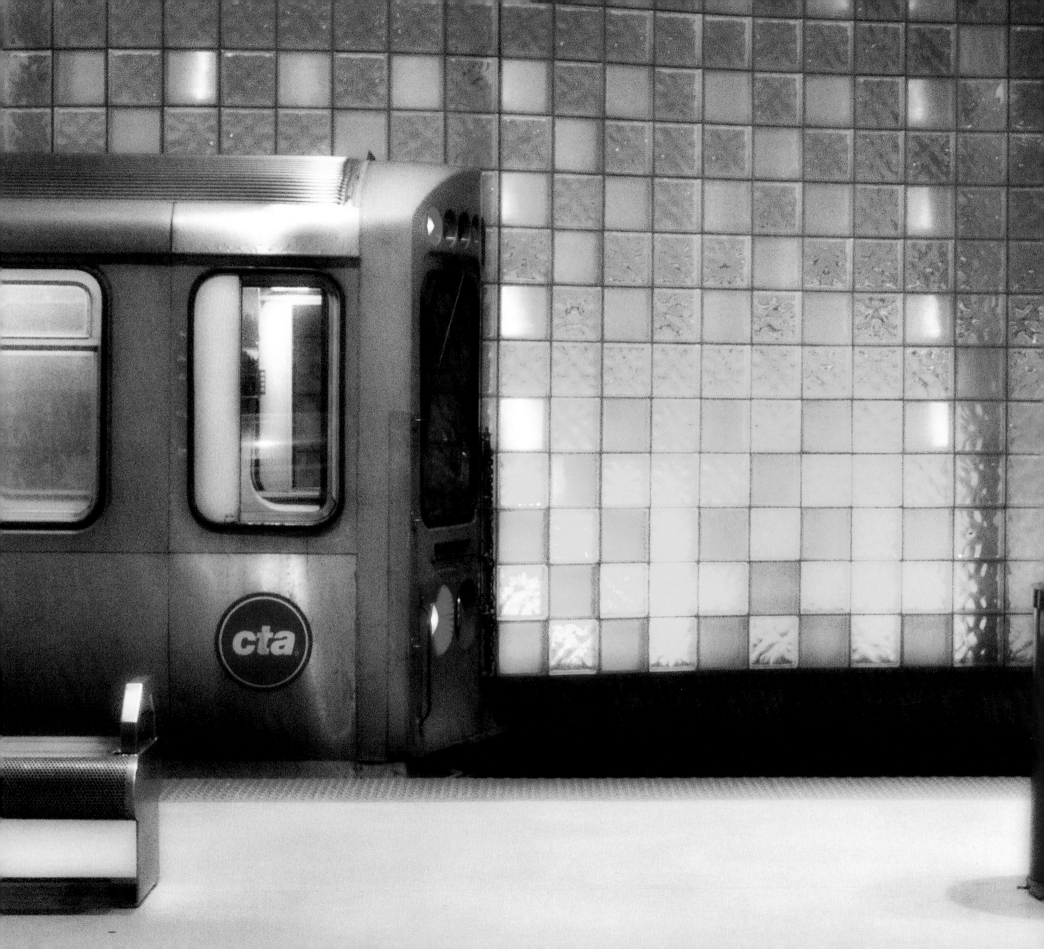

Larry Kanfer is a Midwest-based artist. He was born in St. Louis, moved with his family from east to west and then back to the Midwest. There he earned a degree in architecture from the University of Illinois at Urbana-Champaign.

Since opening his photography gallery over thirty years ago, Kanfer has had the rare opportunity to make his art his career. He has drawn praise from ARTNews, the Associated Press, the *Washington Post*, and others for his remarkable ability to identify what people love about a place and to convey that in two dimensions. Today the galleries in Champaign, Illinois, and online at www.kanfer.com offer original artwork as well as books and award-winning calendars. His publications include *Prairiescapes* (1987), *On This Island: Photographs of Long Island* (1990), *On Second Glance: Midwest Photographs* (1992), *Postcards from the Prairie: Photographic Memories from the University of Illinois* (1996), *On Firm Ground: Photographs by Larry Kanfer* (2001), *Barns of Illinois* (2009), and *Illini Loyalty* (2011). His original artwork is featured in public and private collections nationally.

Alaina Michaelson Kanfer grew up in Chicago, graduated from Northwestern University, and received her doctorate in mathematical social sciences from the University of California, Irvine. She moved to Champaign, Illinois, to take a research position at the University of Illinois, where she founded a research group at the National Center for Supercomputing Applications and published numerous scientific articles on social networks and the social impact of technology. She and Larry live in Champaign with their two children, two cats, and a dog.

List of Illustrations

6	Holiday Shopping
9	Chicago Fireboat
10–11	Twilight over Chicago
12–13	The Place to Be
14	Ashland Elevated
15	The Juggler
16	Cloud Gate by Anish Kapoor, 2006
17	The Bean
18–19	Windy City
20	South Branch of the Chicago River at Roosevelt Road
21	left: On the Avenue
	right: The Berghoff
22+	City Aglow
23	20/20
24–25	Chicago Flag at Diversey Harbor
26	Toast of the Town
27	Navy Pier
28	top left: Performance Art on Michigan
	bottom left: Transit at O'Hare International Airport
	right: The Art Institute of Chicago
29	top: Field Museum
	bottom: River Relay
30–31	Clarence F. Buckingham Memorial Fountain, by Edward Bennett, 1927
32–33	City on the Prairie
34+	Lincoln Park Conservatory
35	top: Museum of Science and Industry
	bottom: Garfield Park Conservatory
36	Tulip Island
37+	The Inner Drive
38+	Camouflage, at the Alfred Caldwell Lilly Pond
39	Trickling Tempo
40	Hat's Off
41	Converging Lines

42 Ukrainian Village

43 Chicago Circle

44 Clark Street Bridge

45 The Iron Forest

46+ Crossing Michigan Avenue

47 Chicago Gold

48–49 Perpetual Motion

50–51 Soldier Field

52 Tiffany Glass Dome at the Chicago Cultural Center

53 The Union Station

54–55 Fourth of July, Chicago Style

56 top left: The Kids

 top right: Catching the Waves

56–57 bottom: Looking North from Montrose Beach

57 top: Chicago Air & Water Show

58–59 Vanishing Point

60 top left: Urban Art on Wabash

 bottom left: The Loop

 right: Neighborhood Coach

61 left: Holding Court in Bronzeville

 top right: Wrigleyville

 bottom right: Our Stop

62–63 Binary Beat

64 Polar Bear Club

65 Reminiscing

66 Jay Pritzker Pavilion, by Frank Gehry, 2004

67 BP Bridge in Millennium Park

68 Chicago Riverwalk

69+ Visitor to Pioneer Court

70 left: South Shore Cultural Center

 top right: DuSable Museum of African American History

 bottom right: Frederick C. Robie House, by Frank Lloyd Wright, 1910

71 South Shore Golfing

72 Northwestern University, Chicago Campus

73 Rockefeller Chapel, University of Chicago

74 Armitage Shopping

75 Canine Cadre

76 Carmine's on Rush Street

77 South Side Irish St. Patrick's Day Parade

78 Blues on Halsted

79 Gino's East Pizzeria

80 Chicago Fun

81 The Spirit: Michael Jordan at the United Center, by Omri Amrany and Julie Rotblatt-Amrany, 1994

82–83 Maxwell Street Market

84 North Avenue Beach Chess Pavilion, by Maurice Webster (architect) and Boris Gilbertson (sculptor), 1957

85 center: Sam's Red Hots on Armitage

 clockwise from upper left: Morrie O'Malley's Hot Dogs, Bridgeport; Ballpark Favorites, Wrigley Field; The Wiener's Circle, Lincoln Park; 35th Street Red Hots; Byron's Chicago Hot Dogs on Irving Park; Wolfy's Hot Dogs, Peterson Park; Fran's Beef, Pilsen

86 The Polish Triangle

87 Little Saigon

88 Urban Frost

89+	A Likely Story		105	Coffee Break
90	Commuters		106	Neighborhood Oasis
91	Colorful Stories		107	Old Town Alley
92	Third Shift		108	Happy Dance
93	Layered Walking		109	Tall Tale
94–95	Front-runners		110	Weekend Routine
96	Chicago Bridge and Iron		111+	Afterglow
97	Cosmopolis		112	Urban Rainbow
98+	A Day at the Beach		113	Building Blocks at IIT
99	The Life Guard		114	Night Lights
100+	Ribfest		115	After School
101	Mario's		116	Laugh, Stay, Dance
102–3	Devon Avenue		117	Chicago in Springtime
104	Pilsen		118+	CTA Colors

The University of Illinois Press
is a founding member of the
Association of American University Presses.

Designed by Dustin J. Hubbart
Composed in 10.5/13 Frutiger 45 Light
with Hardwood display
by Dustin J. Hubbart
at the University of Illinois Press
Manufactured by Bang Printing

University of Illinois Press
1325 South Oak Street
Champaign, IL 61820-6903
www.press.uillinois.edu